PRAISE FOR
YOUNG BLOOMSBURY

"This lively group biography offers an intimate glimpse of the Bright Young Things, the artistic coterie that emerged in the nineteen-twenties as successors to the prewar Bloomsburyites."

—*The New Yorker,* "Best Books of 2022"

"This captivating history explores the second generation of queer British writers and artists who pushed the original Bloomsbury Group, which included Virginia Woolf and E. M. Forster, to live more publicly and go farther creatively."

—*The New York Times*

"There is much for Americans to learn from and celebrate in this lively account of Bloomsbury's freethinking pioneers."

—*The Washington Post*

"A brisk, light tonic . . . Strachey provides frothy accounts of their gatherings . . . For each rising generation there's reason to illuminate again their particular, if fleeting, triumphs."

—Claire Messud, *Harper's Magazine*

"It's only a slight exaggeration to say that the story of Bloomsbury is the story of modern literary biography itself."

—*The Wall Street Journal*

"In this sharp, thoughtful look at the group, their work, and its impact, Nino Strachey shines a light on cultural masterminds whose lives and work would change the world forever."

—*Town & Country*

"The author's group portrait is both enlightening and fond . . . and does literature a great favor by gifting [readers] with this fascinating account."

—*Booklist*

"Insightfully analyzes the substance of Bloomsbury's social network, how their lives intertwined as a kind of queer chosen family, and how they adapted to heteronormative expectations while remaining true to their desires and identities . . . Written in lucid prose, this is a dream to read for those interested in queer history."

—*Kirkus Reviews*

"Illuminating . . . When it came to sex, the Bright Young Things of the 1920s were 100 years ahead of their time."

—*The Daily Mail* (UK)

"A superb, sparky and reflective book charting the doings of the younger members of the artistic and intellectual coterie."

—*The Spectator* (UK)

"Enjoyably intimate and assured in tone . . . One comes away slightly breathless with the sense of having left an excellent party full of wit and intrigue."

—*The TLS* (UK)

"A highly entertaining, pacy volume, based on considerable research, and a must for modern Bloomsbury fans, whether young or old."

—*Country Life* (UK)

"This witty, fascinating book is a delight. Read it."

—Miriam Margolyes

"A thrilling and new insight into an extraordinary group of people so ahead of their time, they even remain ahead of ours . . . I want to climb inside this book and live there."

—Phoebe Waller-Bridge, creator of *Fleabag*

"*Young Bloomsbury* brims with the same kind of sexy vitality embodied by the characters Nino Strachey describes in such effervescent detail . . . Nino's exhilarating lens offers an entirely original and thrilling focus. As skepticism, admiration, envy, and confusion ebb and flow between one chattering, seductive, thinking, inspiring generation and another, this is Gatsby made real."

—Juliet Nicolson, author of
*Frostquake: The Frozen Winter of 1962 and
How Britain Emerged a Different Country*

"With a deft turn of the Bloomsbury kaleidoscope, and an impressive gift for finding treasures in the archives, Nino Strachey reveals colorful new patterns of experiments in living that speak trenchantly to our own cultural moment."

—Mark Hussey, author of
Clive Bell and the Making of Modernism

"Great fun and, for all fans of the Bloomsbury Group, enormously informative . . . You never know who you're going to meet."

—Simon Fenwick, author of
The Crichel Boys

"Above all else, Bloomsbury was a liberating force, as Nino Strachey shows in her sparkling new book. The younger friends and relations of the Bells, Stracheys and Woolfs lived, worked, and loved freely,

finding their own ways to personal and artistic fulfilment. This book is packed with their brilliant, subversive energy."

—Anne Chisholm, author of
Frances Partridge: A Biography

"A lively account of a group of bright young things in the 1920s. A hundred years ahead of their time, these creative souls were pushing the boundaries of gender identity and sexual expression, and—surprisingly—finding acceptance among their friends and families."

—Robert Sackville-West, author of
*The Searchers: The Quest for the Lost of
the First World War*

"An extraordinary account of the bustling nonbinary heart of the literary and artistic Roaring Twenties, filled with the most vivid characters, who lived and loved under the shadow of conversion therapy and yet found ways to express themselves so boldly and beautifully. *Young Bloomsbury* gives new context to the later stages of life for the original Bloomsbury Group. I loved every page."

—Jack Thorne, BAFTA, Tony, and
Olivier Award–wining screenwriter and playwright

YOUNG BLOOMSBURY

The Generation That Redefined Love, Freedom, and Self-Expression in 1920s England

NINO STRACHEY

ATRIA PAPERBACK

NEW YORK LONDON TORONTO SYDNEY NEW DELHI

ATRIA
PAPERBACK

An Imprint of Simon & Schuster, Inc.
1230 Avenue of the Americas
New York, NY 10020

First Atria Paperback edition August 2023

ATRIA PAPERBACK and colophon are trademarks of
Simon & Schuster, Inc.

For information about special discounts for bulk purchases,
please contact Simon & Schuster Special Sales at 1-866-506-1949 or
business@simonandschuster.com.

The Simon & Schuster Speakers Bureau can bring authors to your live
event. For more information or to book an event, contact the Simon &
Schuster Speakers Bureau at 1-866-248-3049 or visit our website at
www.simonspeakers.com.

Interior design by Joy O'Meara @ Creative Joy Designs
Border art @ Tartila/Shutterstock.com

Manufactured in the United States of America

1 3 5 7 9 10 8 6 4 2

Library of Congress Cataloging-in-Publication Data is available.

ISBN 978-1-9821-6476-8
ISBN 978-1-9821-6477-5 (pbk)
ISBN 978-1-9821-6478-2 (ebook)

To Cas

CONTENTS

CONTENTS

DRAMATIS PERSONAE

"OLD BLOOMSBURY"

The Strachey and Grant Families

LYTTON STRACHEY (1880–1932), biographer and essayist

DUNCAN GRANT (1885–1978), painter and decorative artist, first cousin of Lytton Strachey (an only child, partly brought up by his aunt, Lady Strachey, as his parents were living abroad)

Lytton's siblings and Grant's first cousins:

JAMES STRACHEY (1887–1967), psychoanalyst, married to ALIX SARGANT-FLORENCE (1892–1973), psychoanalyst, co-translators of *The Standard Edition of the Complete Psychological Works of Sigmund Freud*

MARJORIE STRACHEY (1882–1964), writer

OLIVER STRACHEY (1874–1960), cryptanalyst, married to RAY COSTELLOE (1887–1940), writer and suffrage campaigner

PIPPA STRACHEY (1872–1968), campaigner for female suffrage

PERNEL STRACHEY (1876–1951), French scholar, head of Newnham College, Cambridge

The Stephen Family

ADRIAN STEPHEN (1883–1948), psychoanalyst, married to KARIN COSTELLOE (1889–1953), psychoanalyst

VANESSA STEPHEN (1879–1961), painter and decorative artist, married to CLIVE BELL (1881–1984), writer and art critic

VIRGINIA STEPHEN (1882–1941), novelist, essayist, and publisher, married to LEONARD WOOLF (1880–1969), literary editor, publisher, political theorist

Other Key Figures

ROGER FRY (1866–1934), painter, art critic, curator

MAYNARD KEYNES (1883–1946), economist, married to LYDIA LOPOKOVA (1891–1981), ballet dancer

DESMOND MacCARTHY (1877–1952), literary editor, married to MOLLY MacCARTHY (1882–1953), writer

EDWARD MORGAN FORSTER (1879–1970), novelist and essayist

Early Recruits

DORA CARRINGTON (1893–1932), painter and decorative artist, married to RALPH PARTRIDGE (1894–1960), assistant at the Hogarth Press, secretary to Lytton Strachey

DAVID "BUNNY" GARNETT (1892–1981), bookseller, publisher, and writer, married to RAY MARSHALL (1891–1940), illustrator

"YOUNG BLOOMSBURY"

ANGUS DAVIDSON (1898–1980), assistant at the Hogarth Press, writer

DOUGLAS DAVIDSON (1901–1960), painter and decorative artist

EDDIE GATHORNE-HARDY (1901–1978), antiquarian bookseller

FRANCES MARSHALL (1900–2004), bookseller, diarist, second wife of Ralph Partridge

RAYMOND MORTIMER (1895–1980), journalist and literary critic

PHILIP RITCHIE (1899–1927), barrister

GEORGE "DADIE" RYLANDS (1902–1999), assistant at the Hogarth Press, literary scholar, and fellow of King's College, Cambridge

EDDY SACKVILLE-WEST (1901–1965), novelist and music critic

ROGER SENHOUSE (1899–1970), translator and publisher

WALTER "SEBASTIAN" SPROTT (1897–1971), psychologist, lecturer, and professor at the University of Nottingham

JOHN STRACHEY (1901–1963), journalist and socialist politician, married to Esther Murphy

JULIA STRACHEY (1901–1979), novelist, married to Stephen Tomlin

STEPHEN TENNANT (1906–1987), artist and illustrator

STEPHEN "TOMMY" TOMLIN (1901–1937), sculptor, married to Julia Strachey

Transatlantic Visitors

HENRIETTA BINGHAM (1901–1968), former student at Smith College

MINA KIRSTEIN (1896–1985), professor on study leave from Smith College

ESTHER MURPHY (1897–1962), aspiring author, married to John Strachey

YOUNG
BLOOMSBURY

◆

INTRODUCTION

◆

On a warm summer evening in 1923, Lytton Strachey and Duncan Grant headed across London for an extravagant late-night party. Lytton wasn't entirely sure that he liked the flashy American hosts, with their fancy Sunbeam car and sudden interest in all things Bloomsbury. But he knew that his partner Dora Carrington and many of his other younger friends were smitten. Beautiful, rich, and bisexual, Henrietta Bingham and Mina Kirstein exuded Jazz Age glamour. They could mix the latest cocktails, dance the latest steps, and knew all the popular show tunes.

Guests of honor that evening were dancer Florence Mills, known as the "Queen of Happiness,"[1] and blues singer Edith Wilson, the Black American stars of *Dover Street to Dixie*—Charles B. Cochran's latest hit revue at the London Pavilion. Mills and other cast members danced and sang, and Henrietta hitched herself up onto the piano to play her saxophone, resplendent in a purple dress. Even the most jaded spirit must have found it hard to resist the megawatt smile of Mills; publicity photos from the show taken that summer capture a triumphant Mills raising a top hat above

her shimmering bugle-beaded dress, a silver-handled cane tucked deftly under her arm.

Revelers drifted into the lamplit garden through the open French windows; jazz music lingered in the air. Strachey stayed until the small hours, amusing himself by chatting to Mina's handsome teenage brother, who had sneaked downstairs to join in the fun and, intrigued by Lytton's old-fashioned appearance, had decided some gentle teasing was in order: "I was urged to ask Lytton if he slept with his beard inside or outside. (Outside, he confided.)"[2] Duncan Grant was in equally mellow mood, telling Mina when she came to sit for a portrait that everything had been "absolutely perfect . . . Beautiful to look at and delicious to taste."[3]

Bingham and Kirstein had arrived in England with a fistful of society introductions. Henrietta's millionaire father was a Kentucky press magnate and Mina's wealthy family owned a Boston department store. To begin with, they hung out in the obvious places with the obvious people; Mina knew the daughter of Harry Gordon Selfridge, founder of the Oxford Street store, so evenings were spent dancing at the Savoy or the 43 Club. But the pair had a more adventurous spirit, seeking company where hidden sexualities might be more accepted. Months of Freudian analysis in Harley Street had failed to quench their passion for each other or their desire for partners of both sexes. A chance meeting in Bloomsbury bookshop Birrell & Garnett led to friendship with a group of writers and artists who had made sexual openness their watchword.

Lytton Strachey and Duncan Grant led the "Old Bloomsbury"[4] cohort at Henrietta and Mina's party; they belonged to a different age group from their hosts, but their attitudes were thoroughly modern. According to Vogue, Strachey had created "a revolution in the art of biography,"[5] demolishing the stuffy heroes of the Victorian era with his deliciously ironic takedowns. Grant's paintings were proving similarly popular—bold enough to feel subversive but decorative enough

to retain a broad appeal. The *Telegraph* had described him as "one of the most audacious, and it must be owned, one of the most brilliant post-impressionists or extremists,"[6] and his work was finding its way into the papers and onto the stage. Provocation was the order of the day, and the two first cousins contributed in equal measure. Grant took a devil-may-care approach to his image, but Lytton's "look" was intended to inspire a reaction—the long dark hair, flowing red beard, and distinctive drooping demeanor were perfect material for caricature (and popular cartoonist Max Beerbohm duly obliged).

The Bloomsbury Group had gained a controversial reputation before the First World War; by 1923 they were becoming "unforgivably successful."[7] Bloomsbury's irreverent spirit struck a chord with the postwar generation, reaching an audience eager to challenge traditional conventions. Young people who met them in person were struck by their frank approach to life and love. It was rare to find an older group so open to new ideas, so accepting of different sexualities. Indeed, meeting your heroes was easier when most of them lived next door to each other. *Vogue*'s October 1925 edition provided a helpful guide to the Bloomsbury area of London. Assembled within a radius of about a hundred yards were an impressive array of "brains": "All the Stracheys, Maynard Keynes . . . Adrian Stephen, Clive Bell . . . round the corner the house of the Hogarth Press, where sits, most satisfying to me of all writers, Virginia Woolf, and not far away her sister, Vanessa Bell, and the best of contemporary painters Duncan Grant."[8] Diarist Frances Marshall was one of the lucky "young fringe-Bloomsburies"[9] who gained direct access. Fresh from Cambridge University, Frances was only twenty-one when she joined the staff at her brother-in-law David Garnett's Bloomsbury bookshop and found herself in daily contact with an awe-inspiring set of customers: "These, I reflected, were the sort of people I would like to know and have friends among, more than any others I had yet come across. I was instantly captivated and thrilled by them. It was

as if a lot of doors had suddenly opened out of a stuffy room which I had been sitting in for too long."[10]

It's easy to imagine the Bloomsbury Group running on a smooth path toward success, in continuous occupation of their favored territory in London. But their habitat was in fact the result of determined action: dispersed during the First World War, the friends came back together in the twenties like homing pigeons, reassembling in the streets around 46 Gordon Square, the home to which Vanessa and Virginia Stephen had escaped after the death of their father in 1904, seeking a life free from adult interference. It was here that the Stephen sisters had first got to know the Cambridge friends of their brothers Thoby and Adrian, finding new ways to connect: a commitment to honest communication between the sexes, to freedom in creativity, to openness in all sexual matters. A family of choice, they created ties of love that lasted a lifetime, embracing queerness, acknowledging difference, defying traditional moral codes.

With Lytton Strachey as their agent provocateur, the friends challenged each other to break new ground. Economist Maynard Keynes stood alone amidst a group dominated by artists and writers. Painter Vanessa Stephen became Vanessa Bell when she married art critic Clive Bell; writer Virginia Stephen became Virginia Woolf when she married aspiring author Leonard Woolf. Of the writers, only Edward Morgan (E. M.) Forster reached a major audience before the First World War. In the early days it was the painters who captured public attention: curator and critic Roger Fry inspired Duncan Grant and Vanessa Bell with his passion for the French postimpressionists. Seen as part of a pioneering group of British modernists, their reputations were amplified through association with the Omega Workshops— an artists' collective that helped to develop public perceptions of Bloomsbury as a brand.

Critical support was just gathering momentum when war broke out in 1914 and the war years formed a temporary break in the

group's activities, but sales of works by Bloomsbury writers and artists took off again after 1918, building a definitive reputation on both sides of the Atlantic. By this stage most of the original members were nearing their forties, their ideas honed by years of close-knit conversation. Lytton Strachey set the ball rolling with *Eminent Victorians* in 1918; Maynard Keynes challenged conventional economic thinking with *The Economic Consequences of the Peace* in 1919; Duncan Grant held his first solo exhibition in 1920, impressing reviewers with his "defiant modernity."[11] Strachey followed up with *Queen Victoria* in 1921, breaking British publishing records by selling four thousand copies in twenty-four hours. Virginia Woolf couldn't compete with Lytton's sales figures, but she took comfort in the response of literary critics, signing with the same US publisher—Harcourt, Brace—for her American editions. By the time Lytton Strachey and Duncan Grant partied with Henrietta Bingham and Mina Kirstein, Woolf could relax, comfortable in a sense of shared acclaim for her old friends: "all 40 and over; all prosperous . . . there we sat, with H. Brace's catalogue talking of us all by name as the most brilliant group in Gordon Square! Fame, you see."[12]

Virginia resented the way journalists began to lump together prewar founding members with the younger circle of admirers who gathered in the 1920s. Others were more phlegmatic—well aware of the publicity value of linking their names with fashionable "Bright Young Things," a nickname given by the tabloid press to the bohemian young aristocrats and socialites who gathered in London and at parties of the type hosted by Henrietta and Mina. Vanessa's husband, Clive Bell, welcomed the new generation, recognizing that they "shared a taste for discussion in pursuit of truth and a contempt for conventional ways of thinking and feeling—contempt for contemporary morals, if you will."[13]

Who were these unconventional younger figures who invigorated the aging "Bloomsberries"[14] with their captivating looks and

provocative ideas? Some were the children of Bloomsbury families; others were lovers who became friends. Individually intriguing, their collective value has been consistently underplayed—their achievements obscured in later accounts: young men dismissed as frivolous for embracing their femininity; young women judged by their relationships rather than their careers; connections with fashion, show business, or the popular press portrayed as culturally inferior to more "intellectual" pursuits. Talented and productive, they led interesting professional lives, and complicated emotional ones. Most remarkably for the period, they were a group of queer young people who found the freedom to express their sexuality amidst a group of supportive adults. To a twenty-first-century world still riven by homophobia, biphobia, and transphobia, they provide a powerful historical example of the benefits of acceptance.

"Young Bloomsbury" seems the most helpful shorthand to describe the acolytes who gathered near Gordon Square, renting rooms in Gordon Place, Taviton Street, Brunswick Square, and Heathcote Street. A lucky few found lodgings in Gordon Square itself, leasing whole floors of tall Bloomsbury houses from Vanessa Bell or Lytton's brother James and his wife, Alix Strachey. Many were fresh from university, finding useful starter roles as models or assistants; they posed for Grant's and Bell's paintings, organized exhibitions, set type for the Woolfs at the Hogarth Press, and sifted through Lytton Strachey's erotic correspondence. Others were already launched on their own successful careers, bringing reflected glory on their idols. Journalist Raymond Mortimer, "vivacious in transparent celluloid,"[15] brought his own star quality to *Vogue*. Novelist Eddy Sackville-West and artist Stephen Tennant shared a similar androgynous aesthetic, appearing in Cecil Beaton's generation-defining photographs. Academics Sebastian Sprott and Dadie Rylands were striking both physically and intellectually—Sebastian taught psychology at Nottingham, Dadie lectured in English at Cambridge. Sculptor Stephen Tomlin carved

the definitive images of Duncan Grant, Lytton Strachey, and Virginia Woolf. Author Julia Strachey wrote a searing tale of blighted love for the Hogarth Press, while her socialist cousin John embodied the bold new radicalism of the left. These were not relationships of dependency but of equality and a shared rejection of convention. This book explores their unorthodox lives and their impact on the older generation.

Henrietta Bingham and Mina Kirstein came from the States, but most of the admirers were more homegrown: graduates from Oxford, Cambridge, and the Slade, young people with artistic or literary ambitions seeking their way in the world. Nearly all were looking for ways to explore different sexual identities post-university, and Bloomsbury's approach was unusually appealing. Twenties London was a place of confusing extremes. On one side stood this new, syncopated world of the Bright Young Things—treasure hunts, fancy-dress parties, jazz music, and cocktails. On the other stood the old establishment, stern figures of Conservative reaction, represented most fearsomely by William Joynson-Hicks, repressive home secretary from 1924 to 1929, who cracked down on nightclubs and indecent literature. At the beginning of the decade, Bloomsbury stood somewhere in between, offering safe spaces for experimentation and conversations of reassuring emotional honesty with men and women who had earned a reputation for candor. Gradually, the closed circle expanded to bring in a wider range of new recruits, a more playful understanding of intellectually appropriate activity.

Each group had something to learn from the other. Bloomsbury had always celebrated sexual equality and freedom in private, feeling that every person had the right to live and love in the way they chose. According to Virginia Woolf, Old Bloomsbury's "reticence and reserve" had disappeared decades before: "Sex permeated our conversation. The word bugger was never far from our lips. We discussed copulation with the same excitement and openness that we had discussed the nature of good."[16] But by the 1920s, transgressive

self-expression was becoming more public. Cross-dressing bright young people were as happy to be snapped by Cecil Beaton in broad daylight as they were after dark, and Bloomsbury figures began to embrace the new approach, appearing in popular magazines alongside writers and artists twenty years their junior. Over the next decade, the Oxford and Cambridge graduates transformed into journalists, novelists, poets, and party-givers, inviting their seniors to join in the fun. After some agonized wrestling with intellectual snobbery— her own and that of older critics—Virginia Woolf embraced the high fees offered for pieces in *Vogue*. In an equally bold step, Grant and Woolf signed up as founder members of the Gargoyle Club in Soho—which became a center of bohemian nightlife in the decades that followed—tempted by the idea of "a place without the usual rules where people can express themselves freely."[17] Vanessa's husband, Clive Bell, shifted gears with remarkable ease. One minute he would be at home writing pieces on Proust or Picasso for a worthy journal; the next he would be squeezing into his bathing suit and heading to a late-night Bath and Bottle Party for poolside dancing and bathwater cocktails.

As the twenties progressed, Virginia Woolf was delighted to find her work "praised by the young and attacked by the elderly."[18] The younger generation promoted and inspired their seniors, propelling them into new types of media and energizing their artistic and literary production. Bloomsbury figures learned to broadcast on the radio, mix cocktails, dance the Black Bottom, and exploit the publicity value of gossip columns. This was the age of the elaborate fancy-dress party, and Bloomsbury loved nothing more than gender-blurring costume. Lytton Strachey and Clive Bell appeared regularly on guest lists in the *Evening Standard*, donning elaborate outfits for events like the Nautical Party or the Circus Party. Woolf accepted almost as many invitations, merrily denouncing her hosts and fellow guests thereafter. She and Lytton adored gossip and sexual intrigue,

lending a willing ear to troubled young lovers of varying orientations. *Vogue* journalist Raymond Mortimer captured the spirit of the moment in 1924: "The elderly say the country is decadent and going to the dogs . . . It merely means that their own faculties are decaying and that they are going to the dogs themselves. Really the time in which we live is wildly interesting, fantastically romantic . . . We are discarding our prejudices, each month sees the disappearance of some once formidable taboo."[19]

Raymond was one of the many "young fringe-Bloomsburies"[20] who gathered round the older group. Looking back later in life, Raymond remembered how refreshing it was to find people who "based their beliefs and behavior on reason rather than any accepted ideas" and who ignored the usual gender restrictions, using language "of a freedom most unusual at that time in mixed company."[21] What Raymond's 1950s article for the *Sunday Times* doesn't reveal is the sense of liberation he must have felt to step into a world where queer identities were universally accepted. Raymond moved into a flat in Gordon Place to be near his idols and commissioned Grant and Bell to paint a postimpressionist backdrop for his regular "evenings." Some were mixed—including guests such as his editor at *Vogue*, Dorothy Todd, and her partner Madge Garland—but the majority were male only. A fascinating exchange of letters with Lytton Strachey survives, recording their attempt to find some new beauties to enliven a bachelor party. Invitations were issued for after dinner, and exciting encounters were to be anticipated. As Raymond concluded, "It is always, always a pleasure to see you. And when I hear stories and legends of how ogreish you used to be to your friends, I think I am lucky to have appeared a little later."[22]

Every now and then Virginia Woolf would stray into one of Raymond's "Buggery Poke"[23] evenings, and the frankness of conversation pops up in her letters and diaries. Images are passed round, relationships discussed, clothing admired. Similar intimacies are shared in

correspondence between young and old, male and female, across the group: in letters to Lytton, Dadie Rylands reveals his passion for fellow students, his success with soldiers and sailors: "a divine weekend at Dartmouth: the cadets are like puppy dogs."[24] Dora Carrington sends love and lust to Lytton's niece Julia Strachey; Lytton teases Sebastian Sprott for gladdening the eye of male admirers with his taste for rings, décolleté shirts, and Venetian sombreros; Eddy Sackville-West pours out his heart to Lytton's psychoanalyst sister-in-law, Alix Strachey, who returns the favor with tortured accounts of her rejection by lover Nancy Morris: "You see Eddy, she has been hating her situation with me & it has been making her ill, so that she might anyhow have lost her capacity to love me from sheer break-down."[25]

Sexual openness of this type between friends would be impressive in the 2020s, but in the 1920s it was remarkable. Homosexuality remained illegal, and hostile attitudes to lesbian love were whipped up when Radclyffe Hall's *The Well of Loneliness* was condemned as an obscene publication in 1928. Bloomsbury provided a supportive environment for queer young people that they were unlikely to find elsewhere. For those who could afford it, mental health care tended to be a traumatic experience: mainstream psychiatry still saw same-sex love as an illness requiring treatment. My heart bleeds for Eddy Sackville-West, who was subjected to an eight-week "cure" in Germany involving painful testicular injections. Stephen Tennant spent twelve months of virtual isolation in a psychiatric hospital. Freudian approaches were scarcely more sympathetic: leading British analyst Dr. Ernest Jones diagnosed Henrietta Bingham as suffering from sexual inversion with neurotic symptoms, suggesting strategies for displacement. Using her as a case study for the treatment of "female homosexuality," Dr. Jones was sharing progress reports with Freud in Vienna, and anonymized accounts with the British Psychoanalytical Society. While Virginia Woolf took no prisoners with her language—she mounted the occasional "anti-bugger revolution"[26]

and described Vita Sackville-West as a "pronounced Sapphist"[27]—it was surely far better to feel able to have a robust debate with Virginia or Lytton on sexual terminology than sit in fearful silence, ashamed of your unmentionable identity.

Why does this matter to me? As the mother of a child who identifies as gender-fluid and queer, I have learned some sad truths about the ongoing impact of prejudice. Queerness is no longer seen as a mental illness in Britain, but the mistreatment of queer young people persists. Bullying and discrimination lead to alarming rates of depression, self-harm, and feelings of suicide. Children and young adults still go to school and university feeling unsafe, their peers using labels they identify with as insults. Trans pupils are particularly at risk; according to the LGBTQ+ charity Stonewall's 2017 school report, 84 percent have self-harmed, and 45 percent have tried to take their own life. With queer histories so often silenced, and records destroyed through fear of discrimination or prosecution, sharing stories of positive interaction between the generations takes on a new relevance. Older people play a vital role when they show their support, building confidence, nurturing future talent. My child and I have found much to celebrate in the world of Young Bloomsbury and in the queer history of our own family.

When I was a little girl, growing up in an ancient house where Stracheys had lived since the 1640s, it was hard to weave your way through the bewildering array of gloomy relations. Rows of disapproving portraits stared down from the walls; dusty volumes gathered on the endless shelves. Stracheys seemed to have been doing dull things for government or empire since the time of Shakespeare, gathering awards and titles along the way. But I wasn't so interested in all of that. There was a group of recent characters who seemed much more exciting. Beautiful Teddy Strachey, so handsome that he was known as "Venus" in the Grenadier Guards. His uncle Harry, an artist who painted lyrical images of athletic young men, excelling

in his rendition of the naked torso. And Harry's first cousin Lytton, who had lived in Bloomsbury and caused a family stir by loving his own sex and satirizing the worthies of the Victorian period. All was forgiven after his early death in 1932, and Lytton joined his parents in the Strachey chapel in Somerset, surrounded by memorials to his other god-fearing ancestors.

Luckily for me, the Stracheys were inveterate hoarders as well as being prolific writers, so if I reach out a hand from my desk to pull down a book from the shelf, a letter will invariably fall out. It might be from Lytton's sister Pippa, returning a borrowed book to the Strachey library at Sutton Court and apologizing for her "ancient crime."[28] Or it might be from art historian and sexologist John Addington Symonds, advising his nephew Harry Strachey on the best way to paint young men bathing. Many of the Strachey papers are in public collections, but some are still spread amidst the cousinhood, stored carefully in numbered boxes, or emerging randomly from unsorted piles. Together they build a picture of a warm and loving family who nurtured creativity and individualism rather than conformity, honoring the life of the mind above all else. The typical Strachey, male or female, young or old, Somerset or Bloomsbury, would be found wrapped in a shawl with their nose in a book. Lytton's niece Julia found herself in alien territory when she was taken in by her American step-aunt, who firmly told her off for spending too much time indoors: "Thee doesn't want to grow up all—thee knows—kind of eccentric and weird like thy Strachey relations. Like thy Uncle Lytton. Or thy Aunt Marjorie Strachey, thee knows: now does thee? See what I mean?"[29]

For "eccentric" and "weird," read "independent" and "open-minded"—key characteristics of Bloomsbury Group life in the 1920s. Younger visitors often felt they were stepping into a family environment, and in many cases they were: Lytton's mother and two of his sisters moved to Gordon Square in 1920, and by 1925 his brothers

James and Oliver each had their own houses. The surviving Stephen siblings—Vanessa Bell, Virginia Woolf, and Adrian Stephen—soon found themselves outnumbered by Stracheys. As Lytton's first cousin and Vanessa's partner, Duncan Grant stood somewhere in between. Marjorie Strachey was one of many who thrived in the company of her older brother and his friends. She conjures up an appealing image of the characteristics that proved so attractive to the new generation of postwar admirers:

> They were vivid and witty. They were very affectionate. They were addicted to the truth . . . they often abused their friends, but in a friendly way. It was delightful to live among them—to grow up among such amusing, brilliant, affectionate people. Of course Bloomsbury was not an earthly paradise. There were many tragedies, there were quarrels and rifts. They had their faults, but let us not overstress them. As Lytton wrote, in the last month of his life: "In this wretched world unkindness is out of place."[30]

The Bloomsbury Group reached a high point of fame in the 1920s. Success is always alluring, but this was not the only reason why a group of forty-somethings suddenly appealed so strongly to young men and women in their twenties. There was something else, something more subtle at play. The growing numbers of "young fringe-Bloomsburies" who gathered like bees round a honey pot were not just seeking celebrity; they were seeking affection. As queer young people they were looking for a place where they could be themselves, amidst adults who would accept them for who they really were. Bloomsbury writers and artists seemed to have defied conventional morality and lived to tell the tale—faith, fidelity, heterosexuality, and patriotism had all been rejected, but without noticeable penalty. Ahead of their time, they had established an open way of living that would not be embraced for another hundred years.

1

Bloomsbury Comes Together

FINDING THEIR CHOSEN FAMILY, 1904–14

---◆---

Some strange sort of alchemy seemed to have happened in the early 1900s, when Stephens and Stracheys had first come together in Bloomsbury, debating the nature of human existence, trying to find the best way to "be."

It began when Vanessa and Virginia Stephen set up home with their brothers Thoby and Adrian at 46 Gordon Square. With both parents dead, and the vast Stephen home in Kensington put up for rent, the siblings clubbed their inheritances together to lease their own property. Occupying a whole building in Gordon Square might seem an impossible dream today, but in 1904, Bloomsbury rentals were more affordable. Middle-class families tended to lease rather than buy, flexing their space up and down to suit changing numbers, paying for housework as part of the package.

Like the Schlegel sisters in Forster's *Howards End*, Vanessa and Virginia had escaped the grasp of disapproving older relatives, using their brothers as token chaperones, choosing a life of determined independence. Cambridge friends of Thoby and Adrian Stephen

got an unexpected freedom pass: permission to hang out in a proper grown-up London house and talk to women of their own age, with no controlling parental presence. The Stephens held a weekly "open house" on Thursday evenings; after a slow and bumpy start, conversation eventually began to flow. Virginia noted the point of transition as the young men grew more comfortable in female company, more confident in the expression of their secret desires: "Thoby and Adrian would have died rather than discuss the love affairs of undergraduates. When all intellectual questions had been debated so freely, sex was ignored. Now a flood of light poured in on that department too. We had known everything but never talked. Now we talked of nothing else."[31]

Although some of those who gathered in the light-filled rooms at Gordon Square were biologically related, the majority came together through choice. Thoby and Adrian's circle was predominantly gay, and even those young men who had a sexual interest in women were full of Edwardian inhibitions. It was unusual to spend time unchaperoned with a female contemporary, let alone stray off a carefully proscribed set of socially acceptable topics. As intimacy grew, limits were gradually released: sexuality of all types became open for discussion, along with every form of intellectual or philosophical theory. Traditional hierarchies were disrupted, gender divisions blurred, queer perpectives explored. As Virginia concluded, "There was nothing that one could not say, nothing that one could not do, at 46 Gordon Square . . . It may be true that the loves of buggers are not—at least if one is of the other persuasion—of enthralling interest or paramount importance. But the fact that they can be mentioned openly leads to the fact that no one minds if they are practised privately. Thus many customs and beliefs are revised."[32]

One of the most regular visitors to 46 Gordon Square was Lytton Strachey, whose influence on the early years of Bloomsbury Vanessa Bell remembered well: "Only those just getting to know him well

in the days when complete freedom of mind and expression were almost unknown, at least among men and women together, can understand what an exciting world of explorations of thought and feeling he seemed to reveal. His great honesty of mind and remorseless poking of fun at any sham forced others to be honest too and showed a world in which one need no longer be afraid of saying what one thought, surely the first step to anything that could be of interest or value."[33] Lytton would riff provocatively on sodomy or semen, deliberately using bawdy language to spark a reaction; conversations begun at the secret Apostles society in Cambridge would continue unabated in Gordon Square.

Thanks to Lytton, Vanessa felt free to express her own feelings. Literary critic Desmond MacCarthy went further, suggesting that Strachey was the dominating influence on his generation of Cambridge graduates, fixing their attention on "emotions and relations between human beings." Lytton was a master of "psychological gossip, the kind which treats friends as diagrams of the human species and ranges over the past and fiction as well as history, in search of whatever illustrates this or that side of human nature."[34] For Vanessa, her Bloomsbury friends came to represent a community of shared feeling—people among whom you could "say what you liked about art, sex or religion," safe in the knowledge that you could also "talk freely and very likely dully about the ordinary doings of life."[35]

Clive Bell saw the Stephen sisters standing at the center of a wheel in which Thoby and Adrian's Cambridge friends acted as the spokes. When Thoby died tragically young from typhoid in 1906, and Vanessa married Clive, "the circle was not broken but enlarged," as Virginia, with her surviving brother, Adrian, moved into a house in nearby Fitzroy Square, "thus instead of one salon, if that be the word, there were two salons."[36] Their houses began to fill with a distinctively Bloomsbury style of art—the work of Vanessa Bell herself, Lytton's cousin Duncan Grant, and their older associate, the

painter and curator Roger Fry. Aided and abetted by their many art-
ist friends, the sisters were shaping spaces that could support and
activate—acting as a catalyst for their own female creativity, provid-
ing opportunities for queer contemporaries to thrive. It was from
these surroundings that Lytton Strachey emerged as a biographer,
Maynard Keynes as an economist, and E. M. Forster as a novelist.
James Strachey and Adrian Stephen eventually found their voca-
tions as Freudian psychoanalysts, while journalism provided a more
immediate path for Clive Bell and Desmond MacCarthy. Egged on
by Roger Fry, prewar Bloomsbury championed modernism in litera-
ture and the arts, with predictably explosive reactions from the more
traditional sections of the press. When Fry curated his controversial
postimpressionist exhibitions of 1910 and 1912, Bloomsbury friends
rallied round. Desmond MacCarthy helped him with the first, and
Leonard Woolf acted as secretary for the second. Audiences re-
mained perplexed by the works on display, their boldness of color
and liveliness of form—as Virginia concluded: "Once more the pub-
lic exposed themselves to the shock of reality, and once more they
were considerably enraged."[37]

Virginia's marriage to Leonard Woolf in 1912 reinforced an-
other long-standing Cambridge connection. After seven miserable
years in the colonial civil service, Leonard was drawn back into the
Strachey-Stephen cortex in 1911, rejecting his safe salary in favor
of love—and a chancy existence as a writer and journalist. Jealous
literary and artistic rivals came to see the Bloomsbury Group as smug
and self-absorbed, pursuing their own interests to the exclusion of
others. But in the early years Bloomsbury was less of a mutual ad-
miration society than a place of mutual aid. Something we might
recognize today as a "family of choice": a group of queer friends and
allies, drawn together by affection, bound for life. Later accounts
tend to fetishize sexual connections between the friends, obsessing
about who put what into whom at which date. Sexual contact was

just one facet of a many-sided emotional equation, fidelity a restrictive illusion paraded by the sanctimonious bigots of the Victorian age. What mattered most was the sense of a shared approach to existence, the long-term commitment to a loving connection. Lytton Strachey, Maynard Keynes, and Duncan Grant may all have slept with each other in the early 1900s, but these were brief interludes in relationships that lasted a lifetime, reinforcing rather than threatening their mutual bond.

Thinking of Virginia and Vanessa as Bloomsbury den mothers gives a dynamic twist to their role; a general term for female leaders who help and look after the less experienced, it takes on a special meaning in the context of chosen families, and has become a familiar part of modern drag culture. Presiding over an intricate network of nonhierarchical associations, Vanessa and Virginia nurtured queer creativity among their friendship group while developing their own professional careers. Like modernist bowerbirds, they embellished successive homes with distinctive ornament, signaling difference, boosting confidence. Descriptive language changes slowly over time, gradually catching up with subtle changes in human behavior. If only the heteronormative Bloomsbury-bashers of the 1950s and '60s had had more vocabulary to play with, then perhaps they would have been less critical of the tangle of sexual relationships and more appreciative of the human benefit.

In terms of thought and argument and articles and artwork, early Bloomsbury was intensely productive. In terms of financial rewards or critical acclaim, the results were less impressive. Ironically it was the least attached member of the group, E. M. Forster, who achieved an early hit in 1905 with his first novel, *Where Angels Fear to Tread*. Forster—christened Taupe (the mole) by Lytton—was famously elusive after Cambridge, popping in and out of Bloomsbury at will and producing a string of increasingly popular novels in between periods of travel. Lytton spotted Forster in the London Library just after

Angels had gone into its second edition, and he sent a long letter to Leonard Woolf, musing on their own lack of progress and speculating on what the future might bring:

> *I went yesterday to the London Library, and saw something that seemed familiar burrowing in a corner. I looked again, and yes! It was the Taupe. We talked for some time . . . He admits he's "successful," and recognises, in that awful taupish way of his, the degradation that that implies. But he's of course perfectly contented. The thought of him sickens me. I think if one really does want a sign of our lapse, the Taupe's triumph is the most obvious. If we ever do boom, shan't we be horribly ashamed?*[38]

What prewar Bloomsbury lacked in terms of earned income, they more than made up for in terms of bravura. Roger Fry and Clive Bell caught the public eye with their advocacy of French postimpressionist art, introducing shocked British audiences to the work of Cézanne, Gauguin, Picasso, and Matisse. Fry's Omega Workshops, founded in 1913 with Grant and Bell as co-directors, made a bold attempt to drum up a market for their groundbreaking designs. Omega aimed to break down the false divisions between fine and decorative arts, allowing artists to experiment in every type of media, introducing the bold colors and abstract forms of modernism into all areas of the home. As Fry told the press: "It is time that the spirit of fun was introduced into furniture and into fabrics. We have suffered too long from the dull and the stupidly serious."[39]

Buoyed up by the enthusiasm of their compatriots, Bloomsbury figures tended to make an impression wherever they went, regardless of the state of their bank balance or the critical reaction to their work. Lytton Strachey's unconventional appearance—maintained on a shoestring—surprised the Woolfs' landlady that Christmas when she spotted him shopping in Marlborough in 1914. Leonard conjured

up the eye-catching vision for a friend: "He has an immense and immensely beautiful russet beard, an immense black broad-brimmed felt hat, a suit of a maroon corduroy, and a pale mauve scarf fastened with a Duke's daughter's cameo brooch. He is the most charming and witty of human beings since Voltaire."[40] Hopeful that fame and recognition lay just around the corner, the friends boosted each other's confidence and gave each other the courage to persist along an independent path.

DISPERSAL,
1914–18

◆

Just at the moment when the Bloomsbury Group might have expected their careers to be taking off, other priorities intervened. Born in the 1870s or '80s, most of the men were in their thirties when war broke out in 1914, exposing them to the pressure to enlist. Bloomsbury's initial resistance to the lure of government propoganda hardened into outright support for pacifism as the war effort gathered pace. When conscription was introduced in 1916, military service tribunals loomed, requiring formal application for exemption on the grounds of ill health or conscientious objection. The process was protracted and distressing for all involved.

Scattered to the winds by force of circumstance between 1914 and 1918, the friends ventured far from their familiar haunts. Only Maynard Keynes obtained a wartime role that allowed him to remain continuously in London. Employed by the Treasury, Keynes moved into 46 Gordon Square, offering beds to those passing through town. Leonard Woolf, Clive Bell, and E. M. Forster were pronounced medically unfit for the military; Lytton and James Strachey, Maynard

Keynes, Adrian Stephen, and Duncan Grant all applied for exemption from service on grounds of conscientious objection. Their experience before tribunals was varied, and most ended up carrying out "work of national importance": Keynes never attended his tribunal, having already secured exemption due to his role at the Treasury; Duncan won on appeal, with farm labor imposed as a condition. Lytton had an even luckier escape: having been denied objector status (famously bringing a pile cushion to the tribunal and offering to interpose his body between his sister and the German if a soldier attempted to rape her), he was then rejected on grounds of ill health. Clive Bell earned a dangerous reputation as a polemicist, thanks to his 1915 pamphlet *Peace at Once*, which was seized by police in Manchester as part of a raid on the National Labour Press and then burned in London by order of the mayor.

Pacifism was deeply unpopular during the jingoistic war years, and London could be a hostile environment for those not overtly fulfilling patriotic functions. The nighttime regime of bombing raids, searchlights, and artillery fire made it doubly threatening. Londoners were terrified by the zeppelin attacks that started in 1915; German bombers became even more daring when airships were exchanged for aircraft in 1917. Retreat to rural surroundings was a sensible option for all those who could find a safe spot. Clive Bell joined like-minded companions at Garsington Manor in Oxfordshire, working the farm recently bought by two former Bloomsbury residents—Liberal MP Philip Morrell and his wife, Ottoline. Vanessa's affections were now focused on Duncan; amicably separated from Clive, Vanessa and Duncan found a shared refuge at a smallholding in Suffolk before more stringent farm employment requirements forced their move to Charleston in Sussex. Vanessa painted when she could, Duncan worked the land, and the household expanded and contracted to include children, friends, and lovers. Lytton withdrew to a thatched cottage in Wiltshire—the Lacket—where he began to write the

character sketches that would become his bestselling book, *Eminent Victorians*. In their different ways, in their different locations, the friends did their best to maintain their chosen way of life against the frightening backdrop of international conflict.

Roger Fry's commitment to the arts remained unstinting: the *Burlington Magazine* noticed that the Omega Workshops showed "no sign of flagging in the general paralysis of art-production,"[41] while the *Illustrated Sunday Herald* did a spread on the female Omega artists as "Women who do the Most Original War Work of all."[42] Sadly, Omega's transformative aesthetics still tended to attract mockery rather than applause; actual buyers remained thin on the ground, reluctant to engage with what skeptical journalists described as the gaudy products of a "futurist factory in full swing."[43] Although Vanessa and Duncan remained nominal co-directors, their contributions were limited by distance, their focus increasingly on their own work and their interlinked artistic practice. Enforced agricultural labor left Duncan with little time to paint, making snatched moments in their various makeshift rural studios even more precious. Roger Fry found contributors wherever he could, fulfilling decorative commissions with unusual combinations of refugee artists and recent Slade graduates, but it was difficult to sustain as a business. However, thanks to his persistence, Omega limped on into peacetime, closing in 1919 when the costs became impossible to underwrite and the disputes between the various contributors too difficult to resolve.

As the war years progressed, other members of the group pinned their creative colors to the mast: the Woolfs had moved to Richmond in 1914, setting up a printing press at their house. They aimed to produce their own experimental work, as well as material unlikely to be published elsewhere. Such were the modest origins of the Hogarth Press that each publication's page was laboriously typeset by Virginia and hand-printed by Leonard. In the 1920s and '30s the press would come to play a key role in many lives, allowing the

Woolfs to enable others through the power of print: employing assistants, commissioning designs, bringing the work of queer young writers and artists to a new audience. But all of this lay in the future. At the beginning, Leonard hoped for little more than provision of a therapeutic task repetitive enough to keep his wife beneficially occupied during her recurrent episodes of depression.

The Bloomsbury family may have dispersed geographically during the war, but their resistance to conscription and antipathy to nationalism drew them philosophically together. Conscious of their status as outsiders from the mainstream, there was a sense of combining as a group for mutual protection: during the First World War, the friends were despised for their pacifism; later they would be seen as privileged and perverse. Detractors on the left would see them as a self-serving elite, shamelessly promoting their own advantage. Enemies on the right sniffed out immoral activity, suspicious of the equality given to Bloomsbury women and their apparent acceptance of the feminized male. In these interpretations, deviant sexuality took center stage, casting followers as deluded converts led astray by a corrupt and effeminate code. Clive Bell was being only partly tongue-in-cheek when he concluded that he and his fellow "malefactors" would be identified as "the curse of a decade or two in the twentieth century." Examining attitudes to Bloomsbury in the 1950s, he worried that "some will be sure that it was a religious heresy, a political deviation or a conspiracy, while others, less confident, may suspect it was no more than a peculiar vice."[44]

Very few gave Bell and his friends credit for the nurturing role that they played, firstly to each other and then to an emerging generation of queer young people. As the friends teased each other mercilessly and bickered incessantly, it can be hard for modern readers to recognize the loving honesty in their denigrating humor, or see how refreshing this was at a time when superficial platitudes were the order of the day. Lytton and Virginia tore loved ones apart in their

letters to each other and met them smiling the next day. Vanessa and Leonard gave the impression of fairness and reserve but could be strangely implacable when crossed. Gentle Duncan was so indiscriminate with his affections that he left a trail of bemused young men in his wake. Even the ever-cheerful Clive could be pushed too far; he was once so furious with Lytton that he wrote a long letter firing him as a friend. Shared with Virginia and Leonard after posting, the letter is a masterwork of elegantly phrased denunciation: "You walk in an alley sheltered and comely . . . your hedges are grown so tall that you know nothing of the sun, save that he falls some times perpendicular on your vanity and warms your self-complacency at noon."[45]

Clive knew that Lytton found his exuberance ridiculous—"florid and vulgar, over emphatic and underbred;"[46] Lytton's hauteur was equally unattractive to Clive. Lytton was amused by Clive's taste for luxury, funded by a rich, mine-owning father. His analysis is typical of the brutally open perspectives shared between the friends: "Bell. His character has several layers, but it's difficult to say which is the fond. There is a country gentleman layer . . . There is the Paris decadent layer . . . There is the 18th Century layer . . . There is the layer of innocence . . . There is the layer of prostitution . . . And there is the layer of stupidity, which runs transversely through all the other layers."[47]

Ultimately the pair found each other lovable despite their faults, and the friendship survived unscathed. At its base was a deep understanding of character, developed over many years and pored over with fascination by the group. Love given within the Bloomsbury family was very rarely taken wholly away; affection tended to diffuse anger, however hard-hitting the insult. In Clive's words: "When one cares, such superficial things become a joke, an attraction almost, not a source of constant irritation."[48]

NEW RECRUITS

---◆---

Families—biological or chosen—tend to grow, and Bloomsbury was no exception. Marriage in the traditional heterosexual sense was a minority interest, but the friends found inventive ways to experiment within the only model then allowed. A small number of babies did gradually appear from some of these unions; as it would take years for them to develop into conversable adults, their position was largely thought to be "pending." Genuine recruits tended to turn up hosed and shod, having reached a similar age to that of the core members when they'd first come together. Additions during wartime might have seemed unlikely, bearing in mind the hostile circumstances, but as Clive Bell noted in his rueful examination of Bloomsbury history, there were a few brave souls who defied the prevailing patriotic culture and "became intimate with most of us"[49] in this period.

By the time the Woolfs' first co-authored pamphlet *Two Stories* was issued by the Hogarth Press in 1917, Bloomsbury was undergoing a subtle transition: a new generation was knocking on the door, and

some of them were gaining entry. The most vociferous was Duncan Grant's lover David Garnett—known by his childhood nickname "Bunny." A biology graduate with literary leanings and a fellow conscientious objector, he came to form a crucial part of Grant and Bell's wartime households. Quieter in demeanor, but equally persistent, was the artist Dora Carrington, who was fast becoming indispensable to Lytton. Determinedly known by her surname only—she rejected the feminine "Dora" in favor of a less gender-specific identifier—Carrington was employed intermittently at the Omega, producing all four woodcut illustrations for the Woolfs' *Two Stories*.

Although Bunny and Carrington came into regular contact with Bloomsbury at almost exactly the same time, and became involved in equally intimate ways, later accounts of their experiences tend to diverge. Bunny's ebullience is cast in a positive light, his lack of commitment to any career post-university an amusing quirk of a carefree young man eagerly seeking new mentors. Carrington, a year younger, but already established as a professional artist, is mysteriously underappreciated, hovering somewhere between "victim" and "groupie." The reality was rather different. While Bunny was doing enforced farmwork with Duncan and dithering over whether to become an art dealer or a bookseller after the war, Carrington was doggedly grasping every scrap of opportunity offered to the female painter. Paying double rent—for a flatshare and a studio—she took on teaching work, painted frescoes, did woodcuts for the Woolfs and Omega, and restored pictures for Roger Fry. In the spaces left between she somehow found time to paint portraits and landscapes, sending a stream of illustrated letters to cheer her friends. Even Virginia Woolf was impressed, finding the combination of comic imagery and mayfly writing "completely unlike anything else on the habitable globe."[50]

Bunny was born in 1892, Carrington in 1893. Although they were only ten years younger than most members of Old Bloomsbury,

they brought new perspectives to the mix, and a fresh enthusiasm for communal living.

Bunny was the only child of progressive parents. His mother was a respected translator of Russian literature, his father a publisher's reader. The pair led amicable but separate lives; Bunny was their shared priority, the recipient of an alternative education, and the focus of their limited resources. With Cambridge financially out of reach, Bunny spent his undergraduate years in London, mixing with an ever-changing crowd. A chain of overlapping friendships took him to a fancy-dress party in aid of women's suffrage at Crosby Hall in Chelsea. James and Marjorie Strachey danced down the center of the room; Adrian and Virginia Stephen stood watching at the side. James Strachey had little interest in Bunny's botany course at the Royal College of Science, but he found the young student intoxicatingly attractive.

Invitations were soon extended, and Bunny found himself heading to the theatre with the Stracheys and playing poker with the Stephens. James made his intentions all too obvious, but Bunny politely rebuffed the older man, dipping in and out of Bloomsbury at will, enjoying the company of young women his own age. Duncan Grant proved harder to resist. In January 1915 the pair were thrown together at a series of gatherings organized by the Stracheys. Grant fell deeply and unexpectedly in love, declaring his passion in heartfelt letters, fretting when Bunny disappeared to France as a volunteer for the Quaker Relief Mission. In 1916, with conscription looming, Grant asked Bunny to join him at Wissett Lodge in Suffolk, tending fruit trees in anticipation of enforced agricultural labor.

Sharing a home with Duncan Grant and Vanessa Bell was ideal for war work, and it helped to maintain the delicate emotional balance in the unusal partnership between a straight woman and a mostly same-sex-loving man. Bell recognized that Grant would continue to seek male partners, while Bunny wanted to remain open to approaches from other lovers, female or male; Bunny allowed his

affections to be engaged by the person, regardless of gender. Happy to flirt with others while Grant was in the house, Bunny had no concerns about Grant sleeping with Vanessa, or Vanessa living separately from her husband, Clive Bell. Clive and his female lovers were equally welcome to visit. It was the honesty, the open acknowledgment of feelings of every type, that appealed to Bunny. And the joy of free intellectual debate, unfettered by the stifling concerns of the past. A merry-go-round of Bloomsbury guests stayed first at the smallholding in Suffolk, then at Charleston Farmhouse, the longer-term home leased by Vanessa Bell from September 1916. Bunny and Grant worked for the farmer on the adjoining land, while Vanessa began the slow transformation of every surface within the house, creating the integrated work of art that remains a lasting memorial to their shared creative endeavor.

With gender restrictions facing her at every turn, Carrington envied Bunny's more open way of life. The daughter of conservative middle-class parents, Carrington was expected to lead a sheltered existence, free from unsupervised male contact. As a prize-winning female scholar at the Slade, she had outclassed her male contemporaries, only to be subjected to constant sexual pressure. Placation and dissimulation were the inevitable result. To her parents, she had to maintain the illusion of female flatmates, female traveling companions, chaste associations only. For her artist friends, virginity was seen as a reactionary stance, submission the inevitable step. Carrington's manipulative former lover Mark Gertler (a fellow Slade graduate) ignored her expressions of gender dysphoria, her interest in female sensuality, her fear of penetrative sex. When she fell in love with Lytton a new path opened up, a brighter future with a different type of intimate companion. She found in Lytton "the only person to whom I never needed to lie, because he never expected me to be anything different to what I was."[51]

Introduced to Bloomsbury via Vanessa and Duncan in 1915, Car-

rington's contact with Lytton relied initially on subterfuge—moments snatched during weekends at Garsington Manor, complicated plans for holidays cloaked via a smoke screen of changing destinations and fellow travelers. By this time Lytton was living back at home with his mother; the prospect of renting another cottage like the Lacket was impossible without friends willing to spread the costs. Frustrated by their inability to meet without all these machinations, Carrington became determined to find a solution. It was Carrington who propelled Lytton into a new shared home at Tidmarsh Mill, near Reading, in 1917. Behind the worshipful façade lurked a thoroughly independent spirit, and Virginia was right to sense the determination of a woman committed to achieving her own goals. Carrington's childishly innocent face, with its rosy cheeks and unblinking blue eyes, was deceptive in the extreme: "She is odd from her mixture of impulse & self-consciousness. I wonder sometimes what she's at: so eager to please, conciliatory, restless & active. I suppose the tug of Lytton's influence deranges her spiritual balance a good deal. She has still an immense admiration for him & us. How far it is discriminating I don't know. She looks at a picture as an artist looks at it; she has taken over the Strachey valuation of people & art; but she is such a bustling eager creature, so red & solid, & at the same time inquisitive one can't help liking her."[52]

Carrington lapped up Lytton's literary instruction, amusing the eavesdropping Woolfs by her diligence: when the couple came to stay, they could be heard reading Macaulay's *Essays* aloud in bed to each other at night. In matters of painting, Carrington followed her own path. Closer in style to her Slade contemporaries Stanley Spencer and Paul Nash than to Grant and Bell, she dreaded the public pressure of selling exhibitions. Although she did submit pictures to the London Group and the International, her preference was for commissioned work, or small-scale pieces that she could sell through shops. Carrington had no interest in abstraction; she painted the

people and places she loved—the intricacy of plants, the texture of buildings, the delicacy of human expression. Of her paintings currently in public collections, the most famous is her view of Lytton in typical Strachey pose—lying in bed, wrapped in a shawl, reading. The long fingers reach up to grasp an antiquarian book; the red beard is spread out in splendor over the narrow chest.

Carrington recognized Lytton's homosexuality from the start, deciding that "one always has to put up with something, pain or discomfort, to get anything from any human being." In her view, there may always be a "trait in their character" that will jar, but "when one realises it is there—a part of them and a small part—it is worthwhile overlooking anything bigger and more valuable."[53] Loving Lytton beyond all others, Carrington was open to relationships with other men or women, providing they could accept her overarching tie. She was equally accepting of Lytton's desire for male adoration, his fascination with muscular youth.

Regardless of his sexuality, Lytton was still a man, so further deception was required as far as her parents were concerned. When searching for a cottage near a station where she and Lytton would live, she gave her parents the impression that the rental would be with a group of former Slade students, all women. Distracted by their own house move, her parents apparently accepted the fiction—which Carrington sustained until her father's death in December 1918—and there was no need to explain that the lease on Tidmarsh Mill had been signed by Lytton's brother Oliver (keen to have a place he could occasionally bring his mistress) or that the other tenants were all male friends of Lytton. Financial arrangements were initially complicated: far from being a "cottage," the mill was a substantial six-bed house. Each of the six subscribers would contribute £20 a year to cover rent, servants, and bills, but only Lytton and Carrington would be permanent occupants, the others gaining the right to a bedroom for weekend use.

Carrington presided over the intricate decorations at Tidmarsh Mill (and later in Lytton's house at Ham Spray, Wiltshire, which the couple moved into in 1924), painting the dresser bright yellow with bold scenes of birds and flowers, and hanging her own pictures alongside Lytton's growing collection of Duncan Grants. Firmly in charge of the household, she managed the domestic staff, organized the rota of co-lessee visits, and entertained Lytton's continuous stream of crushes and flirts. Her role in Tidmarsh Mill mirrors Vanessa Bell's at Charleston Farmhouse. There was no formal name for their position, no socially acceptable formula that would turn them into the automatic "plus one" for a conventional invitation. Each was in a loving long-term relationship, occasionally sexual, with a promiscuous gay man. The Strachey-Carrington, Bell-Grant households were communal affairs, with a constantly changing array of occupants. Some secured permanent space by paying rent, others appeared by favor, basking in Strachey's or Grant's regard. Each residence formed a creative crucible, the rooms humming with activity: painting, writing, carving, acting, making.

Carrington's artistry was expressed as much in her assemblage of people as it was in her paintings or decorative schemes. Tidmarsh and, later, Ham Spray provided backdrops for gloriously free-spirited Bloomsbury gatherings, but they were also places of hard work. As soon as he was successful, Lytton pressed money on Carrington, but she refused to accept his generosity, determined to maintain an independent income. Thanks to her father, she had £150 a year from investments, and the rest of her income came from decorative commissions—long days on-site painting furniture, doors, and fire surrounds, or hours in the studio at home creating endless sets of tiles. There was a lucrative sideline in tinsel paintings of flowers, harlequins, pugilists, and sailing boats, each a glistening confection of different materials, dazzling the eye with a generous application of silver foil.

Carrington would never claim to be part of the core Old Blooms-bury group, who had known each other since the early 1900s, but neither did she see herself as a member of the postwar generation of Young Bloomsburys. Occupying an intermediary status, she described herself to Lytton's niece Julia as "your loving Tante," while seeking relationships with young men and women of a similar age to Julia. Julia saw her as "a changeling, at once too old and too young," providing a magical role: "For me, in my twenties, she produced powders and perfumes, hats, beads and ribbons; she helped dress me up to go out to parties, and entered into all my most fantastic projects."[54] As a child of Gordon Square, Julia found that Carrington was a ubiquitous figure: "She was everywhere, in everyone's house—and once inside, so glowing with sympathetic magnetism and droll ideas for them all that there wasn't a person of her vast acquaintance who did not get the impression she was their very best friend."[55]

At the end of the war, Bunny Garnett returned to London, convinced this would be the place to launch his career as a potential picture dealer or bookseller; he remained a frequent visitor to Charleston, but he never took up residence there again. There was an awkward incident when he turned up unexpectedly one weekend, only to find the painter Edward Wolfe already occupying Duncan's bed. Lytton and Carrington stayed put at Tidmarsh, with surprisingly fruitful results: they recruited a new permanent addition. Major Reginald "Ralph" Sherrin Partridge made his somewhat unlikely appearance in July 1918. Born in 1894, he was a year younger than Carrington but a world away in sensibility. A student friend of Carrington's brother before the war, he returned to Oxford to finish his degree in 1918. As a decorated war hero with a passion for rowing, he had a bawdy sense of humor and a strong desire to leave his recent experiences behind him. Drawn as he was to both Lytton and Carrington in equal measure, the Oxford–Pangbourne train line grew

hot with two-way traffic. Partridge spent weekends at Tidmarsh; Lytton and Carrington took turns visiting him during the week.

To the horror of his family, Partridge metamorphosed into the more romantic "Ralph," rejecting all their hopes for a prosaic middle-class career after Oxford, embracing love, literature, and the life of the mind. It was Lytton who encouraged the change of name. Torrents of Ralph's adoring letters to Lytton survive, many written rather cheekily from Vincent's, the heartiest of Oxford's sporting clubs. Peppered with endearments and requests to keep them from the prying eyes of Carrington, they contain jaunty references to erections, orgies, flagellation, and the clap. The tone is playfully arousing as Ralph juggles visits between his two lovers and his different worlds. One minute he is coaching rowers, the next reading *The Faerie Queene*. He sends Lytton chaste and unchaste kisses and invites him to shock the Essay Club by lecturing on sodomy in the Elizabethan poets: "I should like to see them buzz and blush and go pale . . . it jostles their complexes very lasciviously to hear their secret thoughts shamelessly commented on in public."[56]

As soon as Ralph left Oxford, he, Strachey, and Carrington settled into what would be described today as a polyamorous throuple—a consensual relationship between three people. This caused little comment or upset among their Bloomsbury friends, other than the occasional caustic remark from Virginia Woolf: "What is the *real* relation between Lytton, Carrington and Mr. P? . . . God knows . . . at our time of life we ignore each other's private relations and find them boring."[57] Widely admired for his physical prowess, Ralph took on dual supportive roles: during the week, he heaved boxes and set type for the Woolfs at the Hogarth Press; on weekends, he did all the stereotypically masculine tasks required at Tidmarsh Mill—chopping wood, tending animals, collecting visitors in Lytton's smart new car. Carrington would have been happy for the arrangement to continue indefinitely, but Ralph wanted more formal recognition for their

connection. Emotions came to a head in 1921, and the status quo was protected when Carrington agreed to marry Ralph in order to secure a joint future. Officially "Mrs. Partridge," Carrington's name remained unmodified by their friends, and life carried on largely as before. Ralph summed up their happy state in a poem addressed to Lytton:

Some books, a house, a girl & boy
(Lord o'mercy, give him joy!)
Leisure to write, an ocean bed
A choice of pillows for his head

I'll say he's plenty; and I might
Envy his far-from-horrid plight
Yet why should I begrudge his joy
When I'm far richer being his boy?[58]

Physical passion between the trio gradually faded, but the strong ties of affection never waned and domestic harmony was sustained by Lytton's newfound prosperity. The Bloomsbury family was entering a fresh and more positive postwar phase, and the new recruits were to prove a vital part of the mix.

2

◈

Bloomsbury
Meets the
Bright Young Things

BLOOMSBURY REASSEMBLES, 1919–22

---◆---

In January 1919, Virginia mused on a familiar theme: Stephens versus Stracheys—who was up, who was down. Lytton had scored his first big hit with *Eminent Victorians*, so the Stracheys needed tearing down a peg or two: "There are three words knocking about in my brain to use of Stracheys—a prosaic race, lacking magnanimity, shorn of atmosphere."[59]

Eminent Victorians, published in May 1918, was an immediate success, making Lytton famous overnight. Consisting of biographies of four leading figures of the era—Cardinal Manning, Florence Nightingale, Thomas Arnold, and General Gordon—the book hit the market at exactly the right moment; a new sense of cynicism was in the air—frustration with the generals who were sacrificing young men at the front, suspicion that the "lions" were being led by "donkeys." Lytton's irreverent assessments of the four figures challenged the moral superiority of the Victorian age. Bloomsbury attitudes chimed with the feelings of the upcoming generation, and Lytton reaped the rewards. According to the literary critic Cyril Connolly,

Eminent Victorians anticipated the mood of the twenties; Strachey "struck the note of ridicule which the whole war-weary generation wanted to hear, using the weapons of Bayle, Voltaire & Gibbon on the creators of the Red Cross and the Public School System. It appeared to the post-war young people like the light at the end of the tunnel."[60]

Virginia was more disparaging of the Strachey success. For her, Lytton, James, Oliver, Pippa, Pernel, and Marjorie were all as bad as each other: "To the common stock of our set they have added phrases, standards, & witticisms, but never any new departure, never an Omega, a Post Impressionist movement, nor even a country cottage . . . or a printing press." Lytton's writing "lacked originality and substance"; it could be dismissed as "superbly brilliant journalism, a supremely skilful rendering of the old tune." Even at Tidmarsh, Lytton "had to be propelled from behind, & his way of life insofar as it is unconventional, is so by the desire and determination of Carrington." The Stephens and Bells, on the other hand, had "the initiative, & the vitality to conceive our wishes into effect," refusing to be "chilled by ridicule or checked by difficulty."[61]

As her friends gradually reassembled in London after the war, Virginia reflected, too, on the different members of the group and their various achievements. There were Thoby's friends from the "Cambridge stage of life," the group she met later when sharing houses with Adrian and, most recently, the 1890s babies: Bunny, Ralph, Carrington, and Carrington's troupe of artist friends from the Slade, known collectively as the "cropheads,"[62] thanks to their shingled hair. The recent additions had made important emotional contributions during the difficult war years, helping to hold relationships together when force of circumstance might have driven the friends apart. Bunny had provided the glue in the Bell-Grant household, and Tidmarsh had become a haven for many thanks to Carrington. At this stage Woolf thought Carrington had made Lytton braver

and kinder, reinforcing rather than supplanting her connection with him: "I like Carrington . . . She has increased his benignity. O yes, if he were to walk in at this moment we should talk about books & feelings & life & the rest of it as freely as we ever did, & with the sense, on both sides I think, of having hoarded for this precise moment a great deal peculiarly fit for the other."[63]

Bloomsbury writers and artists suddenly seemed to be booming. Hostility toward pacifists and conscientious objectors was fading, and Britain was experiencing a peacetime surge in consumption: prices stayed low, so those who had jobs had more to spend on an ever-expanding range of goods. Sales of books and newspapers were on the up, and younger people were feeling less respectful toward the heroes of the past. Lytton Strachey was the first to benefit, but Maynard Keynes's *The Economic Consequences of the Peace*, which attacked the self-interested principles of the men who negotiated the treaty that ended the First World War, also became a runaway success when it was published in 1919. Keynes had written the book hunched over a desk at Charleston, infuriated by his experience as a Treasury representative at the Versailles Conference. Published soon after his return to lecture at Cambridge University, the book pushed Keynes to the forefront of economic scholarship, making him a respected pundit called on by press and politicians alike. Duncan Grant made a similar grab for public attention in February 1920 with his first-ever solo exhibition. Reviews were mixed, but buyers tended to agree with Virginia—who found the pictures heady, like wine, "so lovely, so delicious, so easy to adore."[64] Lytton spent £60 on Grant's enticingly muscular image of circus artists, their bulging thighs encased in thick pink and blue tights. *Juggler and Tightrope Walker* was duly hung over the desk in his library at Tidmarsh.

The critics associated with Bloomsbury sensed the shift in public response, the connection to changing currents in popular taste. Roger Fry praised Grant's *Venus and Adonis* in the *New Statesman*:

"Whatever influences he has submitted to are all fused here into something that belongs entirely to our own age and country, and, indeed, just to one intensely individual view on life."[65] Grant's pictures captured the optimistic mood of the moment, the growing appetite for joyous color, fanciful imagery. For Clive Bell, Grant's style was "fantastic and whimsical and at the same time intensely lyrical."[66] His luscious *Venus* now reclines in colossal splendor at the Tate, her gaze fixed sphinxlike on the tiny figure of Adonis running off to enjoy the hunt. It's tempting to read all sorts of hidden messages into Grant's depiction of a man who chose sport over love, but when questioned by a Tate cataloguer he claimed to have thought only of the myth: Venus "calm and unpreoccupied," Adonis "hunting safely."[67] At Charleston Farmhouse, domestic commitments to Vanessa took center stage; in London, Grant was free to roam. Still loosely involved with Bunny Garnett, he was always eager to meet young men, drawing inspiration from their bodies, enjoying the stimulation of fresh ideas.

Leonard and Virginia were still ensconced in suburban Richmond, but others were beginning to settle back into familiar territory. With rural retreat no longer a necessity, central London was the obvious place for the friends to regroup, and Bloomsbury the most appealing destination. Maynard Keynes had taken over the lease of 46 Gordon Square in 1918, with Duncan Grant as his main lodger. Fifty Gordon Square became a layer cake of Bells and Stephens in changing configurations: Adrian Stephen and his new wife, Karin, as the main leaseholders, the Bells initially together, then Clive solo for many years. Stracheys began arriving en masse soon after, leasing numbers 41, 42, and 51—all on the same side of the square. Lytton tended to stay with his mother and sisters at No. 51; James and Alix Strachey were at No. 41, and Oliver and Ray Strachey at No. 42. When Bunny Garnett decided Taviton Street in Bloomsbury would be the perfect place to open a new bookshop, Duncan Grant was de-

lighted. Running northwards from the top corner of Gordon Square, the row of tall nineteenth-century houses with narrow windows might seem an unlikely location for a business, but it was perfectly positioned to catch passing Bloomsbury Group trade.

With so many prospective purchasers nearby, success for the bookshop, Birrell & Garnett, was guaranteed: the ground-floor rooms didn't have a proper shopfront, but they had plenty of room for shelves, and space for Omega Workshop tables. Bunny and his business partner, Frankie Birrell, stocked up on all the things most likely to tempt the local audience: a goodly selection of eighteenth-century literature, ripe for inclusion in Lytton's library; the latest English and French novels; newly fashionable Russian translations; and everything you might need on modern art. Hogarth Press books were a certainty, along with Carrington's quirky foil paintings. There was a comfy sofa to settle down in and chat, and impromptu sessions could be expected after hours, especially when Bunny joined the group of lodgers living upstairs. It was here in 1920 that Bunny met his wife, the wood engraver Ray Marshall, who injected some much-needed cash into the Garnett coffers without noticeably limiting his chosen way of life. Ray retreated to the countryside after their son Richard was born in 1923, leaving Bunny in London during the week, free to continue his ongoing connection with Duncan Grant and pursue amorous encounters with anyone who caught his eye, of any age or gender. Bunny constantly reassured Ray of his love, his commitment to their growing family, but Ray struggled to accept the presence of so many other lovers in their lives.

Birrell & Garnett formed a key meeting point between the generations, a ready source of fresh blood for the Bloomsbury family. Chance encounters were an easy way for Old Bloomsbury to spot new talent and for Young Bloomsbury to connect with a successful older crowd. The former "outsiders" were becoming "insiders"; their artistic and literary output was bang up to the minute, and their

open approach to living had a particular appeal for younger people exploring their sexuality. It was in the heady atmosphere of Taviton Street that Bunny first came across the young American academic Mina Kirstein and her pupil and lover Henrietta Bingham. Mina was petite and delicate, Henrietta tall and athletic; both were wealthy, both were attractive, and both were being encouraged by their psychiatrist to try relationships with men. Mina had lectured in English at Smith, an elite women's college in the States, so she was attuned to the group's literary output. She was also aware of Duncan Grant's growing reputation as a painter, choosing to sit for him for a portrait sketch, but it was Bunny who captured most of her attention, particularly when he made the transition from bookseller to popular author. In autumn 1922, his book *Lady into Fox* was a surprise success for Chatto & Windus, securing a brace of highly regarded (and well-funded) literary prizes. The novel explored themes of sexuality and fidelity in fable form, and was illustrated by Bunny's long-suffering wife, Ray.

While Mina dallied with Bunny and Grant, Henrietta connected with another of Bunny's recent discoveries—the sculptor Stephen "Tommy" Tomlin, who had wandered into Taviton Street in search of art books and wandered out with a fascinated Bunny in tow. Bunny remembered the intense physicality of their first encounter in 1922; here was a young man with "very broad shoulders. Luxuriant fair hair crashed straight back from a fine forehead, a crooked nose and deep-set blue eyes. A delightful intimate smile played about his mouth." Their attraction was instant, a coming together of both mind and body: "At this meeting I was first aware of his charm, then of a penetrating mature intelligence. We were alone in the shop . . . we at once forgot that he had come to buy . . . and by closing time, the talk had ranged from Maillol, Gaudier and Brancusi to Blake, Dostoevsky and the French unanimists."[68]

Golden-haired Tommy had dropped out of Oxford in 1919 to

study with established sculptor Frank Dobson. Bloomsbury was a world away from the stifling atmosphere of his parental home, where his father, Judge Tomlin, held disapproving sway. With a studio in Fulham and a growing cohort of willing sitters, Tommy seemed destined for a shining future. Like Henrietta Bingham, Tommy had suffered mental health problems at university, and as with Henrietta, these may have been linked to a difficulty in finding acceptance for same-sex desires. One of his old friends from school and Oxford was said to have committed suicide by drowning, and Tommy was tormented by episodes of extreme self-loathing. With Bunny, Grant, Lytton, and Carrington, Tommy could relax and allow his creativity to thrive. Commissions followed like ducks in a row as Tommy carved the heads of his male and female lovers, enchanting Lytton, seducing Grant, cheering Carrington when she felt downcast.

Like an ever-evolving structure, the Bloomsbury family adapted in shape to take newcomers in; Mina and Henrietta were transitory additions, but Tommy became a long-term fixture. Bunny loved to bring people together through the bookshop, giving fascinated employees a bird's-eye view of the ever-changing canvas; when his sister-in-law Frances Marshall started working at Birrell & Garnett in 1921, she had ample opportunity to watch the merry-go-round in action. Born in 1900, Frances and contemporaries like Tommy and Henrietta were twenty years younger than the original members of the Bloomsbury Group, their childhoods shaped by very different influences. But in instinct, and outlook, they were remarkably alike. Frances never forgot the excitement of her early days at Taviton Street, when she first came across this rare group of older people who "valued friendship extremely highly" and "laughed at one another often," believing "marriage to be a convention" over which "love, whether heterosexual or homosexual, took precedence." Above all, "they were serious but never solemn, and nothing was sacrosanct or immune from fun, certainly not themselves."[69]

For Frances, the Bloomsbury approach to love was immediately appealing, a release from the prevailing strictures of middle-class morality. She also enjoyed the passionate discussions of art and literature, the commitment to pursuing a fulfilling career, regardless of gender. It's easy to imagine the twenties as a time of newfound freedoms and flapper fun, but most young women were still hedged round by convention, with traditional marriage an assumed outcome. In 1921, Frances had only just finished her studies at Cambridge University and wasn't yet sure what she wanted to be. Work at the bookshop gave her time to consider the options and to record the hordes of new acquaintances who might pop in to make a purchase: "The Twenties were the dancing years and also the era of Bloomsbury parties," she wrote in her memoirs. "The original 'members' were still far from old, and around them a host of quite young fringe-Bloomsburies had collected."[70]

YOUNG PEOPLE FROM OXFORD

◆

Lytton Strachey always enjoyed his visits to Birrell & Garnett, but it was by no means his only source of introduction to attractive young men. During their seduction of Ralph Partridge, Lytton and Carrington had become rather fond of visiting their lover in his Oxford college, taking turns dropping into his student rooms. Once Ralph had finished his degree and moved into Tidmarsh Mill, Carrington's visits to Oxford ceased, but Lytton often found reasons to return. Oxford University was only a short drive away from Garsington Manor, home of the pacifists Philip and Ottoline Morrell. A haven for Bloomsbury conscientious objectors during the First World War, Garsington Manor remained a welcome weekend retreat thereafter. Ottoline's eccentricities were ruthlessly mocked by Lytton and Virginia, but the charms of her golden stone house, with its shaded terraces and cool swimming lake, were hard to resist. In the 1920s, Garsington gained a further attraction: delicate Oxford undergraduates, said by Virginia to grow like asparagus shoots on the lawn. Invited by Ottoline to amuse her teenage daughter, these

young men were of far more interest to Lytton Strachey and Duncan Grant, who followed them attentively around the gardens.

Queer, aristocratic, and Etonian, this new crop of Oxford students represented a subtle change in Bloomsbury attitudes toward the most privileged classes. Eddy Sackville-West, heir to the ancient Sackville estates, was a talented pianist and aspiring novelist. The Honorable Robert and the Honorable Eddie Gathorne-Hardy, sons of the Earl of Cranbrook, had a passion for rare books. The Honorable Philip Ritchie was the grandchild of a Conservative peer, while Roger Senhouse came from a wealthy family of Cumbrian landowners, counting a marquess among his near relations. All were friends of Lytton's elegant young cousin John Strachey, whose father owned the *Spectator* magazine. Some worked with John on student journals; others helped with his productions for the Magdalen Dramatic Society. Packed tightly into open-topped cars, they would pull up at Garsington full of enthusiasm for the entertainment ahead, slightly awestruck by the assembled older company.

As they tumbled out onto the grass in their crumpled finery, Lytton might be lolling languidly in a deck chair, Virginia and Duncan lingering by the tea table, but all eyes would be turned on the decorative arrivals. Cushioned by their private incomes and free from the threat of enforced military service, these young men adopted a joyfully expressive style of speech and dress that appealed to tabloid gossip writers looking for eye-catching copy. Extreme aestheticism was celebrated by the postwar press as an amusing quirk of fashionable youth, parodied with apparent affection in society columns and on the pages of contemporary novels. Queer fictional characters like Evelyn Waugh's Miles Malpractice hid in plain sight, touching up their makeup with insouciance. Bright young people were supposed to be beautiful, and physical adornment of every type became an expected feature of society photography—the bolder the better, if images were to hit the front page.

Virginia Woolf noticed the change: "All the young men tend to be pretty and ladylike, for some reason, at the moment. They paint and powder, which wasn't the style in our day."[71] Lipstick and foundation were favored by many of the Oxford aesthetes, alongside elegantly tailored suits and a cheeky array of accessories. Ottoline Morrell's photograph albums from the 1920s capture the crowds of smartly dressed students gathered expectantly on her Garsington lawns, conscious of the circling presence of interested older guests. Virginia was equally aware of the deliciously slim youths "walking to & fro, round and round," and of the "compliments, attentions"[72] paid to them by her friends. Lytton could be spotted flirting on garden benches, and heads were bent to catch the quiet murmurings of Duncan Grant. Judging by her smiles of delight in the pictures, Virginia was thoroughly beguiled by their worshipful chatter, however teasing her accounts in later letters.

By the mid-twenties most of this close-knit group of Oxford charmers had finished their degrees and were starting to make their way in London. Virginia noticed them popping up in Bloomsbury, where Lytton could soon be seen surrounded by "40 young Oxford men" at Gordon Square parties, "booming and humming from flower to flower."[73] Ever on the alert for gossip, she lent an ear to their troubled love lives and assessed the successes and failures of their emerging careers.

Eddy Sackville-West became a particular object of fascination. Small and delicate, with a domed forehead and large violet eyes, Eddy had his own distinctive charm. Virginia pretended to be irritated by Eddy's effeminacy, his short temper, his frivolous interest in makeup and jewelry, but she never turned him away. She listened to agonized accounts of broken relationships, had spirited debates regarding sexuality, and even agreed to read his diary if it would help to unravel some of the emotional entanglements. As the first cousin of Virginia's lover Vita Sackville-West, Eddy was bound to capture

her attention. Lytton and Duncan were equally intrigued; both were present during Eddy's first visit to Garsington in June 1922 and both found something to admire in a student who played the piano like a virtuoso, read all the latest French authors, and dreamed of becoming a writer, filling notebook after notebook with exuberantly expressive text.

After Oxford, Eddy's life became a crisscross of Bloomsbury connections: in 1924 he moved into a London flat with Lytton's cousin John and later enjoyed brief but passionate love affairs with Stephen Tomlin and Duncan Grant. Weekends at Charleston were repaid with invitations to the Sackville ancestral seat at Knole in Kent, where Eddy occupied apartments in the Gatehouse Tower bedecked with crucifixes and Bloomsbury art. His first two novels were snapped up by Heinemann and appeared in quick succession: *Piano Quintet* in 1925 and *The Ruin* in 1926. Eddy experienced a brief flurry of press attention; the proud young author was pictured lying upside down under a leopardskin by society photographer Cecil Beaton and painted in profile by the surrealist John Banting.

Eddie Gathorne-Hardy was another Garsington regular. In one photograph, taken by Ottoline, he sits next to Lytton, confidently facing the camera while the others stare dreamily into the distance. Cigarette box in hand, silk handkerchief tucked artfully into the pocket of his tailored three-piece suit, Eddie looks every inch the dandy. As the younger son of an earl, he was reliant on family money to fund a somewhat extravagant student lifestyle, his income sustained after Oxford through work for the booksellers Elkin Mathews. By day, he developed a widely respected expertise in eighteenth-century rare books, supplying ornate volumes to Lytton and other Bloomsbury collectors. By night, he shone as one of the brightest of the Bright Young Things. According to Cecil Beaton, Eddie made a striking first impression: "uncommonly tall, vellum complexion, tortoiseshell glasses, long hair, a bemused expression about his eyes

and mouth."[74] Eddie shared a flat with the famously dissolute poet Brian Howard, and Beaton left a vivid account of a typical evening out with Brian and Eddie in 1927. According to Beaton's biographer, after meeting at the Gargoyle Club in Soho, they headed to a party where, to Cecil's surprise, they "declared their intention 'to find a man' and brought out powder puffs."[75] Makeup was applied all around, and, after a brief altercation with Brian, Cecil was pushed into a cupboard with Eddie, "where most exciting thrilling things happened."[76]

Lytton Strachey was amused by Sackville-West and Gathorne-Hardy, but it was Philip Ritchie who really captured his emotional attention. A fellow Oxford undergraduate, Ritchie appeared at Garsington from 1922 onwards, satisfying Lytton's growing aspiration for aristocratic connections and his preference for an aesthetic sensibility combined with hints of dominant masculinity. Ritchie's grandfather was the son of a "Dundee Jutewallah," raised to the peerage as Lord Ritchie of Dundee. The "Dundee Jute Barons" imported raw jute from Bengal, processed it in Dundee, and spun it into cloth in factories in London. Almost a thousand women had worked in the vast Ritchie works at Stratford, but expectations of young Philip were very different. His parents hoped he would become a barrister and sent him to train at Lincoln's Inn with Charles Percy Sanger, a Cambridge connection of Lytton and Leonard, and another familiar face from the Garsington lawns.

Ritchie's well-groomed façade hid a dangerous edge: he had served briefly as a conscript in the army before starting at Oxford and was hardened by the experience. Photographs reveal a handsome, broad-shouldered figure with a dapper taste in suits; he had thick auburn hair, green eyes, and a tendency to burst into song. Escaping the restrictions of his background through drink and gambling, Ritchie experienced a sense of release when introduced to Lytton's Bloomsbury friends; Carrington remembered him talking very seri-

ously about buggery "as if it was a public duty," rejoicing in the ability to "have bawdy conversation and be outspoken."[77]

Ottoline photographed Ritchie and Lytton loitering in the Garsington flower garden: knee-deep amidst the tulips, Ritchie leans nonchalantly back, hands in pockets; Lytton stands deferentially beside him, looking as if he can't believe his luck. Soon Lytton was showering the young man with poems—"What need of more, When I have had my fill?"[78]—and invitations to Tidmarsh Mill. Oxford contemporary Maurice Bowra described Ritchie as "engaging, amusing, fanciful and self-indulgent," delighting in gossip—"the vagaries of his friends occupied much of his time."[79] But it was a Cambridge friend, Dadie Rylands, who worked as an assistant at the Hogarth Press with the Woolfs, who provided the most intimate summary:

> Dear Philip: his charm: a kind peculiar to himself, none of the rest of us has it. I see him clearly—spraying soda-water into half a tumbler of whisky with some pomp and a smile at his characteristic activity—the narrow sidelong face and green browless eyes: then later in the evening his hair very tousled; many an affectionate squeeze to the arm intimating that it is impossible, uncivilised, unnatural to venture out into the wet streets, when there is still spirit in the decanter and the bed of an old friend to be shared.[80]

Through Ritchie, Lytton was introduced to another former Oxford student: Roger Senhouse of Netherhall in Cumbria. The Senhouse family had built docks at Maryport on the Cumbrian coast, opening up the area for trade in coal and iron, investing in slave plantations in Barbados and Dominica. As a second son, Roger never expected to inherit the Netherhall estate; while his elder brother wrestled with the impact of Maryport's declining heavy industries, Roger buckled down to the boring City job his family had lined up for him in the import/export trade. Tall, thick-set, and blond, he

had a muscular attraction very much in the Ralph Partridge mode. Already inseparable at university, Ritchie and Senhouse continued their friendship in London, with Lytton tagging along enthusiastically behind—taking pictures of Senhouse swimming or posing smiling against a laburnum in flower, the very image of a handsome Grecian youth from classical antiquity.

When Lytton exchanged Tidmarsh Mill for a more luxurious home at Ham Spray in Wiltshire in 1924, Ritchie and Senhouse became weekend fixtures. Dora Carrington and Ralph Partridge still tended to his domestic needs, but Lytton's affections had moved elsewhere, straying back and forth between the two younger men. In February 1927, Virginia noted in her diary that "Lytton has thrown over Philip, and is on with Roger Senhouse, whom he wants us to be nice to";[81] by March the same year, Lytton was giving a party at the Ivy "to seduce me into liking a pink boy of his—a new pink boy—called Roger Senhouse."[82] Lytton expected his friends to absorb his lovers, old and new, into the broader Bloomsbury family; this was easier with some than others. Senhouse was a slightly enigmatic figure, finding sexual release in sadomasochistic fantasies. Lytton loved to be spanked, and Senhouse happily obliged. Photographs show him lying bare-chested on the Ham Spray lawn, with Lytton kneeling worshipfully beside. But at Ham Spray—at least according to Virginia—Lytton's domestic satisfaction was complete: "Lytton now—dear old Lytton—well, he was in very much melodious humour returned to his Senhouse, his Partridge, his book, at peace with the world."[83]

YOUNG PEOPLE FROM CAMBRIDGE

Cambridge was an equally productive source of stimulating youth. Here the connection was more direct: Maynard Keynes left the Treasury to return to King's College as an economics lecturer in 1919. One of his first actions was to help revive the Apostles—the secret discussion society where so many of the original Bloomsbury Group had met in the early 1900s. Old members were allowed to return for the Saturday night meetings, and Lytton Strachey and E. M. Forster spent many pleasurable weekends in Cambridge surveying each new set of initiates. Students often found these first encounters awe-inspiring. Shyness was replaced by excitement when they realized the famous authors had a sense of humor and encouraged open conversation on any topic, however subversive. Strachey's approach tended to be bawdy and direct; Forster's manner was more tentative, his attendance less frequent, thanks to a period away working in India. But each was equally committed to nurturing their connection with queer young men. Forster's novel *Maurice*—written in 1913–14 but unpublishable during his lifetime—celebrated same-sex love be-

tween university students and between men of different classes. Although Strachey did not tackle these topics directly in his writing, he promoted sexual honesty through all his personal interactions.

Unaffected by modern concerns regarding power dynamics or student-teacher relationships, Keynes used his position at King's College and his link with the Apostles society to befriend and seduce undergraduates. Strachey and Forster were bemused by the sheer number of choices on offer, envying their friend's proximity to an ever-replenishing supply. Lytton told his brother James in November 1921 that Keynes's "activities seem terrific—particularly the social ones, and he confessed he was terrifically exhausted keeping it up. I don't know whether there are other reasons for his exhaustion, but on the whole I should think so."[84]

Walter Sprott—rebranded as "Sebastian" when he joined the Apostles—enjoyed a nonexclusive relationship with Keynes from 1920 to 1925. The son of a provincial solicitor, Sebastian was less aristocratic and less financially comfortable than his Oxford equivalents but equally decorative in appearance. Elegantly attenuated, with sharp cheekbones and a shock of thick, dark hair, Sebastian was studying moral sciences in the hope of becoming an academic. Friendly and self-effacing, he was quickly absorbed into many Bloomsbury households. Virginia Woolf worried about his skinny frame, his lack of resources, and made sure he was included in invitations to Garsington. Ever needy of cash, Sebastian spent the summer of 1921 tutoring the Bell children at Charleston, and Vanessa and Duncan both painted him during this period—sitting upright, smartly dressed, in a tall wing chair and reclining on a picnic rug in the garden, his long white neck emerging swanlike from a deep-green tunic. Sebastian seemed to enjoy the stirring effect of his clothing and jewelry on older queer men.

Lytton took Sebastian to Venice in 1922, telling Ralph Partridge, "I can't say he looks ultra-respectable, with a collarless shirt, very

décolleté, and the number of glad eyes he receives is alarming. However so far his behavior has been all that could be desired."[85] By 1924, Lytton could report that "Sebastian's clothes have improved. He now wears a jersey (grey) and a collar open at the neck, which produces quite a romantic appearance." But his finger adornments remained provocative: "the rings remain."[86] Lytton loved Sebastian's stream of constant chatter, looking forward to hearing all about the "developments of his various love affairs," his "fifth-form adventures."[87] It would have been hard to find someone less likely to be shocked by the sexual honesty revealed in Lytton's extensive correspondence, and it was to Sebastian that Lytton turned when he hoped to instill some order among the daunting piles of personal papers at Ham Spray. Not every famous writer could call on a sympathetic young psychologist to sift through their compromising letters during university vacations; publication was impossible at this date due to the illegal homosexual content, but Lytton treasured the memories, and Sebastian's careful categorization by author and date proved very useful for later biographers.

Sebastian took a double first in moral sciences in 1922, securing a paid postgraduate position at the Cambridge Psychological Laboratory so that he could remain close to Keynes. He lectured on "Theories of Perception with special reference to experimental work"[88] and produced a translation of Ernest Kretchmer's *Physique and Character: An Investigation of the Nature of Constitution and of the Theory of Temperament*. Promotion came quickly: in 1925 Sebastian transferred to the University of Nottingham as a lecturer in psychology. This provided a final break from the on-off relationship with Keynes (who was now involved with Russian ballerina Lydia Lopokova) and brought him closer to Forster and Strachey. Free from the glare of publicity focused on Bloomsbury writers, Sebastian set up home in Nottingham with a local man called Charles Lovett. As was the case for many gay men in this period, their first meeting place

was a public lavatory and their relationship masked by the fiction of employment as a servant. Forster gave Sebastian free use of his London pied-à-terre in Brunswick Square. Lytton went to see him in Nottingham, sending regular invitations to Ham Spray and checking on his welfare by post: "I hope Nottingham has not become too appalling, and that you are supported by your various friends, old and new."[89] Fleeting references to Sebastian appear in most accounts of the life of Maynard Keynes, but the coverage tends to be sketchy: his personality is seldom explored, his successful academic career brushed over, and his ongoing role in Bloomsbury lives barely mentioned.

It was through Sebastian, and his raffish friend the writer Joe Ackerley, that Forster began to connect more regularly with young gay men from working-class backgrounds. Although many of these interactions were brief and transactional, several evolved into more meaningful relationships. Forster found these experiences life-changing, triggering revisions to *Maurice* and the creation of other work celebrating homosexual love between men of different social classes. Although none of this material could be published during Forster's lifetime, thanks to the looming threat of prosecution, the posthumous impact was considerable.

Back in Bloomsbury, other Cambridge students were making their presence felt. Frances Marshall was struck by the Davidson brothers—Angus, Douglas, and Malcolm—children of a Harrow housemaster: "tall, gentle-voiced men who always seemed surprised or apologetic and were splendid dancers of the Charleston and Black Bottom."[90] Angus harbored literary aspirations, working as an assistant at the Hogarth Press and writing unpublishable plays, before finding his niche as a translator. Malcolm was a singer and composer of pastoral songs, trained after Cambridge at the Royal College of Music. Attractive Douglas became a painter; a member of the London Artists' Association, he worked happily

with Duncan Grant and Dora Carrington on decorative schemes, his style almost indistinguishable from theirs. Amenable to direction, he and his brothers were willing participants in Bloomsbury performance. Virginia Woolf found them kicking their heels up at 46 Gordon Square in July 1924: "It was great fun at the party, enchanting, lyrical . . . dancing; the Davidsons, three of them, hung with chandeliers, and stately as caryatids . . . in a ballet designed by Duncan."[91]

Equally eye-catching was Dadie Rylands, the vibrant young man admired by Virginia Woolf for his corn-colored hair and sky-blue suits. Dadie was a Cambridge contemporary of Douglas, the youngest Davidson brother, and both were protégés of Maynard Keynes. The Rylands family had owned wire factories in Warrington, but Dadie's ambitions were firmly aesthetic. Cambridge offered new possibilities: membership in the intellectual Apostles society and the chance to seize press attention in eye-catching feminine roles. English and drama were his twin passions, and in 1923 Dadie joined the gaggle of Bloomsbury contributors invited to supply reviews to Britain's leading liberal journal, the *Nation and Athenaeum*. Keynes had lined up financial backing to take over the journal, reserving the position of chairman for himself, and appointing Leonard Woolf as literary editor. Aged only twenty-one, Dadie found himself besieged by a flurry of impressive invitations: Lytton lured him to Tidmarsh, and Keynes summoned him to Studland in Dorset, where Virginia gave him the once-over and pronounced him visually appealing.

In 1924, Rylands beat fellow undergraduate Cecil Beaton to the lead part in *The Duchess of Malfi*. Swallowing his envy, Beaton described Dadie's performance as "like a unicorn, neither male nor female, dignified, rare,"[92] and sold the ensuing photograph of Dadie as the Duchess to *Vogue*. This was Beaton's first commercial sale, helping to set him on the path to success as a professional photographer. Looking at Beaton's portrait, it's easy to see why

journalist Raymond Mortimer considered Dadie "the most intoxicatingly beautiful young man it is possible to imagine."[93] Lytton was fascinated, listening to the vagaries of Dadie's butterfly love life and proffering wise counsel in return. As Dadie flitted from casual street pickups to heartrending affairs with the sons of rural clergymen, Lytton took on a kindly paternal role. Virginia was amused by Dadie, but Lytton treated him with real affection, their relationship captured in a touching photograph: Dadie seated casually on the grass and Lytton standing above, his hand resting on the younger man's head as if giving a blessing.

When Dadie graduated in summer 1924 and the Woolfs offered him a job at the Hogarth Press, Virginia began the experiment with high hopes—"he shall be a partner & take over the work . . . and we shall be the benefactors of our age; & have a shop; & enjoy the society of the young."[94] By November the gloss was wearing off; Dadie had decided to try for a Cambridge fellowship and had become easily distracted: "He is a very charming and spoilt boy . . . rather dazzled by London and parties . . . and all the young and oldish men . . . fall in love with him, and he dines out every night, and treats his lovers abominably."[95] Despite this defection, the Woolfs printed Dadie's first slim volume of poetry—*Russet and Taffeta*—in 1925.

By this stage Dadie and Douglas had become thoroughly embedded in the Bloomsbury family. When Vanessa Bell and Duncan Grant took over the lease of 37 Gordon Square, Dadie and Douglas moved in as lodgers on the upper floors. Lytton found the youthful goings-on at No. 37 vastly entertaining; he went shopping with Douglas for louche pajamas and attended one of Malcolm's concerts. Dadie was working on his fellowship dissertation and lending a friendly ear to Lytton's romantic entanglements; his letters to Lytton reveal a stream of candid confidences: seductions of students and soldiers, apologies for passing on crabs, and sensitive inquiries

regarding the progress of love affairs with Philip Ritchie and Roger Senhouse. There was a moment of high drama when Dadie's man-servant was suspected of theft and dismissed, though—according to Lytton—"not before it was discovered that he had been carrying on in the most shocking manner with Malcolm Davidson, who had been lent Douglas's rooms for a night or two. Quite a bombshell for the two boys."[96]

Malcolm dipped in and out of Bloomsbury, but Angus Davidson—like Douglas—became a permanent fixture. Dismissed by Lytton as colorless, he made a deeper impression on Duncan Grant, who found him inspiring as a lover and a model, returning to the same subject again and again. Angus sat patiently for portraits in oil, and for inti-mate drawings of his naked form. When Angus acquired rooms near to Gordon Square in Heathcote Street, Grant insisted on covering the walls and furniture with exuberant decorations—serenading lov-ers on the cupboards, giant arum lilies over the fireplace, panels of swirling color in every alcove. This was a typical act of generosity—"If I go to a house of a friend who hasn't anything, I think of my-self almost unconsciously decorating the space over the fireplace, or something like that,"[97] Grant wrote—but it was also a gesture of affection for a beloved companion.

Angus's rooms were illustrated in *Vogue* and *New Interior Deco-ration* as examples of Grant's work, and astute obervers would also have noticed Angus's figure appearing both naked and clothed in Duncan's solo exhibition at the Independent Gallery in 1923. Nei-ther Vanessa Bell nor Virginia Woolf saw Angus as a disruptive pres-ence; he was unlikely to upset any of the domestic arrangements at Charleston Farmhouse by trying to elope with Duncan or appear weeping on Virginia's doorstep, demanding emotional support. In December 1924 the Woolfs took Angus on as their new assistant at the Hogarth Press, and after Dadie's vagaries Virginia was vastly re-

lieved by his abilities, telling her friend the painter Jacques Raverat: "I like him very much and I think him likely to be our salvation—gentle, considerate, cautious, kind."[98] Quietly industrious, Angus slipped peacefully into the background: "Slightly hesitating, diffident and unselfconscious. He is working in cross stitch at a design by Duncan for a chair."[99]

YOUNG RELATIONS
AND MANY MORE

◆

Only a few children of Bloomsbury families reached adulthood in the early 1920s. Of these the Stracheys were the most noticeable. By 1925 the family occupied more space in Gordon Square than any other: Lytton, his mother, and three unmarried sisters lived at No. 51, younger brother James leased No. 41, with his wife, Alix, while older brother Oliver was at No. 42, with his second wife, Ray.

Stracheys tended to be a rather dominant presence at Bloomsbury gatherings, their distinctive high-pitched voices fluting above the crowds. Most Oxford and Cambridge students could join in the fun with abandon, but young Stracheys were faced with daunting numbers of relations whenever they ventured out. It took determination to establish your own identity amidst the throng. There were two in particular who raised their heads above the parapet, experimenting with different ways of living, pushing boundaries even further than the generation before.

Julia Strachey, eldest daughter of Oliver, would have stood out in any crowd. Virginia Woolf described her as a "gifted wastrel"[100]—

one of those beautiful young people who seem to be able to turn their hand to anything but settle at nothing. Julia wrote, acted, and drew with unusual sensitivity, and could play jazz piano like a demon. Her cousin John invited her to Oxford to star in student plays. Her father hoped she could make her living as a commercial artist, sending her to study at the Slade. What Julia really wanted to be was a writer, but she found it hard to commit when London offered so many distractions. Drifting in and out of modeling jobs, Julia threw herself headlong into the world of the bright young people, joining her flapper friend Elizabeth Ponsonby on the nightclub circuit. Beset by money worries, alcohol, and angry young men who threatened to shoot themselves if she refused to love them, her life spiraled briefly out of control and by 1925 she was back with her father in Gordon Square, suffering from emotional exhaustion.

Uncle Lytton and "Tante"[101] Carrington came to the rescue. Lytton's new house at Ham Spray became a second home for Julia in 1925–26, and she spent many lazy summer days lying on the lawn or modeling for Carrington, who fell for her. So, too, did sculptor Stephen "Tommy" Tomlin, an equally constant presence at Ham Spray. Tommy and Carrington started 1925 pining for the same absent female lover, Henrietta Bingham, but found comfort in each other and their shared admiration for Julia. Carrington drew Julia in veils as a Persian princess and encased her head in a silken turban for a portrait in oils, writing that she found it maddening to "have (or rather don't 'HAVE') a lily white lady with Chinese eyes of purest milk sleeping night after night in my house."[102]

Lytton enjoyed the undercurrents of attraction at Ham Spray, paying Tommy for a series of sculptures modeled on-site. Tommy's *Nymph of the Ilex* has echoes of Julia in face and form, and Tommy, Julia, and Carrington were photographed, arms entwined, beside the statue. Confident that Tommy's romantic interests were so widespread that they would never be curtailed by something as prosaic as

a wedding vow, Lytton and Carrington were pleased when Julia and Tommy fell in love and married in July 1927. Once settled at Swallowcliffe in Wiltshire, Julia found the peace she needed to write, filling her notebooks with Proustian descriptions of the people and landscape around her, season by season.

Life was proving equally stimulating for Julia's cousin John, who seemed set to follow the typical family path. Having been embedded in the aesthetic crowd at Oxford, he became a regular at Garsington and set up home in London with Eddy Sackville-West. He was soon spotted by Carrington carousing at Bloomsbury parties, huddled in corners with his Oxford chums. Eddy and John both hoped to become great writers, and since John's father owned the *Spectator*, a career in literary journalism seemed the most likely starting point. John had no problem getting his pieces published in the *Spectator*, but other publishers were less forthcoming. As the rejection slips piled up, John confounded his flatmate by striking out in a new and more forceful direction. Inspired by a sense of rebellion against conventional social and moral practices, the aspiring author decided to take his activism beyond the personal sphere and into the political arena. John joined the Labour Party in 1923, campaigning unsuccessfully for his first Labour parliamentary seat in 1924. He became a committed Marxist, editing the *Socialist Review*, and standing on the side of the workers in the general strike of 1926.

John's life was full of contradictions. One day he might be playing croquet at Garsington Manor with Philip Ritchie and Roger Senhouse, watched indulgently by Lytton. The next he could be on a train to industrial Birmingham, ready to address a working-class audience angry about conditions in factories. Leonard Woolf had trodden a similar path in 1922 when he agreed to be the Labour candidate for the Combined English Universities constituency, trudging back and forth to Liverpool and Manchester to drum up votes. Although sympathy for the Russian Revolution was high in

Bloomsbury, their enthusiasm was theoretical rather than practical, and active membership in the British Labour Party remained rare. The prevailing spirit was liberal, expressed most forcefully when Maynard Keynes took over chairmanship of the *Nation and Athenaeum* in 1923. According to a contemporary Russian commentator, the *Nation* stood for "Bloomsbury liberalism," defined as "a thin-skinned humanism for enlightened and sensitive members of the capitalist class who do not desire the outer world to be such as might be prone to cause them any displeasing impression."[103] Lytton and James shared exactly this type of liberal outlook; they never sought a fundamental change to the organization of their country. John Strachey had grown up in a more revolutionary era, exposed to the siren call of Soviet propaganda, lured by the mirage of a socialist utopia.

John also surprised his older cousins by showing a sexual interest in women. Entirely comfortable in the company of gay men, he was equally open to female friendship, and to love affairs if the opportunity arose. Like Clive Bell and Ralph Partridge, he enjoyed female company, heading out on sprees with Julia Strachey and Elizabeth Ponsonby, testing boundaries with older married women.

Travel offered even broader horizons for John in 1928 as political invitations took him to Russia and lecturing took him to America. Thanks to his cosmopolitan upbringing, John felt ready to tackle any form of nightlife that bohemian New York could offer. But no sooner had he set foot in the city than he was spotted by a familiar face from Bloomsbury—journalist Raymond Mortimer, over in the States to promote his own career. It was hard for any Strachey to escape the Bloomsbury net, and reports of John's activities were soon winging their way to Lytton across the Atlantic.

Slightly older than John, Raymond had gone up to Oxford before the war, returning in later days to lounge in deck chairs at Garsington, alert to the fresh faces around him. Unlike Ralph Partridge, he

had decided not to finish his degree, choosing London and journalism as a more appealing option. As a smart young man about town, he was soon writing pieces for the *New Statesman* and *Vogue*. Slim, dark, and attractive, with a mop of curly hair, Raymond would never be Lytton's idea of a "beauty," but he cut a dashing figure. Virginia Woolf was amused by his tiger-striped sweaters and loud ties, and the curious shape of his inquisitive nose. Ever charming, he was invited everywhere, figuring as often in the social columns as he did on the review pages. Virginia loved to puncture his precocious enthusiasm, telling Lytton: "Raymond was here last week end [sic], very polished and agreeable; and I daresay it's supercilious to refer to the end of his nose, or his clothes, or his modernity which seems to me miraculous, as if he had already been to a lunch party which has not yet been given."[104]

For a few brief years in the twenties, Raymond became what would be described today as a "social influencer." Old Bloomsbury were pleased when he reviewed their work or attended their parties, and Young Bloomsbury turned out in droves for his after-dinner gatherings. His flat in Gordon Place was helpfully located halfway between the Woolfs' new home in Tavistock Square and the ever-growing cohort in Gordon Square itself. Lytton could hardly bear to look at his bizarre newspaper wallpaper "or the pierrot or the other monstrosities,"[105] but they were catnip to the press. The anonymous author of *Vogue*'s Diary in October 1925 conjures up a wonderful vision of supper chez Raymond: he or she dashed to Gordon Place "to end the evening in a Bloomsbury attic with a few best friends. The Bloomsburyites know that houses get better towards the top—lighter, brighter and cheaper. Supper was in a charming room hung with newspapers of all nations, very cleverly used in juxtaposition to one another."[106] Every detail had been catered for; Raymond prepared the perfect meal, followed by peppermint creams and heated discussion of Michael Arlen's latest play, *The Green Hat*. As they

popped downstairs to collect their coats, Raymond offered each lucky guest the choice of a book to borrow from his shelves.

Raymond had already gained his own entry in *Vogue*'s monthly Hall of Fame column in February 1925. The caption under the enticing photograph gives the reasons for inclusion: "Because of his book reviews, which amuse everyone except the authors criticized . . . because he enjoys all the arts but likes that of conversation best . . . because of his intimate knowledge of young Paris painters . . . and because he is one of those who set the fashions of the mind."[107]

Clive Bell had been his first friend in Bloomsbury, and Raymond was delighted to find an older critic who "admired the best living painters, French as well as English." Clive encouraged him to buy "beautiful Duncan Grants, always at a low price."[108] Thanks to Raymond, and his equally supportive editor Dorothy Todd, Bloomsbury artists began appearing in *Vogue*. Duncan Grant featured in no fewer than nine articles in 1925, crowing to Vanessa Bell in April: "*Vogue* this week is full of us."[109] Bloomsbury writers were equally well represented. In the same month, a surprised Virginia Woolf found herself posing for their in-house photographers alongside a fashion shoot. By June, *Mrs. Dalloway* was selling more copies in a month than *Jacob's Room* had in a year, and Virginia wrote of "sweeping guineas off the *Vogue* counter."[110]

Patronage was added to promotion when Raymond commissioned Grant and Vanessa Bell to produce painted wall panels for his flat in Gordon Place. Already rewarded by £60, a launch party, and a *Vogue* article, Vanessa sent her own note of thanks: "To all artists whom it may concern, we should be delighted to recommend you as everything that is generous, encouraging, and prompt. In fact, you are perfect, and I wish I could write on the behavior of patrons in *Vogue*."[111] When Todd and Raymond produced the book *The New Interior Decoration*, Raymond's wall panels appeared again, along

with a gushing paragraph: "That Duncan Grant's pictures are the best work that the English school has produced since the age of Constable is the opinion of many good judges. And some of these will add that he is more remarkable as a decorator than he is as a painter of easel paintings."[112]

Strachey relations like John and Julia could take their inclusion in the Bloomsbury fold for granted; for young men like Raymond Mortimer the experience was transformative, and worthy of effusive thanks. As Raymond told Virginia Woolf: "You can't imagine what it has been for me to know Bloomsbury. They're different human beings from any I thought possible."[113] Raymond knew that he had stepped into rare territory, becoming one of the lucky group of bright young people who had found a new arena for self-expression, free from the contempt usually conveyed by the disapproving older generation. This was, after all, a decade dominated by the Conservative governments of Stanley Baldwin, with fashionable youth culture standing in frivolous contrast to the sober ethos of the prevailing political regime. The atmosphere was one of mutual support, with each generation helping the other. Dadie Rylands and Douglas Davidson, for example, sublet one of their rooms at 37 Gordon Square to Lytton from 1928 to 1929, allowing him to entertain male lovers away from the prying eyes of his sisters. Dadie was tender in his care for the older man: "You say we shall all need each other's support during the coming months. But I am at all seasons and in all places terribly dependent upon you for my peace of mind and way of life. I seem to become more & more so. And you must in return call upon me by day and by night when you are in need."[114]

Young Bloomsbury learned from Old Bloomsbury, but there was also a sense of beneficial exchange, of finding a way to connect with the glossy modern world of stage and screen promoted on the social pages of popular magazines. As the cast of new young people assembled, surprising encounters emerged, leaving a frisson of ex-

citement in their wake. Dadie remembered the night when he and Douglas staged a complete takeover of 37 Gordon Square, holding "an immense gathering of everybody we knew; the ballet, and Margot Asquith, Mary Pickford, Lady Ottoline Morrell, and all Bloomsbury and everything else. There was nothing much to eat except heaps of strawberries and cream and cheap white wine. We didn't mind much in those days what we ate or drank as long as there was plenty of everything . . . The party spread all over the house."[115] Silent screen star Pickford brought her equally famous husband, Douglas Fairbanks, causing quite a stir among all age groups; according to Bunny Garnett, "Everyone formed an enormous circle, while, at the center, two particular guests were left to introduce themselves—Lytton, and the film actress Mary Pickford."[116] It would have been hard to imagine a more unlikely pairing, but—thanks to Douglas and Dadie's boundless enthusiasm—the evening went with a swing.

3

Bloomsbury Parties

PLAYING CLOSE TO HOME

◆

Bloomsbury parties formed safe spaces for sexual expression—places where men who loved men could meet women who loved women, with little threat of exposure or challenge. Gender nonconformity was to be expected, and age was never seen as a barrier. For a queer young person in the twenties, these gatherings represented welcome moments of life-affirming normality in a generally hostile adult world. Their parents were unlikely to be supportive, and severe legal penalties threatened the unwary.

A series of Criminal Law Amendment Acts had turned nearly every form of sexual contact between men into an offense: acts of "gross indecency"[117] in public or private were punishable, along with anything that could be interpreted as "importuning for an immoral purpose."[118] The Metropolitan Police were statistically less likely to pursue Londoners into their private homes, but arrests in public spaces were common during this period. Plainclothes policemen patrolled popular cruising spots, looking for signs of difference: wide-legged trousers, colored shirts, a powdered face. Painted boys were

portrayed as a social menace, endangering British society with their moral contagion, a predatory presence in the streets around Piccadilly.

These sentiments found little sympathy in Bloomsbury, where performative display was an expected part of any evening worth remembering. Entertainments came in all shapes and sizes, every occasion an opportunity for departure from the mainstream. The drawing room at 46 Gordon Square had swung back into full action after the war. Occupied by changing groups of friends and family in separate bedsits, these first-floor rooms were often the only spaces in tall Bloomsbury houses kept for communal use by all residents. They were also the place for bold assertions of Bloomsbury aesthetics. At No. 46, Grant and Vanessa Bell painted the walls deep red, covering the doors, mantel, shutters, and ceiling with sensuous decoration. Younger guests would have been left in no doubt about the different world they were stepping into. One visiting Oxford graduate, Roy Harrod, was suitably stirred when he arrived in July 1922: "The room itself made a strong impression. It seemed empty, devoid of the usual ornaments and appendages, in a style that was rapidly to come into fashion, but was strange to me . . . This environment, with its assertion of modernity, itself provided a slightly exciting background."[119]

Frances Marshall loved the "elaborate performances"[120] staged by Maynard Keynes once he took over the lease at 46 Gordon Square. Thanks to his bestselling book, and a stream of speculative investments, the economist was doing well. As one of the wealthier hosts in Bloomsbury, Keynes could afford to fund provocatively scripted theatricals, often with a ballet sequence for his new female partner—the Russian dancer Lydia Lopokova. Duncan Grant designed sets and costumes, Young Bloomsbury supplied the chorus line. The themes tended to be deliberately titillating, exploring love in all its varieties, sometimes stretching across into the animal kingdom. A favor-

ite example told the true tale of Hayley Morris of Pippingford Park, an eccentric wolfhound enthusiast arrested for sex with underage girls. Stephen "Tommy" Tomlin took the lead role as Morris, eagerly spouting his own bawdy lyrics, and Duncan Grant played the main wolfhound. Cross-dressing was required for other parts: Angus and Douglas Davidson and Dadie Rylands turned into attractive kennel maids, wearing evening dresses and pearl chokers. Frances Marshall and two other female party guests formed a matching group of young women dressed in masculine white tie and tails.

When not at Charleston, Duncan Grant spent the early twenties lodging with Keynes at Gordon Square; with less money to flash about, he took a more spontaneous approach to entertaining. Grant's studio—a ten-minute walk away in Fitzrovia—was an ideal venue for impromptu parties. Nearly forty feet long, with tall, east-facing windows, the studio had an impressive artistic pedigree: James Whistler, Augustus John, and Walter Sickert had all painted there. Guests teetered in via a rickety metal walkway, emerging awestruck into the cavernous space. Bunny Garnett liked to lie flat on the floor and imagine he was looking into the hull of a sailing ship—the walls "rose without a ceiling to a rounded roof of brown timber so that it was like a big boat turned upside down."[121] Canvases could be pushed back to make way for drinking or dancing, and Grant loved making merry with his friends.

Ever generous, he lent the studio to Bunny for his thirty-first birthday in March 1923. Some crucial connections were made that night: according to Bunny, the party was Frances Marshall's "first introduction to Bloomsbury society."[122] Mina Kirstein and Henrietta Bingham also made an impression by bringing a selection of mysterious bottles and an enormous cake. Everyone wanted to taste the cocktails they mixed, and Henrietta had brought her guitar. The partygoers listened with rapt attention when she sang African American spirituals from the Deep South.

Mina and Henrietta were used to hiding the true nature of their relationship from their wealthy families, but disguise was less necessary for the professor and her student in this company. Dr. Jones, their psychoanalyst, wanted the women to explore relations with men, and bisexual Bloomsbury seemed like a good place to start: Bunny had his eye on Mina; Tommy was struck by Henrietta. Dora Carrington was equally entranced, drinking so many of Henrietta's cocktails that she "became completely drunk and almost made love to her in public."[123] Carrington was thrilled when Bunny claimed afterwards that Henrietta "continually asks after me and wants me to go and see her."[124] Benefits were soon flowing in all directions: Duncan Grant began painting Mina's portrait; Bunny found himself writing a column for one of the Bingham family newspapers, promoting Bloomsbury authors in the States; Tommy secured his first commercial commissions—a pair of carved eagles for Judge Bingham's gateposts in Kentucky and a bronze head of Henrietta.

There were only twenty-five guests at Bunny's birthday party, but it was a resounding success, setting a good example for many events to come. Contact between the different age groups revived spirits and changed perspectives; cross-pollination inspired creativity among all involved. Clive Bell was the conduit for many of these introductions, inviting new people to join the crowds at larger gatherings, hosting dinners of his own at 50 Gordon Square. Clive rejoiced in sensory experience, declaring in his 1922 essay "The Creed of an Aesthete": "Always life will be worth living by those who find in it things which make them feel to the limit of their capacity."[125] Moving contentedly in and out of different social circles, Clive embraced anyone who appreciated "the beauty, the romance, the fun of life."[126] It was Clive who first promoted Raymond Mortimer as a like-minded spirit, and Clive who first connected Virginia with the writer Vita Sackville-West. By this stage Woolf was growing tired of life in suburban Richmond and eager to pursue the "lovely gifted

aristocratic Sackville-West," who "makes me feel virgin, shy and schoolgirlish."[127] Raymond was attracted to Vita's husband, Virginia was attracted to Vita, and Clive watched the amatory results with amusement.

When Woolf moved her London base back to Bloomsbury in 1924, it was because she was keen to join in the fun: "music, talk, friendship, city views, books, publishing, something central and inexplicable, all this is now within my reach."[128] Leonard was worried about the potential impact on her sometimes fragile mental health, but his wife was determined: as she later affirmed, "I'm naturally sociable, it cannot be denied."[129] The Woolfs' apartment in Tavistock Square was soon filled with vibrant Grant and Bell designs and an equally potent range of people. Virginia didn't have the square footage to entertain in Gordon Square or Fitzroy Street style, but she loved to invite small groups of mixed ages for drinks or dinner. Nervous young guests would make their way up the gloomy stairs past solicitors' offices on the ground and first floors, emerging amidst "vast panels of moonrises and prima donna's [sic] bouquets"[130] on the second floor. Cocktails were drunk beside the striking murals in the sitting room, while dinner was eaten from geometric furniture painted by Vanessa Bell. Subverting traditional ideas of male precedence, each chair was emblazoned with Virginia's VW initials in bright yellow.

Dinners at Tavistock Square were intimate affairs, and conversation could be daunting for the uninitiated. Virginia thrived on gossip and sexual innuendo, winkling salacious details from the unsuspecting young. On a typical evening, Raymond Mortimer or Julia Strachey might be combined with familiar members of the older cohort. More young guests would appear after dinner, perhaps coming from a show. Opinions about "hard, handsome, manly"[131] Vita Sackville-West were varied, but Vita and her first cousin Eddy became regular fixtures. Eddy turned up late one night with gay novel-

ist C. H. B. Kitchin; on another evening Philip Ritchie appeared, "his little green eyes hazed bunged up with drink."[132] Virginia had mixed feelings regarding "Lytton's harem,"[133] taking on the pose of a disapproving colonel horrified by the sudden rise in pretty young men and Sapphic young women. She pretended to be cross when Lytton and Grant fell in love with Hogarth Press assistants, but her protestations were largely tongue-in-cheek: "My anti-bugger revolution has run all around the world as I hoped it would. I am a little touched by what appears to be their contrition, & anxiety to condone their faults . . . The pale star of the bugger has been in the ascendant too long."[134] Avoiding buggers in Tavistock Square would have been pretty hard, even if Virginia had really wanted to. Her diaries reveal a constant stream of queer visitors calling during the day, often for tea and sympathy. Virginia loved the stimulation of cross-generational conversation, declaring, "My theory is that at 40 one either increases the pace or slows down."[135]

Literature, art, music, and love were all on the agenda for debate. On a sunny afternoon in 1926 Virginia welcomed a typical sequence of impromptu callers: "Dadie comes up for 5 minutes. Bell rings. Eddy comes. Telephone rings. Duncan is coming. We all have tea together. Make toast. Room frightfully untidy. Never mind. Eddy is very well and spruce. Duncan like an old bundle, which is coming undone in the middle. He perpetually hitches up his trousers as he talks. We all chatter hard about music . . . Eddy explains . . . Duncan attacks . . . we compare movies and operas . . . All to me highly congenial, and even a little exciting, in the spring light . . . suddenly we find its 7 and jump up."[136]

For larger events, Virginia borrowed space in Gordon Square, teaming up with Vanessa or with her sister-in-law, Karin Stephen. On one memorable occasion Virginia spent weeks planning a white-tie party with Karin, only to be struck down by influenza at the last minute. Leonard provided a blow-by-blow account of events, which

Virginia passed on in suitably ironic style to her old friend the painter Jacques Raverat. Reading Virginia's self-deprecating description, you might assume that Eddy Sackville-West, Stephen "Tommy" Tomlin, and a host of young Oxford men had all turned up by some magical accident, rather than being deliberately invited. Her invitation to Lytton gave him a very good idea of the temptations being offered that evening: "An appalling party is being given by Woolves and Stephens at No 50 Gordon Square on Wednesday next—9.30. No wine, no food; nothing (except indeed Philip Ritchie)."[137] And her efforts weren't just for Lytton's and Duncan's sake; many others enjoyed the company of the younger generation. Vanessa spent hours chatting to Tommy that night, while Karin got so overexcited that she rushed downstairs to see if she could borrow a gramophone from the housemaid. In her letter, Virginia conjures up a wonderful vision of queer contentment: crowds of young men in white tie and tailcoats waltzing around the room in each other's arms while the equivalent young women flirt happily with each other in corners.

TESTING THE BOUNDARIES

M en who danced with men were a clear target for police enforcement during the twenties; plainclothes officers inveigled their way into clubs and dance halls, seizing clothing and makeup as evidence, and recording what they saw. If you were unlucky enough to have a hostile neighbor, then raids on private homes did sometimes occur. A dancer named Bobby Britt was subjected to the full force of the law when officers stormed into his basement flat at 25 Fitzroy Square, arresting everyone present and photographing the sad results. Bobby was performing in the chorus of Fred and Adele Astaire's show *Lady, Be Good* at the Empire Theatre in Leicester Square, but a steady job didn't save him from a harsh sentence. The police had been watching his home for several days, peering in through the bedroom skylights, looking for signs of men entering the room together. Bobby appears in the photos wearing a black and gold skirt and a stylish turban. He had been ready to spring into action as Salome to perform the dance of the seven veils when officers knocked on the door.

Wary of backchat from expensive lawyers, the police were generally reluctant to tackle wealthy targets. Class privilege provided a degree of protection to those who dressed smartly, but it was by no means a free pass. Although the twirling dancers at Virginia and Karin's party were highly unlikely to be arrested, Dadie Rylands put himself at risk every time he roamed the West End streets after dark, cruising for casual sex. Raymond Mortimer was sailing equally close to the wind when his set of upper rooms at 6 Gordon Place became the setting for regular late-night gatherings. Even when these were mixed-sex, Virginia commented on "the atmosphere of buggery"; Raymond, E. M. Forster, and Eddy Sackville-West would be clustered round Lytton's chair, looking at photographs of attractive young men, or "Stephen Tennant, in a tunic, in an attitude."[138] *Vogue* articles mentioned Raymond's bizarre newspaper wallpaper, but they tended not to dwell on his pair of backlit wig stands, perched on corner cupboards painted by John Banting with naked men and portraits of Eddy and other male friends. In the adjoining room, Grant's and Bell's murals showed rich red curtains being drawn back to reveal a lush garden filled with fountains, flowers, and fruit. The stage was set for amorous interaction on the divan below.

Judging by the number of repeat invitations in Lytton Strachey's correspondence, Raymond's evenings were usually bachelor affairs, starting at either 10:40 or 11:00, and continuing into the small hours. Raymond writes with tempting references to the young men invited, saying how happy he would be if Lytton could join them. On one occasion they plan a party together, with Lytton sending a list of potential names from Ham Spray, familiar and unfamiliar: Duncan Grant, Roger Senhouse, Angus Davidson, Eddie Gathorne-Hardy, and Dadie Rylands all make the first cut, and Raymond suggests a long list of wild cards. Raymond decides against asking anyone from the criminal rent-boy fraternity—"When I have burglars to breakfast, I don't leave my Cartier links about"[139]—but he jokes that Peter

Howard, captain of the England rugby team "might be a distraction. He is most handsome in his massive chastity."[140]

Showered with appealing offers to party with young men, Lytton began to find the pace of life in London "enthralling—but also wrecking: and while I sometimes long to stay for months, I really say that I should become an absurdity if I did."[141] Dadie was one of the worst encouragers of bad behavior. On one night he and Lytton started the evening at the Café Royal, went on to Ciro's Club, then to various private apartments via taxi, consuming magnums of champagne en route. On another night they had dinner at the Ivy, then headed to the BBC to watch Dadie give a broadcast, finishing the evening in a seedy pub so Dadie could pick up a soldier. Retreating to Ham Spray provided only temporary respite for Lytton. Carrington loyally entertained whoever she was asked to, reporting to James Strachey whenever Lytton was "moving off on to another even more exquisite wealthy and aristocratic young man."[142] Lytton held the purse strings, expecting Carrington and Ralph to tolerate his new loves in the same way that he tolerated theirs. Carrington tried various male and female partners; Ralph Partridge veered between different women before settling on Frances Marshall as an additional long-term fixture.

Christmas parties at Ham Spray became big events; extra bedrooms were hired at the Bear in Hungerford, so Lytton could assemble enough guests to stage his own transgressive plays, followed by wild dancing until 3:00 a.m. Ralph—by this stage working solely as Lytton's secretary and "fixer"—drove the lucky invitees back and forth in the shiny new car Lytton had bought for him. *A Castle in Spain* was the theatrical offering for Christmas 1924; according to James Strachey it was:

> [a] *farce of extreme complexity, in which everyone's sex was doubly disguised. Lytton himself was the principal figure, Don Bartolo,*

with Dady as Cherubino, looking ravishing as a lady.. Then there
was the new young man, Roger, very handsome as the Spanish
boots at the inn. Carrington was the maidservant. The Major the
widowed countess. And so on . . . After that . . . the gramophone
was turned on & the dancing began.[143]

James retreated to the library with Sebastian Sprott, who insisted
on extracting "little snippy 'anecdotes' about psycho-analysis."[144]
Though puzzled by Lytton's sudden penchant for the young smart
set, James was happy enough to accept tickets for boxes at the op-
era with Philip Ritchie and Roger Senhouse but was irritated when
these drifted into longer dance-filled evenings: "Lytton . . . took us
afterwards to the Berkeley to supper. An awfully vulgar place—with
a Jazz band and dancing. The rest of the party between them knew
almost everyone in the room."[145] Ritchie and Senhouse were entirely
at home in the brave new world of twenties club culture centered on
fashionable new venues in Knightsbridge and Soho. Lytton's niece
Julia was proud to be a member of "a younger generation," noting
that her contemporaries "lived in a very different manner indeed
from those others—from those cultured and super-talented, schol-
arly, middle-aged members of the 'Bloomsbury Group' . . . we were
in the habit of dancing the night hours away underground in the
pitch dark and smoke-filled avant-garde nightclubs of that day."[146]

Julia must have been perplexed when her uncles and aunts started
turning up at her favorite haunts. Their "middle-aged" Bloomsbury
friends were equally quick to catch on, and in 1925 Virginia Woolf
and Duncan Grant signed up as founder members of the Gargoyle
Club. The club was created by Stephen Tennant's older brother, Da-
vid, who wanted somewhere to take his actress girlfriend Hermione
Baddeley after she had finished a show. Having inherited a chunk
of the family chemical fortune in 1920, David Tennant had money
to burn and he invested a goodly amount of it turning the top three

floors of a Soho printworks into a multistory jazz venue. Hermione's stage designer brother-in-law helped to create the extraordinary ambience. Having arrived via a metal lift on the outside of the building, members wound their way through a series of cozy snugs to a dark blue dance floor, "lit from silver stars in a sapphire ceiling"; there was a fountain in the middle of the room, and "couples moved gently round it in the bluish light."[147] A sweeping circular staircase linked the dance floor, restaurant, and roof garden, and the huge mahogany cocktail bar ran the full width of the building.

While most club owners focused on the wealthy smart set, David Tennant deliberately sought to attract an artistic crowd. His carefully drafted press release claimed that "the Gargoyle will be a chic night-club for dancing but also an 'avant-garde' place open during the day where still struggling writers, painters, poets and musicians will be offered the best food and wine at prices they can afford."[148] Clive Bell loved "Gargling at the Gargoyle Club"[149] after dark, enjoying the flattering effect of the dim lighting: "Everyone congratulates me for looking young."[150] Duncan and Virginia preferred the Gargoyle at lunchtime, attracted by the glistening dining room with its gilded coffered ceiling, and walls lined with glass tiles cut from old French mirrors. David Tennant had connections with the Parisian art world, so Matisse had advised on the decoration and supplied two vast canvases: *The Red Studio*, 1911, now at the Museum of Modern Art in New York, and *Studio, Quai St Michel*, 1916, which hung on the main staircase. Postimpressionist art was a reassuring backdrop for Bloomsbury painters, and Duncan Grant hosted a lunch party there in 1930 to celebrate Vanessa Bell's latest solo exhibition.

In 1925 it would have been hard to describe either Duncan or Virginia as "still struggling"; they fell neatly into the *Telegraph*'s assessment of the Gargoyle membership, thought to contain "more famous names in society and the arts than figure on the roll of any other purely social club."[151] Virginia was well on her way to success;

by 1929 she was earning nearly £3,000 a year—a sum she equated proudly to the salary of a cabinet minister—and her confidence was growing: "Inwardly I am more full of shape and colour than ever. I think I am bolder as a writer."[152] Duncan was turning into the Peter Pan of the British art world, well aware of the advantage of connecting with a younger audience. They flocked to see his solo exhibitions throughout the twenties, peaking in 1931 at the Cooling Galleries, where he sold £1,600 worth of paintings in three weeks. Feminist magazine *Time and Tide* declared that "he grows lighter and freer every year,"[153] and fifty-seven-year-old Ottoline Morrell found herself rather out of place at the closing drinks party: "Duncan was flitting in and out and these extraordinary beings were flushed, silly and excited with cocktails, looking most offensive . . . artificial and terrible altogether. I fled very soon, and went in to see Vanessa—next door . . . who seemed absurdly matronly and old compared to them."[154]

Duncan's exhibition was underwritten by the wealthy sponsors of the London Artists' Association: John Maynard Keynes, the textile magnate Samuel Courtauld, writer Leo Myers, and Frank Hindley-Smith, a Bolton mill owner and collector of modernist work. The revelers at Grant's after-party came from a much younger age group—equally at home in the Cooling Galleries in Mayfair, Grant's studio in Fitzrovia, or the Gargoyle Club in Soho. Transgressive sociability thrived in each of these spaces, with a fashionable young audience moving seamlessly between gallery, studio, and nightclub. At the Gargoyle you could sip your cocktails beneath a Matisse, but in Fitzroy Street you could guarantee a conversation with the ever-alluring Duncan Grant, and possibly a rendezvous thereafter.

VENTURING FURTHER AFIELD

———◆———

It took energy and commitment to keep pace with the changing currents in popular culture. International influences were at play—American cocktails and jazz, Parisian art and fashion, Russian dance. Paris was full of expat authors and artists from the United States, and the Russian Revolution had sent a generation of performers scuttling across Europe to find new audiences. It was only a hop, skip, and a jump to cross the channel, and Sergei Diaghilev's Ballets Russes had taken London by storm, creating a new cohort of dance celebrities to join the stars of musical theatre and silent cinema in a merry-go-round of social reportage. According to the *Illustrated London News*, changing attitudes to sexual equality had also played their part in shaping fashionable nightlife. The new dance clubs, and the hotels with dance floors and cabaret shows, provided a "fashionable development from the old 'Bohemian' habits of the past." Their "social tone" was "much higher" and "the setting more sumptuous and magnificent . . . The transformation of such resorts into recognised places of amusement is largely due, no doubt, to the

emancipation of woman, who has won her right to share with man his frivolities as well as his professions."[155]

Old Bloomsbury paid equal attention to the flapper and the fragrant young man. As the twenties progressed, Bloomsbury figures mingled with an ever-widening circle of bright young people, venturing beyond public nightspots like the Gargoyle into the extravagant private events hosted in Chelsea or Mayfair. Charity pageants don't seem to have held much appeal, but fancy-dress parties were a definite favorite. Academic accounts have tended to highlight a sense of aloof intellectual separation, quoting Lytton Strachey and Virginia Woolf at their disdainful best, but words were not necessarily indicative of deeds. A familiar pattern emerges from letters and diaries: cries of astonishment at the frivolity of gilded youth, accompanied by consistent acceptance of their invitations. After all, why would an aging writer or artist turn down an opportunity for press attention, creative stimulation, and a buffet of potential sexual partners?

The Nautical Party of July 1927 was a case in point. The sailor theme had a spicy Mediterranean appeal, equally enticing for both sexes. Wealthy host Gerald Reitlinger could be relied on to provide luxurious surroundings, limitless cocktails, and handsome footmen to guide you into a taxi on departure. More importantly, he knew all the right people. The son of a banker, Reitlinger had studied at Oxford in the early twenties before moving on to the Slade to train as an artist. By 1927 he was editing the art magazine *Drawing and Design* and starting to put together the astonishing collection of Asian ceramics now displayed at the Ashmolean Museum. The *Evening Standard* devoted several paragraphs to the guest list, picking out Clive Bell, Lytton Strachey, and Duncan Grant, as well as a host of younger notables from stage and screen. For *Vogue* a key attraction was the "glorious conglomeration of wet, white, sun-burnt painted skin, gold-dusted hair and sticky eye-lashes."[156] Carrington remem-

bered "a very mixed gathering of nautical beauties"[157] and felt that Bloomsbury came out on top. In her view, Strachey "predominated as an Admiral,"[158] while Grant "looked very exquisite as a commodore."[159] Masculine interests could be satisfied by "the usual contingent of male beauties, Douglas, Dadie, Angus and many others, in white ducks."[160] For the discerning female audience, Julia Strachey triumphed as a midshipman. There was a professional cocktail shaker who mixed sidecars and moonrakers all evening, leaving Carrington in a happy haze: "As a dream and a vision of beauty, it still gives me great pleasure to think of these lovely sailors and sailoresses, all so very amorous and gay."[161]

For the older members of the group, the party was a welcome distraction from work frustrations: Lytton Strachey was struggling with research for his new book, *Elizabeth and Essex*; Clive Bell had just brought out *Landmarks in Nineteenth-Century Painting* and was trying to finish *Civilization: An Essay*; Duncan Grant was embarking on new paintings after a successful spring exhibition. The younger "fringe-Bloomsburies" were equally occupied with literary or artistic pursuits and keen to broaden their horizons. Angus Davidson was working as the Woolfs' assistant at the Hogarth Press, while his brother Douglas had joined Grant as a member of the London Artists' Association. Dadie Rylands was about to start his fellowship in English at King's College, Cambridge, and Raymond Mortimer was adjusting to the new regime at *Vogue*, appearing at the party alongside his former editor Dorothy Todd, dressed rather surprisingly as a spongebag.

Lytton remembered the night as "a very amusing party—several creatures I'd not seen before—a few flirtations—drink and comfort—the sensation of being quite at home as an Admiral—perfect contentment, in fact."[162] Aesthete Stephen Tennant paraded alongside photographer Cecil Beaton, who stretched the nautical concept somewhat by sprinkling his hair with gold dust and wearing pink

trousers. Theatrical interest was provided by American actress Tallulah Bankhead, and Diaghilev star Serge Lifar, who had performed the lead role in the sailor-themed ballet *Les Matelots*. According to fellow ballet dancer Billy Chappell, "mounds of young men writhed in heaps in every corner,"[163] but despite these distractions, Lytton still found time to have "a jolly dance"[164] with aspiring novelist Nancy Mitford.

Lytton also provided support for Dadie Rylands in an early-morning altercation with their enraged host. Dadie managed to smash one of Reitlinger's precious Oriental vases and was ordered firmly out of the house. As he and Lytton were leaving, Dadie was "slightly cheered to feel, as he got into the taxi, the footman caressing his bottom."[165] After an exhausting evening spent chatting to young glitterati, Carrington was relieved to find herself reunited with her "old lovers"[166] and heading back to Gordon Square with Lytton, Dadie, and Lytton's sister-in-law Alix. Contact with the fashionable crowd had proved so stimulating to all participants that excitement continued on the staircase: creeping out of Dadie's room, still wearing his admiral's uniform, Lytton had a pleasurable encounter with Douglas Davidson; having been briefly propositioned by one young man earlier in the evening (only to find herself deserted in favor of his male lover), Carrington was pleased to find herself being passionately embraced by Alix "half way up the stairs at 4.30."[167] Invigorated by cocktails, Alix declared that "old friends were best and these new adventures really ended in dust and ashes."[168]

By day a highly professional Freudian psychoanalyst, by night Alix Strachey was exploring her attraction to female lovers. She was fascinated by the androgynous group of "tubular cropheads"[169] who dominated evenings like the Nautical Party and appeared in Cecil Beaton's generation-defining photographs: Elizabeth Ponsonby, Allanah Harper, the Jungman sisters. Drink, and occasional experimentation with drugs, helped to fuel a frenzied state of self-exploration,

inexplicable to more sexually settled young women like Frances Marshall. Having endured a difficult evening at the Gargoyle Club, during which a drunken Elizabeth Ponsonby had been sick into a plate of mushrooms, Frances couldn't understand Alix's newfound enthusiasm for fast women and fashionable nightlife: "Alix had (and has) a first-rate brain, but at this time was indulging in a post-dated passion for parties and dancing."[170] Woolf had fun teasing her—"Oh yes, Alix, I know all about you. You simply spend your whole time dancing and sink further into imbecility every moment."[171]

Virginia's dismissive jibes hit a sensitive spot. By 1930 Alix would be involved in a steady extramarital relationship with Nancy Morris, the sister of artist Cedric Morris, and feel confident enough in her butch identity to pose in a leather jacket for bisexual photographer Barbara Ker-Seymer. In 1927 her sexuality felt more vulnerable, less developed, and nightclubs were a vital source for new connections. Alix revealed her ongoing sense of frustration with Virginia Woolf: "She was not angelic in any way, in fact quite the opposite. I thought she had rather a mocking spirit. Her laugh could be a little malicious too, but unlike other members of the Bloomsbury group she was malicious not behind one's back but to one's face . . . For instance, she would say to me 'Now Alix, I wonder what you are really like. I think you must be rather like a bat because I am sure you have a night life.' "[172]

Lytton, Alix, Clive, and Duncan were in fact all flitting around like rather mature (and in the case of Clive slightly portly) bats from party to party in July 1927. Bisexual experimentation was the order of the day, with interesting creative results. Androgynous classical or commedia dell'arte figures feature in work produced by both Grant and Carrington during this period. Duncan had a brief relationship with boyish actress Valerie Taylor, who was simultaneously involved with Raymond Mortimer and Virginia's lover Vita Sackville-West. Valerie spent an afternoon with Vita dressed as Byron, having con-

cocted an elaborate fantasy in which Vita's husband, Harold, would write a play about Byron starring Valerie. Vita also slept with Clive Bell's long-standing mistress, the writer and socialite Mary Hutchinson, who skipped the Nautical Party in order to avoid a confrontation with Clive. Mary poured out her troubles to Lytton and wrote to Vita to retrieve her telltale belongings: "I left a pearl earring on the table by your bed. I remember exactly where I put it, at the corner near you. Will you be very nice and post it to me? . . . Did you sleep among the thorns and petals?"[173]

Summer 1927 was a particularly passionate period for Vita, recorded in letters to and from Virginia Woolf. What seemed ridiculous to Virginia in Alix Strachey was somehow seductive in Vita: "You only be a careful dolphin in your gambolling, or you'll find Virginia's soft crevices lined with hooks."[174] No longer involved sexually, the pair were close emotionally, their amorous friendship buoyed by professional success: *To the Lighthouse* had launched in May 1927, selling more than any of Virginia's previous books, while Vita's poem *The Land*, published in June, had earned her the Hawthornden Prize. Invited to Oxford to deliver a lecture on poetry and fiction, Virginia found herself distracted by Vita's long white legs, temptingly encased in silk stockings. This prompted a letter to her sister Vanessa, extolling the virtues of bisexuality: "You will never succumb to the charms of your sex—What an arid garden the world must be for you! What avenues of stone pavements and iron railings! Greatly though I respect the male mind, and adore Duncan Grant (but, thank god, he's a hermaphrodite, androgynous, like all great artists) I cannot see that they have a glowworm's worth of charm about them."[175]

Exhausted by a "striving working splashing social summer,"[176] Virginia was amused to find her older friends apparently teetering on the brink of self-destruction. Walking back in the early hours after yet another party in late July, Clive Bell stood under a streetlight

declaring: "My dear Virginia, life is over. There's no good denying it. We're 45. I'm bored, I'm bored, I'm unspeakably bored. I know my own reactions. I know what I'm going to say. I'm not interested in anything. Pictures bore me. I take up a book & put it down. No one's interested in what I think any more. I go about thinking about suicide."[177] Despair was an alcohol-fueled illusion, and regenerative forces were soon at hand. Twenty-four hours later, Virginia met a transformed Clive. Youthful actress Valerie Taylor had taken pity on him after a chance lunchtime meeting: "Now that he can say, or lie, I've been to bed with Valerie his self-love is assuaged. He remains Clive the undaunted lover, the Don Juan of Bloomsbury."[178] Invigorated by this encounter, Clive headed to Cassis to finish *Civilization*.

It took tonic of a similar kind to revive Lytton Strachey. In August 1927, Lytton lay in bed at Ham Spray feeling wornout and sorry for himself. Lassitude had descended after the Nautical Party, and work on his latest book—*Elizabeth and Essex*—had ground to a halt. Relations with the growing number of handsome youths described by Ray Strachey and Karin Stephen's uncle as the "young lions, or rather the young tom-cats of Bloomsbury"[179] seemed promising, but nothing had yet been pinned down: Dadie Rylands was about to disappear to Cambridge, while sculptor Stephen Tomlin had called a "lull in the proceedings"[180] in order to marry Lytton's niece Julia. Lytton's assessment of the situation was predictably despondent: "The outlook is rather gloomy. I don't know what is to happen— how am I to get well—how am I to finish Elizabeth—when shall I ever be able to frisk again."[181]

UNEXPECTED OUTCOMES

◆

Frisking seemed even more unlikely in September when news of Philip Ritchie's sudden death reached Ham Spray. Contact with youth could be reviving, but it could also bring despair. Lytton had singled out Ritchie from the host of "young Oxford men"[182] who gathered on the lawn at Garsington, attracted by his unusual quality of troubled charm. Conscripted to serve in the Far East for the last year of the war, Ritchie had developed a taste for drink and gambling, leaving Oxford without finishing his degree. A reluctant pupil of barrister Charles Sanger, Ritchie soon popped up again in London. Virginia Woolf noticed how Lytton perked up at Bloomsbury parties after "the gentle youths came in,"[183] feeling that "Philip Ritchie thinks rather too highly of himself, as notice from Lytton always makes them."[184] Although their relationship waxed and waned in intensity, Ritchie had become a recurring feature at Ham Spray, usually accompanied by his close friend Roger Senhouse. Frances Marshall was always pleased to see them there—"Philip Ritchie, clever and amusing, a devotee of chamber music and discussions on

abstract subjects, whose character had an original twist in it . . . And the extremely handsome and charming Roger Senhouse, who was as uninterested in the truth as Philip was addicted to it."[185]

Ritchie had survived the First World War only to die from tonsillitis in 1927. Turning to Roger Senhouse for emotional support, Lytton found his feelings more warmly reciprocated than on previous occasions. Tall and athletic, Senhouse liked to play sensual games with his admirers, drawing them into extreme sadomasochistic fantasies. Lytton enjoyed similar tastes, sharing a satisfied account of the crucifixion ritual they attempted together—"my own dearest creature, such a very extraordinary night!"[186] At this point Senhouse was living the life of a young man about town, trapped in the City job proscribed by his family. (It would be years before he revealed his true potential as the co-founder of publishing house Secker & Warburg, and a leading translator of Colette.) But Lytton sensed the young man's promise, admiring him for much more than his powerful physique. In autumn 1927, Lytton told Dadie Rylands, "He [Roger] gives me so much happiness that I hardly know what to do about it. I sometimes feel inclined to stand on my head, and do cartwheels all down the Downs."[187]

Trapped at Ham Spray trying to finish *Elizabeth and Essex*, Lytton wrote endless letters to Roger in London. Echoes of their relationship crept into his portrayal of the aging queen and her much younger favorite, with a tenderness much commented on by later critics. When it was published in 1928, the book was a surprise hit, reaching a new audience for Strachey in the UK and across the Atlantic: Lytton boasted to his sister Dorothy that "I have made incredibly huge sums out of E and E,"[188] selling 110,000 copies in Britain and over 150,000 copies in America.

Senhouse may have inspired Strachey, but it was Ritchie's death that provided an unexpected prompt for a grieving Virginia Woolf. Musing in 1927 on the premature passing of Lytton's lover, Woolf

said she "felt this death leaves me an elderly laggard; makes me feel I have no right to go on; as if my life were at the expense of his."[189] Determined not to forget young Philip, and feeling guilty that she had not been kinder to him in his lifetime, she hatched the idea that turned into her own most commercially successful book—*Orlando*.

Saddened by the sudden loss of life, Virginia attempted to memorialize her friends while they were alive, creating a hero who evaded death, remaining forever young. Vita Sackville-West shaped Orlando's character, but it was Philip Ritchie who sparked the initial idea: "One of these days, though, I shall sketch here, like a grand historical picture, the outlines of all my friends. I was thinking of this in bed last night . . . It might be a way of writing the memoirs of one's own times during peoples [sic] lifetimes. It might be a most amusing book. The question is how to do it. Vita should be Orlando, a young nobleman. There should be Lytton & it should be truthful; but fantastic. Roger. Duncan. Clive. Adrian. Their lives should be related. But I can think of more books than I shall ever be able to write."[190]

The Bloomsbury family thrived on sociability, connecting and reconnecting through regular contact, mourning shared loss. Virginia could be unpredictable—sharp one minute, tender the next— but she took a strong personal interest in the lives of her friends, employing successive young lovers of Lytton and Duncan at the Hogarth Press, maintaining a semi-nurturing role for many thereafter. Once Dadie Rylands and Douglas Davidson were installed as Vanessa's lodgers in 37 Gordon Square, their activities became a constant source of amusement. On one memorable occasion, Douglas and Dadie tried to impress Virginia, Lytton, and Clive by giving an elaborate grown-up dinner with food ordered in from Fortnum & Mason. Virginia couldn't understand why they were playing "the pathetic, rather attractive, yet also foolish, very youthful game of being precisely like other people";[191] she wanted the boys to feel

free to be themselves. Old Bloomsbury's appetite for honest living, for the joyous expression of emotion and opinion, however divergent, retained a potent appeal. Parties provided a bridge between the generations, a place for performative excess, allowing guests of all ages to meet on an equal footing and express their identities in whichever way they saw fit.

4

The Cult
of the
Effeminate

MINCING IN BLACK VELVET

◆

O n a cold autumn night in 1928, Virginia Woolf trudged back to Tavistock Square. Looking up through the darkness and the rain, she saw Raymond Mortimer silhouetted against the window of his flat in Gordon Place "in a white shirt doing his hair."[192] Judging by his photograph for *Vogue*'s Hall of Fame, Raymond tended to go out for the evening looking like a singer from the New Romantic era, complete with upturned collar and artfully tousled curls. Waiting at home for Virginia was a letter from an equally decorative member of Young Bloomsbury: Eddy Sackville-West.

Orlando—the book triggered in concept by Philip Ritchie's death—had been published in October, and Virginia was delighted with Eddy's response. "Immensely relieved" that he liked it, she dashed off a happy letter, ostensibly focused on *Orlando*, but actually replete with "life and love, both of course teeming in Bloomsbury . . . Clive fresh from Paris, and Duncan and Nessa back, and I lunching with Colefax to meet Noel Coward."[193]

In *Orlando*, Virginia had combined elements of Eddy with his

first cousin Vita to create a hero/heroine who lives for over four hundred years, changing from male to female as the centuries progress. Virginia's love affair with Vita had drawn her equally close to Eddy and the cousins passed on intimate details of their lives, fascinating the older writer with their transgressive approach to gender expression. While Vita preferred to stride out in breeches and laced boots, Eddy favored the feminine touch: tinted eye shadow, taffeta shirts, golden bracelets, jeweled rings. Virginia kept a beady eye on Eddy's activities, tracking his relationship with Duncan Grant, his friendship with Lytton Strachey, his visits to Charleston and Ham Spray.

Ever hungry for personal information, Virginia was a demanding correspondent: "When shall I see another wad of diary? . . . And are you writing? Of course you are but what, and in what frame of mind? And reading? And thinking? What?"[194] Eddy diligently complied, supplying the perfect blend of gossip and literary criticism. Virginia loved to hear from him when she was writing in Sussex: "I ponder every word of your letter—about the Partridges, about Bloomsbury, about fiction . . . I'm dependent on crumbs falling down to me from life above."[195] And she returned the favor if Eddy was away: "We're still talking, you'll be surprised to hear, about love and sodomy and Bunny's latest book, Vita and Eddy."[196]

Persuaded by the charm of Eddy's "absurdly serious literary views,"[197] Virginia agreed to speak to the Oxford University English Club on poetry and fiction in May 1927. When in London, their contact became so regular that Eddy got into the habit of dropping round uninvited. Comments from Eddy are inserted casually into letters to Vita—"Eddy says he admires the Land, reminds him of Chaucer"[198]—and they had passionate exchanges about music and sexuality. On one occasion Virginia was poised for a difficult conversation with Clive Bell's mistress, Mary Hutchinson, when Eddy suddenly appeared: "We were about to fly at each other's throats when

in walked Eddie [*sic*]; stayed complacently an hour or so; and only left us time for a hasty explanation."[199]

To modern eyes, Eddy's aesthetics seem typically nonbinary—experimenting with design choices and dress codes historically assigned to different genders. In the 1920s male "effiminacy" felt more threatening, provoking mixed reactions even among the usually sympathetic older Bloomsberries. Conscious of their twenty-year age difference, Virginia trod cautiously when meeting Eddy face-to-face: "I like Eddy, I like the sharpness of his spine: his odd individualities and angles. But the young are dangerous. They mind so much what one thinks of them. One has to be very careful what one says."[200] Cutting comments about Eddy's distinctive speech and dress were saved for letters to old friends. For Jacques Raverat, Virginia conjured up "a tiny lap dog called Sackville-West . . . He has a voice like a girl's and a face like a Persian cat's, all white and serious, with large violet eyes and fluffy cheeks."[201] Vita once discovered Eddy "mincing in black velvet"[202] amidst rapiers and crucifixes and was surprised on another occasion to find him turning up for a visit to her country home in Kent "heavily made-up, with a great gold bracelet on one wrist, and two enormous rings."[203] Lytton Strachey continued the feminine theme by describing Eddy's apartments at Knole as "ladylike," expressive in his view of "the bad taste of countless generations of Sackvilles."[204]

Virginia worried about the negative influence of pretty young men on her susceptible friends, resenting the triviality of homoerotic conversation exchanged: "I fought with Eddy Sackville-West over this . . . How silly, how pretty you sodomites are I said, whereat he flared up and accused me of having a red-nosed grandfather."[205] What she could forgive in Eddy she found inexcusable in Cecil Beaton, dismissing him as a young boy kept for sex with older men: "I say, judging from your style and manner (this is what I say to Cecil Beaton) you are a Mere Catamite."[206] Virginia rejected Cecil's re-

quests for photography and was furious when he included an unso-
licited drawing of her in his 1930 *Book of Beauty*.

Eddy's delicate but well-shaped form did indeed became an ob-
ject of desire for many in Bloomsbury. Photographs reveal that Eddy
had a pale, doll-like face, with large eyes gazing soulfully into the dis-
tance, and dark hair swept across a high arched forehead. His body
was small and perfectly proportioned, his muscles kept trim with
the help of a patent chest expander. Eddy took great care with his
clothing, favoring elegantly tailored suits, shirts with a sheen, and an
orchid in the buttonhole. He took equal trouble with his makeup,
focusing attention on his striking violet eyes with their long lashes,
his appealing rosebud mouth. His apparently porcelain complexion
was a carefully constructed confection: Eddy suffered from heredi-
tary hemorrhagic telangiectasia, which could cause agonizing lesions
in different parts of the body—the lungs, the liver, the lining of the
nose, and most commonly the skin. Thick foundation became a ne-
cessity when your cheeks could be covered in creeping red spider
veins or suddenly erupt in bleeding sores.

Living with a rare genetic disorder was no joke, but this didn't
stop hostile contemporaries from mocking his visits to a nursing
home; serious illness tended to be dismissed as prevarication by
those who were prejudiced against feminity in the male. Contempo-
rary Maurice Bowra recognized Eddy's courage in the face of adver-
sity, describing him as "a frail, elegant little figure" who "went out
with a stick and a muffler, and at times fell into fits of melancholy.
But he had an indomitable will that refused to admit defeat, and he
countered his blackest hours with a delicious sense of fun and a ring-
ing laugh."[207] Racked with pain from recurrent lesions and episodes
of random bleeding, Eddy was sometimes plunged into despair. Hy-
peresthesia left him abnormally sensitive to all physical sensation, a
feeling of hovering between life and death: "Pain was personal to me,
shared with no one else, an individual demon of intolerable beauty,

with heart and hands that existed only as instruments by which I was kept for ever in this fiery suspension between the heaven of life and the viewless planet."[208]

In Virginia's novel, the young Orlando has Vita's swashbuckling swagger, her physical energy, and her fine legs. Her talent for poetry also shines through, along with her predatory approach to women. But every now and then a hint of Eddy creeps in: Orlando has "eyes like drenched violets, so large that the water seemed to have brimmed in them and widened them, and a brow like the swelling of a marble dome pressed between two blank medallions which were his temple . . . Sights disturbed him, sights exalted him—the birds and the trees, and made him in love with death."[209] Like Eddy, Orlando was swept by sudden moods of melancholy, flinging himself onto the ground to brood on mortality. Eddy kept a skull beside his writing desk and was photographed holding it on his shoulder and reclining like Hamlet, gazing lovingly into the empty eye sockets. Orlando "took strange delight in thoughts of death and decay"; Virginia imagines her protagonist climbing down into the family crypt to "take a skeleton hand in his and bend the joints this way and that."[210]

Androgyny is a recurring theme in *Orlando*. When the Russian princess appears in the distance, skating determinedly across the ice, her gender is indistinguishable: "The person, whatever the name or sex, was about middle height, very slenderly fashioned"; Orlando assumes she must be a boy, as "no woman could skate with such speed and vigour." Only as she comes closer does he decide that "no boy ever had a mouth like that; no boy had those breasts; no boy had eyes which looked as if they had been fished from the bottom of the sea."[211] The "Archduchess Harriet" is equally perplexing: she wears an elaborate mantilla and riding cloak to disguise her figure and talks knowledgeably about wine, sport, and firearms. "Harriet" turns out to be "Harry" masquerading as a woman in the hope of seducing Or-

lando. Confusions of this type were familiar in Bloomsbury; Virginia and Vita both commented on the bewildering similarity of young people with cropped hair. Eddy's sister held a party at Knole in 1927 that Vita described as being full of "slim young creatures all looking as though they had come out of *Tatler*, all indistinguishable from each other, and young men to match. They lay about on the grass, like aristocratic young animals with sleek heads. I was acutely conscious of the difference of generations."[212]

PAINTED BOYS

---◆---

Vita's role in the genesis of Orlando has been widely acknowledged, but the influence of Eddy and his circle of genderqueer Oxford friends tends to be downplayed. These were the graceful young men Virginia encountered at Garsington, surprising her with their tendency to "paint and powder."[213] Woolf's terminology echoes the language of tabloid weekly journals like *John Bull*, which identified the "painted boy" as the "worst menace of modern times."[214] In a series of hysterical articles, right-wing journalist Harold Begbie denounced a West End venue for being a "modern Gomorrah" where "painted and scented boys congregate every day." Begbie wanted the Conservative home secretary William Joynson-Hicks to rouse the Metropolitan Police and make "a clean sweep of so monstrous an iniquity," removing "creatures who shame the name of England and degrade the face of man." With patriotic fervor, Begbie wonders how Britain could have beaten the Germans in the First World War, only to find in London "an outbreak of this deadly perversion . . . which will surely rot us into ruin unless we recover our sanity and fight it to the death."[215]

Begbie's views were extreme but reflective of interwar prejudice against male expressions of femininity. When the Street Offenses Committee asked a Metropolitan Police constable if men arrested for importuning had any distinguishing characteristics, he replied, "Yes. Painted lips, powder."[216] A strange double standard seemed to apply. If found wandering near Piccadilly with a powder compact in your pocket, you could be charged with importuning for immoral purposes and sentenced to three months in prison. If invited to an expensive fancy-dress ball, you could smother your face in makeup and expect your photograph to appear in the press with little adverse comment, even if you were dressed as a foreign queen or a famous female film star. The context was critical, regardless of social background. Young men who enhanced their features on a daily basis were to be suspected of vice, their behavior a signifier of sexual transgression; Bright Young Things transforming themselves for one night to fit the theme of a party were quite another matter.

With cosmetics more widely available than ever before, it was all too tempting to cross the line. Lipstick, powder, rouge, and eye shadow were being mass-produced by international beauty companies and could be bought easily over the counter at department stores. Cinema provided a heady image of female glamour, and the advertising industry had geared up to besiege young women with a seductive range of products. Eddy's circle of male undergraduates proved equally susceptible, experimenting with clothing as well as skin care. Eddy's friend John Rothenstein conjured up a vivid image of twenties student life in his memoir *Summer's Lease*. Individual sexual interests may have varied, but sartorial expression was similar: a "cult of the effeminate" blossomed in the "prevailing homosexual climate." According to Rothenstein:

> *This cult of the effeminate did not necessarily denote effeminacy in the generally accepted sense, nor even homosexuality, ubiquitous*

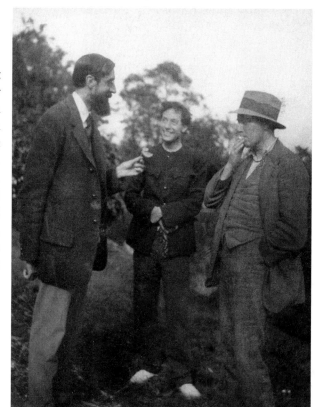

Old friends enjoying themselves in familiar surroundings: Lytton Strachey, Duncan Grant, and Clive Bell at Charleston, 1922.

Photo National Portrait Gallery, London, courtesy of Henrietta Garnett.)

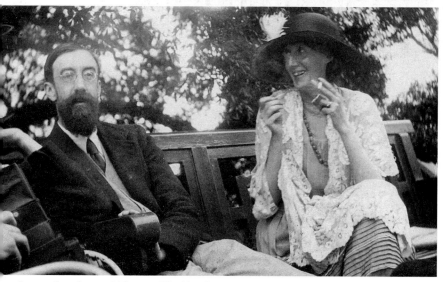

Lytton Strachey and Virginia Woolf at Garsington Manor, admiring the new crop of handsome Oxford undergraduates growing on Lady Ottoline Morrell's lawns, June 1923.

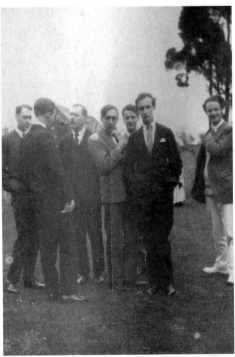

Garsington Manor, June 1923: Oxford students, among them Eddy Sackville-West (center, facing camera) and Philip Ritchie (second from left, back to camera), gather expectantly on the grass, conscious of admiring glances.
(© *National Portrait Gallery, London.*)

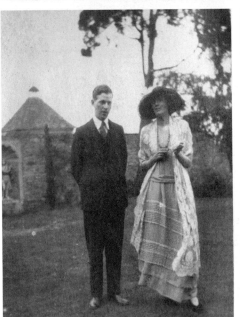

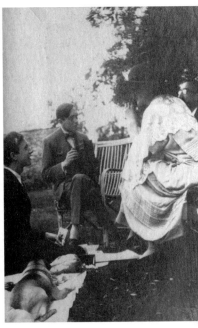

Garsington Manor, June 1923: Virginia Woolf checks out Philip Ritchie (left) and Eddy Sackville-West (right). Lytton Strachey peers over her shoulder.
(© *National Portrait Gallery, London.*)

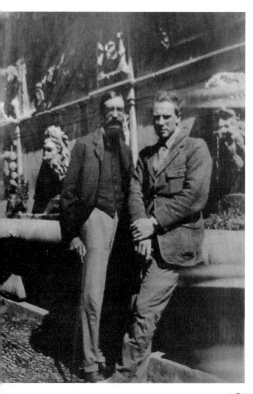

Spain, 1920: Lytton Strachey with his first young man from Oxford University, Ralph Partridge. After Oxford, Ralph worked for Virginia Woolf at the Hogarth Press before becoming Lytton's secretary. (*Courtesy of Modern Archives Centre, King's College, Cambridge.*)

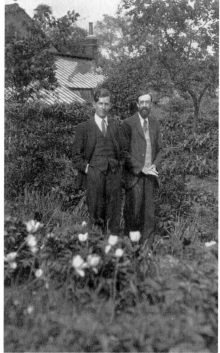

Garsington Manor, 1924: Lytton Strachey lingers in the flower garden with his second young man from Oxford University, Philip Ritchie. Ritchie trained as a barrister with Lytton's old friend Charles Sanger. (© *National Portrait Gallery, London.*)

Ham Spray, 1929: Lytton Strachey's third young man from Oxford University, Roger Senhouse, garlanded with flowers. Roger became a publisher and translator. (*Courtesy of Modern Archives Centre, King's College, Cambridge.*)

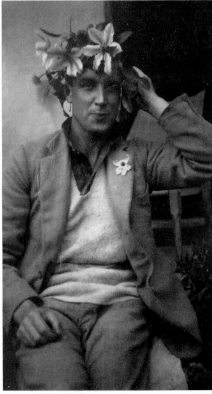

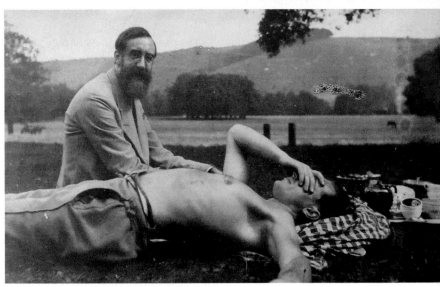

Ham Spray, 1929: Lytton Strachey sits on the lawn beside Roger Senhouse. Roger made Lytton so happy that he wanted to do cartwheels over the downs. (*Courtesy of Modern Archives Centre, King's College, Cambridge.*)

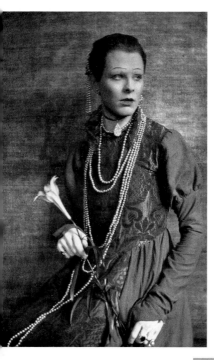

Cambridge student George "Dadie" Rylands as the Duchess of Malfi, photographed by his friend Cecil Beaton in 1924. Dadie worked for Virginia Woolf at the Hogarth Press and rented rooms from Vanessa Bell and Duncan Grant in Gordon Square. (*Cecil Beaton Archive © Condé Nast.*)

Dadie with Lytton Strachey, laying a paternal hand on the young man's head, 1928. Dadie became a fellow of King's College, Cambridge, encouraging generations of students to love the theater through his Marlowe Society productions. (*Courtesy of Modern Archives Centre, King's College, Cambridge.*)

Cambridge student Sebastian Sprott, lover of Maynard Keynes, arriving at Garsington Manor in 1923. Sprott became a professor of psychology at the University of Nottingham. (© *National Portrait Gallery, London.*)

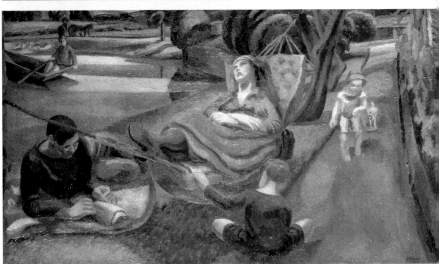

Sebastian Sprott spent the summer at Charleston in 1921, tutoring the Bell children. Duncan Grant's painting shows Vanessa Bell lying on the hammock in the center, surrounded by her children, with Sebastian reclining on the left. (© *Estate of Duncan Grant All rights reserved, DACS 2022. Tyne & Wear Archives & Museums/photo Bridgeman Images.*)

Cambridge student Angus Davidson, lover of Duncan Grant, lying on the lawn at Ham pray. Angus worked for Virginia Woolf at the Hogarth Press from 1924 to 1929. (Copyright © The Estate of Francis Partridge. Reproduced by permission of the Estate c/o Rogers, Coleridge & White Ltd, London, UK.)

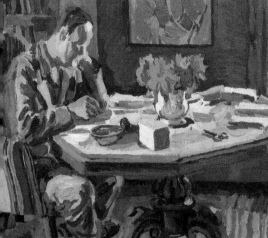

Angus models patiently for Duncan Grant at Charleston, c. 1923–28. (© Estate of Duncan Grant. All rights reserved, DACS 2022. Photo courtesy of PIANO NOBILE, Robert Travers [Works of Art] Ltd, London.)

When Angus moved into a new Bloomsbury flat at 3 Heathcote Street in 1924, Duncan Grant painted the wall above the fireplace with giant arum lilies. (© Estate of Duncan Grant. All rights reserved, DACS 2022. Photo Architectural Press Archive/RIBA Collections.)

Vogue journalist Raymond Mortimer in a typical pose, wearing one of the ultramodern ties noticed by Virginia Woolf. This one has a pattern of dominoes. (© *The Estate of Barbara Ker-Seymer. Photo © Tate.*)

Raymond's Bloomsbury flat at 6 Gordon Place. The wall decorations were done by Duncan Grant and Vanessa Bell, 1924. (© *Estate of Vanessa Bell/Estate of Duncan Grant. All rights reserved, DACS 2022. Photo Architectural Press Archive/RIBA Collections.*)

though this was . . . It was the product of several causes, not the least of which was the defiant assertion of the dandified intellectual (or "aesthete" as he was called) in the face of the formerly hectoring athlete, or "hearty."[217]

At Oxford, aestheticism was expressed in multiple ways, giving freedom to explore different identities. Decorating your room with homoerotic Aubrey Beardsley prints sent signals to your close friends, but clothing and makeup made a wider impression. John Strachey was rumored to carry a ladies' handbag and played cricket for Magdalen wearing a large French peasant's hat adorned with trailing pink ribbons. His beautiful friend Jeffrey Prendergast might have stepped straight from the pages of Raymond Mortimer's satirical novel *The Oxford Circus*: "Prendie" could be spied pulling a white woollen lamb down the street and was once found mourning the loss of his famous allure. Eddy Sackville-West took a more literary angle. He declared his love for the French decadent writers of the 1890s, modeling himself on des Esseintes, the self-indulgent hero of Joris-Karl Huysman's *À Rebours* (*Against Nature*). He began writing a Gothic novel, vowing to retreat one day to a house in the country, wearing black velvet. Reveling in sensory description, and fired by the sorrow of a broken love affair, Eddy poured his heart into emotionally overcharged passages. Virginia's friend Molly MacCarthy met Eddy at around this time and left a telling description of the budding aesthete, who had been a child prodigy at the piano, playing Chopin and Brahms by ear: "I liked Sackville-West, I see he's not as limp as you would think as he played beautifully and every now and then went upstairs and had a good write at his novel."[218]

Eddy Sackville-West, John Strachey, Philip Ritchie, and Roger Senhouse had all been part of the same close-knit Oxford circle; all four were involved with the melodramas staged by John at Mag-

dalen, and all four gradually found their way to Garsington Manor and the welcoming arms of the Bloomsbury Group. Always open to confidences, Virginia loved being drawn into the emotional complexities of young Oxford lives. She and Clive Bell were often blamed for spreading rumors, and a terse letter from Eddy in 1926 produced a partial apology: "My only shred of 'mature wisdom' is that such things are the penalty one pays for the pleasure of talking freely. I've paid it dozens of times. At this moment, doubtless, Philip Ritchie is repeating what Eddy says Virginia says and next week it will come round to me—Such is life in Bloomsbury."[219]

Whatever Virginia's faults, she provided a sympathetic adult ear in a period when same-sex love was open to hostile challenge. Sadly, many families were not so understanding. By the time she met them at Garsington, Eddy and several of his more overtly "painted and powdered" student friends were already being subjected to a bizarre form of conversion therapy at a clinic run by Dr. Marten in Germany. Marten was a medical doctor who combined experimental psycho-analytical techniques with painful protein injections. Ottoline Morrell had a positive experience at his Freiburg clinic and merrily recommended his services to Garsington visitors. Marten appears in images of her summer garden parties, recruiting potential clients. Lytton declared this "a ludicrous fraud":

The Sackville-West youth was there to be cured of homosexuality. After 4 months and an expenditure of £200 he found he could just bear the thought of going to bed with a woman. No more. Several other wretched undergraduates have been through the same "treatment." They walk about haggard on the lawn, wondering whether they could bear the thought of a woman's private parts, and gazing at their little lovers, who run round and round with a camera, snapshotting Lytton Strachey.[220]

Lytton had no time for the "miserable German doctor,"[221] but others allowed themselves to be persuaded. Eddy's Oxford contemporaries Kyrle Leng, Eddie Gathorne-Hardy, and Peter Ralli all made their way to Marten's clinic, with predictably unsuccessful results. Kyrle seems to have been first in line and wrote encouraging Eddy to join him in Freiburg: "There is a quaint atmosphere about the place satisfying to the aesthete, while for the virile exist all forms of pleasure and excitement . . . Martin [sic] will psychoanalyse you and cure you. He may be curing me, I cannot tell, my faith in doctors was shattered long ago."[222]

Conversion therapy is, at the time of writing, still legal in Britain today, with traumatic results for queer young people exposed to a range of religious or pseudoscientific "treatments." Germany only banned the practice in May 2020. From a twenty-first-century perspective it feels disturbing to see Kyrle and Eddy submit so willingly to a "cure." But they were living at a time when homosexuality was viewed by most as a disease or perversion, punishable by imprisonment if exposed. They were also putting themselves at risk by choosing clothing and cosmetics that made them stand out from the crowd. If gender nonconformity was acceptable only in the fancy-dress context, then these young men were sailing close to the wind. There was an added poignancy to the situation: Marten's treatment was expensive, so it seems likely that all four Oxford students would have been subsidized by their families, implying a degree of parental pressure to conform. Looking on the bright side, Marten's analysis may at least have given some support for other emotional or family issues they may have been experiencing. Eddy certainly enjoyed writing down his dreams and received an unusual diagnosis for his stomach problems: "Martin [sic] says my indigestion is mainly due to a maternity complex."[223]

Kyrle Leng was determined to make the best of a bad situation,

fantasizing with Eddy about the fun they might have outside the clinic, "skiing over the snow fields hand in hand with a divine Celtish boy, a Laplander, or a German," or, failing that, "sitting in the Casino, while . . . boys of all nationalities drift past or sit sucking their mochas with glances so frank, candid, fresh and lovely that one might take them for invitations."[224] Eddy seems to have been more susceptible to the negative messaging, declaring in his diary that he would try to appear changed when he got home, avoiding homosexual talk where possible. The injections of novoprotin had excruciating results: "At the end of dinner it had a sudden effect on the seminal glands & I spent 3 1/2 hours of intolerable agony. Martin [sic] said my subconscious mind was prepared for pain just here. God! What agony it was."[225] One of the many terrors was the potential impact of the treatment on his creative abilities: "I am certain that my happiness depends on having written something every day."[226] Eddy was grateful when Dr. Marten reassured him that "psycho-analysis will not spoil my artistic faculties."[227]

Thankfully, Eddy's creativity survived unscathed: he published two novels in quick succession after leaving Oxford in 1924. Having set up home with John Strachey on the Cromwell Road, the pair set about pursuing their respective careers. John wrote articles for his father's magazine, the *Spectator*, but struggled to reconcile his literary ambitions with his commitment to the Labour movement. Eddy's efforts were more focused: his work was widely reviewed, and occasionally prizewinning, but little of it remains in print today. Heavily influenced by his beloved French decadents of the 1890s, the language can feel overblown, the characters overwhelmed by the sensations they experience. His Gothic novel *The Ruin* was panned by most critics for its melodrama, but *Piano Quintet* was generally well received. The *Evening News* decided it was "produced with a finesse and finish usually associated with a mature writer," while the *Daily*

Chronicle was even more complimentary: "Yet another Heinemann first novel reached high watermark. For musical folk it will be a pure joy."[228] Virginia had enough faith in him to commission a piece on Rimbaud for the Hogarth Essays series, and Lytton invited Eddy to Ham Spray to celebrate the publication of his third novel, *Mandrake over the Water Carrier*. Roger Senhouse posed for photographs on the verandah, holding a watering can symbolically in the air. Virginia sent her commiserations, likening authorship to childbirth: "Why does one write these books after all? The drudgery, the misery, the grind, are forgotten every time; and one launches another, and it seems sheer joy and buoyancy."[229]

Virginia's letters position Eddy as an equal—a writer ally against the cohort of Bloomsbury painters, who were prone to be patronizing over matters of domestic taste: "Yes, I like the painters, but I find their attitude a little agonising. 'Poor beetle' that's what they say. At once I have eight legs all squirming. It is for this reason: their ascendancy is over all objects of daily use . . . so that when they come, their presence is one long criticism, from the heights. We, who deal in ideas, are moreover, sensitised to draw out, always more and more, other peoples [sic] feelings never inflict this chill."[230]

When Eddy fell briefly in love with Duncan Grant, the artist did his best to keep the relationship secret, conscious that Virginia might interfere. Grant's letters to Eddy are tender and affectionate, full of self-deprecation. He apologizes for his lack of education, for his failure to read Eddy's books, and for his shocking handwriting and spelling. He paints sensuous word pictures of his recent encounters with Eddy and downplays his own success: "I have a very low opinion of myself as a painter, but [have] come to the conclusion that if one is allowed to continue to paint by the world one is very lucky."[231] Even when their passion faded to friendship, Grant

recorded his pride in receiving confidences denied to Virginia. Bicycling over to Monk's House, the Woolfs' country retreat, in September 1926, Grant arrived in time to hear her reading out a letter from Eddy, which sounded much less sexually candid than the one he had just received.

PRINCE CHARMING

———◆———

Eddy Sackville-West always drew a certain amount of attention from the press, but he could never compete with a new friend who sprang onto the social scene in 1926: the artist Stephen Tennant.

Although possession of a powder puff was still a source of suspicion in court, tabloid opinions on acceptable male attire for the fashionable young man about town seemed to be changing in the second half of the 1920s. According to a 1928 piece in the *Daily Express*, Tennant's "appearance alone is enough to make you catch your breath—golden hair spreading in flowing waves across a delicate forehead; an ethereally transparent face; clothes which mould themselves about his slim figure."[232] Five years younger than Eddy, Tennant paired up with the photographer Cecil Beaton to promote a carefully constructed image of personal beauty. Beaton's career thrived as a result, and journalists identified them as effeminate examples of gilded youth. When the *Sphere* asked, "Who are the young men of today? Or rather who are the models on which they are bidden to mould their personalities?" it was Stephen and Cecil they

chose: "Both these young men are in their early twenties; are slender, with a knowledge of clothes that embraces the female wardrobe, with a most definite artistic sense which their predecessors in the rough old days might envy."[233]

Tennant and Beaton became difficult to miss. In June 1927, twenty-one-year-old Tennant had invited Eddy to join a group of "poets, novelists and artists"[234] for a weekend at Wilsford Manor in Wiltshire—the home of his mother, Lady Grey. American poet Elinor Wylie was the most established author, followed closely by the Sitwell brothers, Osbert and Sacheverell. Eddy already had two novels under his belt, while Rosamond Lehmann's first book, *Dusty Answer*, was hot off the press. Cecil Beaton had signed his first formal contract with *Vogue* that month, while painter Rex Whistler was finishing a set of murals for what was then the Tate Gallery, at Millbank. Their host produced beautiful line drawings in the style of Aubrey Beardsley. Beaton photographed the entire party lying upside down under a leopardskin, and the image duly appeared in *Vogue* as an "amusing and decorative portrait of 'Intelligent Young Persons.'"[235] Lytton Strachey and Clive Bell would have also seen the duo sprinkled with gold dust at the Nautical Party in July 1927, and press accounts snowballed through the summer as they appeared in ever more elaborate costumes at other events.

Few critics give Tennant credit for being an "artist" today; if he is considered at all, it is usually as a socialite or model—the enticing subject of photographs like the one Virginia Woolf noticed being passed round at Raymond Mortimer's party "in a tunic, in an attitude."[236] Tennant's talent for drawing had in fact been evident from an early age. His wealthy mother arranged a solo London exhibition of his line drawings when he was only fifteen, sending him straight to art school at sixteen. Instead of university, Tennant spent two years at the Slade, overlapping with Rex Whistler and the theatre designer Oliver Messel. Tuberculosis had brought his studies to an

abrupt end in 1924 but his friends and family rallied round to support his artistic career. Whistler traveled with him for treatment in Switzerland and the South of France, and his mother kept him at the drawing board, commissioning thirty-two illustrations for her book *The Vein in the Marble*. By 1927, other commissions were flooding in, and Tennant complained to a contemporary of being "swamped with business—I don't know where to turn from bills & work—oh the Hell of being grown-up."[237] Tennant's work is sensuous and atmospheric, very much of its period, with hints of the Russian artist Léon Bakst as well as of Aubrey Beardsley.

Tennant was lucky enough to grow up in a family who nurtured his design aspirations. He set up a studio at his mother's house in Smith Square in 1926, creating an unusual interior that fascinated contemporary journalists. *Vogue* reported on "Stephen Tennant's silver and crystal room, devoid of colour, in which he turns off all light and lets it be lit only by the queer upturned light of the street lamp in the square outside . . . Even the alligator tank behind seems cheerful in comparison, the parrots on the stoop a revelation of happy colour."[238] Cecil Beaton photographed him standing against the silver foil wallpaper and seated on a silver satin chair. One of his parrots peeps out from a cage behind, but sadly no image survives of his alligator, Gloria Swanson. Birds and reptiles became favored companions. Tennant took a toad and a snake to his brother's wedding in Wells Cathedral and designed the medieval-themed bridalwear. A Pathé newsreel records the bridesmaids' striking drop-sleeved velvet robes, said to be in colors inspired by stained glass: golden yellow, sapphire blue, and jade green. Tennant devoted similar energy to creating costumes for parties and pageants; like Beardsley and Wilde before him, he knew the publicity value of an eye-catching accessory.

Tennant's clothing designs explored the boundaries between masculinity and femininity. Sometimes they veered into full drag—

as when he appeared in a shimmering chiffon dress and pearls as Queen Marie of Romania for the Impersonation Party of July 1927, alongside Cecil Beaton as the actress Lillie Langtry. More often they were blended in approach, with an element of parodic humor. For smart dinners, he might wear a white Russian evening suit with a silver train, and a matching bandeau wrapped round his carefully made-up head. In 1927 he amused the *Westminster Gazette* with an appearance as Prince Charming in the "Great Lovers Through the Ages" pageant: "The Hon Stephen Tennant gambolled away in a pink wig and pink satin coat but had some difficulty with the slipper of his Cinderella."[239] His exploration of bodily adornment and his love of performance anticipate the self-expressive confidence of modern drag culture, and friends remembered his appearances fondly: "Stephen was very funny and very good-looking. He used to do a marvellous Nijinsky stunt, taking hours dressing up as Le Dieu Bleu. He would come in to take his applause, then pretend to say goodbye for ever, then in a flash return for more applause."[240]

Contact with Tennant would often be recorded: if Beaton didn't take a photograph, then his footman, William, might be on hand to make a cine-film. If you were really lucky, Tennant would dash off a sketch, perhaps with an amusing epigraph. Eddy Sackville-West was captured in one drawing in a meditative pose, his hair swept back, his deeply shadowed eyelids downcast, surrounded by musical notes from Wagner's Ring cycle. According to Tennant's extravagantly written annotations to the drawing, Eddy's profile revealed his mystical spirit, his brow bones displayed his musicality, and his nostrils had prophetic qualities.

Hyperbolic language of this type entranced Cecil Beaton— "lovely precious brilliant things were said every second"[241]—but it left some members of Young Bloomsbury bemused. Stephen Tomlin, who moved into his new cottage at Swallowcliffe in Wiltshire in June 1927, and to whom Tennant paid a visit, wrote to Julia

Strachey: "Stephen Tennant arrived here the other afternoon &
drove me nearly mad in 10 minutes with his gush . . . He's quite
pleasant—you'd adore him—he's *far* more exquisitely dressed than
any of your Dadies or Gaggers—he talks through his a— in a refined
and futile way."[242]

SHEPHERDS AND SHEPHERDESSES

<div align="center">◆</div>

Lytton Strachey had a similar reaction when the poet Siegfried Sassoon brought Tennant over for tea at Ham Spray in October 1927—part fascination, part horror: "S.T. was more than any of us could brook—a miminy piminy little chit, entirely occupied with dressing-up."[243] Irritation with Tennant's exaggerated speech—"Can you imagine anything more 'perfectly *divine*'"[244]—was coupled with amusement at his accounts of the scene staged at Wilsford that morning. Inspired by the romantic pastoral paintings of eighteenth-century French painter Nicolas Lancret, Tennant had supplied his guests with seven identical shepherd's outfits to wear in a tableau: printed floral jerkins with white ruffled collars on top, knee breeches and stockings below. Beaton and Tennant led the group like pied pipers across the lawn, posing somewhat improbably with baskets of flowers, willow wands, and dangling straw hats. Another Wilsford visitor, the writer Sacheverell Sitwell, was entranced:

The Lancret affair was unforgettable, and I shall remember it all my life. What a marvellous gift you have for making other people happy; in some ways the most wonderful quality that anyone could be possessed of. The whole time was one unending joy and now it is over I feel nearer tears than laughter.[245]

Conscious of being older than the rest of the party and exhausted by an intense week of work on his autobiographical novel *Memoirs of a Fox-Hunting Man*, Sassoon had refused to dress up or participate in the photographs. This did not stop Lytton—himself a few years older than Sassoon—from teasing his old friend mercilessly, or writing to Garsington hostess Lady Ottoline Morrell to let her know about Sassoon's supposed new passion for donning fancy dress in daylight. The story spread like wildfire round Bloomsbury, with Virginia Woolf fanning the flames. Strachey also sent a wryly exaggerated account to Roger Senhouse in London, perhaps designed to confirm that he had not fallen for the notorious Tennant allure:

The night before they had all dressed up as nuns, that morning they had all dressed up as shepherds and shepherdesses, in the evening they were going to dress up as—God knows what—but they begged and implored me to return with them and share their raptures . . . Strange creatures—with just a few feathers where brains should be. Though no doubt Siegfried is rather different.[246]

Beaton directed his unknown assistant (presumably Tennant's footman, William) from a distance so that he could be included in all the shots. Although Lytton was correct to mention shepherds and shepherdesses as both men and women were involved, the costumes were actually unisex. If anything, the male members of the party looked more decorative, as they seemed to have whitened faces and rouged cheeks. Unlike Sassoon, painter Rex Whistler and com-

poser William Walton willingly complied. Sacheverell Sitwell's wife, Georgia, joined the Jungman sisters—Baby and Zita—in the female contingent. Beaton's hair was fully powdered, while Tennant's golden curls, marcel-waved by a well-known ladies' hairdresser, remained on show. The young people skipped across the grass, collapsed in abandon beneath a tree, and lined up on a rustic bridge, their ruffles and ribbons silhouetted against the sky.

Siegfried Sassoon fell in love with Tennant that weekend, devoting much of his next four years to caring for an increasingly frail young man. As with Eddy Sackville-West, snide references to hypochondria turned out to be profoundly misplaced; Tennant was thin and pale for a reason. In the days before antibiotics, tuberculosis was a killer, and when Tennant's symptoms returned, the only option was to retreat to a sanatorium for mountain air. Tennant and Sassoon traveled to Bavaria in the spring of 1929, where Tennant received a lifesaving pneumothorax operation. Tennant's breathing difficulties were improved when the surgeons partially collapsed and then reinflated a lung, allowing the couple to return to England for several months.

Writing of an encounter with the couple at the Union Club in August 1929, Lytton said of Tennant, "The poor creature was really looking extraordinarily beautiful, though I gather he's been terribly ill. For the first time, I quite liked him."[247] Indeed, Bloomsbury attitudes seemed to grow warmer during this period; "Mr. Strachey" becomes "Lytton" in Tennant's playful letters. Lytton, Carrington, and E. M. Forster visited the Tennant home, Wilsford Manor, in November that year, and Lytton sent Roger Senhouse a vivid account of their satisfying day:

> We had lunch on the lawn, in such blazing sun that our host was given an excuse for sending for a yellow parasol for himself and a series of gigantic plaited straw hats for his guests. We were

filmed almost the entire time by a footman . . . We inspected the
aviary—very charming, with the most wonderful parrots floating
from perch to perch and eventually from shoulder to shoulder. Fi-
nally we went indoors, and in a darkened chamber were shown
various films of the past.[248]

Dora Carrington enjoyed watching the fanciful cine-films, and
was equally enchanted by the carefully curated Wilsford experience:
"On Friday I lay in the sun under a large sunshade; on a double bed
with a pale pink fur coverlet with Stephen Tennant; Green lizards
ran on the paths & Tropical Parrots & African birds flew in the avi-
ary. On the table mixed up with lunch were marvellous orchids."[249]

Tennant's vibrant colors and animal imagery mirror Carrington's
decorative artwork of the late 1920s, replete with exotic birds and
entwined flowers. Other similar tastes emerge between Tennant and
Bloomsbury: cine-cameras were the latest craze, film an enticing new
medium. Carrington participated joyfully in a series of short dra-
mas shot at Ham Spray that summer by her lover Bernard "Beakus"
Penrose, younger brother of Roland Penrose, artist and founder of
the ICA. Carrington designed commedia dell'arte–inspired cos-
tumes for the more elaborate and surreal scenes in one of the films,
Dr. Turner's Mental Home, in which Lytton appears briefly, peering
out of an upstairs window. Oliver Strachey also took part, though
most of the roles were played by younger members of the group, in-
cluding Stephen "Tommy" Tomlin, Julia Strachey, Ralph Partridge,
Frances Marshall, and David Garnett. Carrington supplied dummies
and masks and other props for the more complicated stunts. Tommy
had great fun playing the lead role in the film *The Bounder*, a char-
acter who betrays his wife by making inappropriate advances to an
innocent maiden in the garden.

When Sassoon and Tennant left for Italy in December 1929,
this new closeness with the Bloomsbury group—and Lytton in

particular—continued through a stream of postcards. In Genoa, Tennant reported his delight in finding an image of Lytton in Max Beerbohm's entrance hall.[250] After their return, Tennant hatched a plan with Carrington for a fireworks party. He imagined Carrington clutching a rocket in each hand, quivering in mock horror at the erotic implications.[251] By July 1930, Tennant's tone was even more playful, sending tempting descriptions of the new treasures to be found in his home, the beauties of his garden. Sassoon sends his love, too, adding the occasional wry note. Tennant told Lytton that he longed for his arrival at Wilsford; although the lily season would be over, Tennant himself would only just be coming into bloom.[252]

Famously prone to hyperbole, particularly about his youthful beauty, Tennant later claimed that Lytton's interest had made him uncomfortable: "He wanted to be like me. Somebody said 'He can't forgive Destiny for not making him look like you.'"[253] Two things they shared were "a great love of clothes" and "love of a certain amount of publicity but not too much."[254] Lytton never dressed as dramatically as Tennant, but his image was carefully designed to stand out from the crowd—the long hair, the lugubrious beard, the long limbs carefully encased in expensive tailoring. As he grew richer, Strachey's grooming became more precise, and he positively glows in a publicity photograph taken by Eddy Sackville-West's friend Kyrle Leng in the library at Ham Spray. The successful author sits beside his antique globe and his eighteenth-century books, handsomely dressed in a double-breasted Prince of Wales check suit. Prosperity never made him complacent, and it certainly didn't quench his skittish sense of fun. Eddy remembered opening the door at a party to find Lytton hovering on the doorstep: "he piped 'Am I late?' then, gathering himself together, he gave a flying leap into the hall and rushed up the stairs after me, shrieking with laughter & trying to pinch me: he had been to Così fan Tutte."[255]

Confined to Wilsford Manor by recurring illness, Tennant's men-

tal health wavered. He split from Sassoon in 1931, and his sexual activity became dangerously open. There were rumors of soldiers being propositioned at the nearby military camps, and male prostitutes arriving in front of visitors. Tennant's siblings feared that he could be laying himself open to prosecution and persuaded him to seek help. Tennant spent a secluded year in Kent at the Cassel Hospital for Nervous Functioning Disorders. The medical director, Dr. Thomas Ross, had previously run a consumption hospital, developing a parallel expertise in neurotic patients. His approach involved hypnotism and analysis, plus a technique known as "persuasion"; this was ostensibly designed to build patients' confidence in themselves, but there were worrying overtones of the conversion therapy that Eddy Sackville-West and others had received in the early twenties. Tennant was isolated from his friends, encouraged to eat, and given an hour and a half of persuasive treatment every day.

Weight gain and depressive episodes became intermittent features of future years. The passion for exuberant self-expression remained, but it became more inward in focus; the rooms at Wilsford were filled with layer after layer of intricate decoration, and Tennant retreated, like Miss Havisham, to his bedroom. Only traces remained of the confident teenager who told his father that he wanted to be a great beauty when he grew up, and published his first book of drawings at fifteen. Bloomsbury friendships revived briefly in the mid-1930s, resulting in a flurry of creative activity: 125 beautifully bound editions of *Leaves from a Missionary's Notebook* were produced by Secker & Warburg. Tennant's comical fantasia had lain dormant since his time in the Bavarian clinic in 1929. Lytton's lover Roger Senhouse was the publisher, and the flyleaf bore a dedication to E. M. Forster.

Like Eddy Sackville-West, Tennant had found much-needed encouragement in a familiar circle. Buffeted between the twin threats of incarceration and conversion therapy, the "painted boys" of the

twenties trod a dangerous path whenever they strayed too close to the limelight. Admired for their transient physical beauty, their artistic output was often destined to be damned by faint praise, their efforts viewed through an unreliably hostile lens. Public reaction could turn on a sixpence, transforming the hopeful Bright Young Thing into a "vile antithesis" of the sort denounced by Alexander Pope in 1735:

> Amphibious thing! that acting either part,
> The trifling head, or the corrupted heart,
> Fop at the toilet, flatt'rer at the board,
> Now trips a lady, and now struts a lord.
> Eve's tempter thus the rabbins have express'd,
> A cherub's face, a reptile all the rest;
> Beauty that shocks you, parts that none will trust,
> Wit that can creep, and pride that licks the dust.[256]

5

Cheerful Weather
for the Wedding

THE PERSIAN PRINCESS

<center>———————◆———————</center>

Painted Oxford boys were familiar territory for Lytton's niece Julia, the pleasure-loving eldest child of Oliver Strachey. She and her friend Elizabeth Ponsonby were part of the flapper cohort who sped back and forth to Oxford on the train, visiting male students during term time, enjoying *Brideshead Revisited*–style lunches in John Strachey's rooms at Magdalen, lingering until the early hours at May balls. By 1925, Julia was living at the heart of the Strachey enclave in Gordon Square, terrified of bumping into a censorious Virginia Woolf every time she popped out to buy something frivolous. Pretty young men could get away with murder, but Virginia liked to toy with attractive young women, teasing them for their extravagance, making them blush and feel uneasy when they followed the latest fashions. Poor Julia ran the gauntlet of Virginia's disapproval whenever she went to the shops:

> *My father—Oliver Strachey—was an older brother of Lytton Strachey. Lytton S had a flat in my grandmother's house at num-*

ber 51 Gordon Square, the walls decorated with murals by Car-
rington. So that I often met V, on the narrow strip of pavement
that runs along the Square gardens themselves, bodily confronting
her face to face. I would be on my way to Tottenham Court Road
to catch a bus to Derry & Toms or Barkers of Kensington to buy a
hat. Or a pair of shoes, whilst she, Virginia, was advancing along
the pavement facing me, perhaps to see Clive Bell at 50 Gordon
Square or else to see her sister Vanessa Bell who lived with Duncan
Grant at no. 37. Or she even might be going to talk to her tall,
gangling brother—the psycho analyst Adrian Stephen, who also
lived on our side of the square.[257]

In the mid-1920s, impecunious Strachey siblings trod a regular path from Bloomsbury to Lytton's then-new home in Wiltshire, keen to enjoy the luxuries of his burgeoning Ham Spray household: Ralph would pick them up from the station, and Carrington made sure that meals were cooked and rooms cleaned by a changing succession of indoor staff. Flush with the profits from *Queen Victoria* and his 1922 composite volume of literary criticism, *Books and Characters*, Lytton had paid for proper heating and plumbing to be installed, crowing over the inadequacies of Vanessa Bell and Duncan Grant's Charleston, which he felt was "a regular Shandy Hall compared with Ham Spray . . . but of course it's only intended to be a summer residence, and as such does very well."[258] Lytton did acknowledge that Charleston was "very beautiful in parts, owing to the taste and skill of Duncan's decoration," but he preferred Carrington's careful attention to detail, the delicacy of her floral tracery on fireplaces, furniture, and friezes. Compared to Ham Spray's freshly painted interiors and well-appointed library, Charleston was "rather ramshackle—a regular farm-house, not done up in any way."[259]

Lytton's brothers Oliver and James were amused by the endless parade of younger visitors, gamely joining social activities when

asked. Lytton's favorites took priority, but Carrington was free to invite young lovers and their friends, and Ralph brought his new partner, Frances Marshall, most weekends. If Carrington was the resident artist, Stephen "Tommy" Tomlin took on the role of "Sculptor in Ordinary,"[260] producing an ever-extending list of embellishments. Strachey nephews and nieces were a rarer commodity; Lytton was famously uninterested in children, so they seldom appeared at Ham Spray while he was alive: "I avoid the *petit peuple* to the best of my ability."[261] Lucky Julia was old enough to escape the ban; by the time she sought refuge at Ham Spray she was in her mid-twenties, exactly the same age as Tommy. Carrington found the two young people equally alluring, their presence inspirational for her work. On July 10, 1925, she wrote to the author Gerald Brenan:

> *Tommy is still here, as far as I am concerned, as chaste as when he appeared. We go for long walks in the evening. And have endless conversations. He has just finished his statue for the garden. It's very classical and elegant. I am painting a portrait of Julia Strachey, at the moment. She is a most amusing companion. She comes here a great deal nearly every week. But do not leap instantaneously to the wrong surmise. I have come to the conclusion that Henriettas are as rare as mandrakes.*[262]

Carrington's picture captures Julia's distinctive beauty—the wide-set eyes, the tiny rosebud mouth—and her flair for self-adornment. Her head is swathed in rich Chinese silk, the bright flowers cascading onto the golden lapels of her deep blue jacket. Admirers commented on the luster of her glossy dark hair and the clever way she fashioned clothes to fit her slim figure, managing to look elegant on very little. Julia's parents had met while her father was working in India; she had spent her early years on the subcontinent, and Carrington seemed to enjoy depicting her subject with a broad range of

Asian cultural attributes—in a way that would make audiences un-easy today. Carrington drew Julia's face draped in a veil, describing her as "the most beautiful of Persian princesses,"[263] with "Chinese eyes."[264] Julia's mother, Ruby, was neither Persian nor Chinese; her heritage was firmly Anglo-Indian. Ruby's great-grandfather, John Francis Sandys, had been born in Calcutta, the child of Lieutenant Colonel William Sandys of the 5th Bengal Native Infantry and his Indian partner. According to the *Oriental Herald and Colonial Review*, John Francis Sandys, the editor of the *Calcutta Journal*, had become embroiled in a dispute regarding press freedom in Bengal. The Brit-ish founder of the *Journal* was deported to England, but Mr. Sandys, "being of Indian birth and parentage, could not be banished from the country at the pleasure of the Governor General."[265]

Julia was separated from her mother at the age of six when her parents' marriage broke up. Idealizing Ruby, she treasured memo-ries of happy times in Allahabad, Uttar Pradesh, where her mother "went around looking like some kind of wonderful half-butterfly, half multi-coloured flower, with her swirling skirts of muslin fig-ured with patterns of immense roses and hibiscus blossoms colored brilliant pink or cinnamon."[266] The beautiful butterfly had many secrets to hide. Flitting between her husband's workplace in Alla-habad and the airy summer hill station at Mussoorie, Uttarakhand, Ruby conceived two more children by different men while still mar-ried to Julia's father. Given the Strachey name, Rupert and John were brought up in India but appeared in England later in life, caus-ing panic among the wider Strachey family amidst fears that the Strachey barony and the ancient Somerset estate of Sutton Court might somehow pass sideways to "the two spurious children."[267] A drunken Oliver poured out his troubles to the Woolfs, and Vanessa Bell passed on the news to Duncan Grant: "He told them all about his marriage to Ruby and how she had a son by another man, but as he didn't know at the time the son was born in wedlock . . . apparently

he will one day become Lord Strachey. Can this be true? It sounds to me most peculiar."[268]

Ruby's misdemeanors cast a long shadow. Little Julia was passed from relative to relative in England while her mother kicked up her heels in India—marrying twice more, producing five children in total. Her final husband was the son of a wealthy Bombay barrister, and she sent Julia cheery accounts of their extravagant lifestyle: balls, garden parties, polo, racing. Some of the boys were sent to British boarding schools, and Ruby traveled back and forth on the SS *Tuscania*, hiring flats in Belgravia when she was in London, and heading to Germany for the winter sports. If Julia felt abandoned by her flighty mother, she found little comfort with her father and stepmother, who proved equally reluctant to give her a permanent home. They took her in while she was studying at the Slade, and for a second period in the mid-1920s, but otherwise Julia was expected to fend for herself. Looking back later in life, Julia painted a poignant picture of her state of mind as a young woman: "I had only one desire—one real occupation—to find a loved one and get married. Find some family love after all."[269]

Scraping by on small allowances from her father and a wealthy step-aunt, Julia sought employment as a commercial artist. Carrington admired her work, but she never sold enough to advertising agencies to earn an independent living. Modeling was a useful backstop when bills became pressing, and Carrington hungrily absorbed the details: "Tell me about your mannequin job? Is it amusing, does it help to gratify your passion for dressing up in grand gowns? . . . May I come to your shop and buy something from you? Or have you nothing under 20 gns [guineas[in your department?"[270] What seemed "deadly" to Julia exuded glamour to Carrington, stuck in Wiltshire painting endless tiles for decorating jobs. London nightlife became an inevitable distraction, and Julia developed a stamina for dancing much envied by her aunt Alix: "Will you ask Julia how one manages

to dance for 3 ½ hrs. solidly on a Summer afternoon & not sweat? All the females managed it except me. So there's evidently some dodge. Will she tell me what it is?"[271]

By this stage Julia was "well away with falling in love with young men and young men with me."[272] When living in Gordon Square, she drove her father Oliver and stepmother, Ray, mad by lying in bed until lunchtime, staying out most of the night, and taking baths at three in the morning. According to her younger half sister Barbara, Julia "occupied the telephone for hours at a time . . . and would invite several young men to a tete-a-tete lunch at home, each unknown to the other, fail to turn up and leave Ray to cope with the result."[273] Emotionally exhausted and financially astray, Julia spent the winter of 1925–26 on the Riviera, weekly boarding with another aunt and uncle, Dorothy Strachey and her husband, the painter Simon Bussy. As soon as she got back, her stepmother decided she couldn't bear it anymore, decamping with the children to a cottage in Surrey: "It is so disagreeable to me to live in the house with her that I have decided never to try it again. I get exasperated & spend too much of my life raging against her careless & shiftless ways—& why should I do it? It does no good to her, only harm; & it poisons me."[274]

Ham Spray was a haven compared to all the discord in Gordon Square; Uncle Lytton and "Tante" Carrington provided a much more sympathetic audience. Julia moved in the same social circles as the Oxford young men they liked to entertain, fitting in easily with the Roger Senhouse–Philip Ritchie coterie. Carrington was always delighted to see her colorful niece arrive: "I love having Julia here. She is a gay sympathetic character. Her turn of humour is very fascinating."[275] They started a long and playful correspondence, in which Julia took on the role of a glamorous seductress, constantly leaving her admirers in despair: "We all sat on tip toes waiting for the wheels of your new Royce up the gravel drive. But in vain, oh vain Julia. There were rows of young men on tip toes and yet you preferred to

lie on the bracken."[276] In her letters, Carrington's tone veers between loving friendship and seduction: "But I'll learn yer when yer comes down my sweet honey . . . One draught of your sweet lips: now I am becoming both sentimental and in bad taste, so I must stop this letter."[277] Instead of allowing Julia to "lie idle in bed reading,"[278] Carrington threatened to put her to work mending socks and polishing boots.

Lytton encouraged flirtation among the young, enjoying Julia's cheering impact on both Carrington and Tommy. Her Strachey sense of humor—with its typically cutting turn of phrase—also struck a chord. Julia could lacerate as well as amuse, and Tommy wondered who she might be destroying whenever they were apart. To Barbara Strachey, "the individual nature of her vision of life appears in everything she wrote: books, letters, diaries—even her conversation . . . It was tart and unexpected, like an olive, and immensely fresh and sharp."[279]

Virginia Woolf became a regular target for satire. Irritated rather than amused by Virginia's slightly flirtatious cross-questioning, Julia gave as good as she got. Julia felt that Woolf's novels dribbled on like diarrhea, while the illustrious authoress "looked like nothing so much as a benevolent towel horse, with a few cheap (not stylish) clothes loosely thrown over it."[280] As she grew older, Julia began to experiment with writing as well as drawing. She filled notebooks with careful explorations of her motives, asking, "What is my own main pre-occupation in writing?" The answers were revealing. Sensitive to emotion, she wanted "to depict the roughness and chaos of the flood occasioned by the cross currents of peoples [sic] desires all sweeping along hugger mugger against each other as in a Mill Race." With her artistic response to surroundings, Julia hoped to convey "the physical reality of life—to make the reader see the room, feel the wind, experience the sensation of cold roughness as if it were direct experience."[281]

CONSENSUAL NON-MONOGAMY

---◆---

Ham Spray was Liberty Hall when it came to sexual relationships, so Julia had the perfect vantage point to observe human desire in all its ramifications. The core trio—Lytton, Carrington, and Ralph—remained committed to each other while sleeping with other partners under the same roof. Julia would have witnessed the mutual acceptance of different types of love: Lytton's attention was focused on young men, Carrington sought lovers of both genders, while Ralph preferred women. Modern poly families have an array of handbooks to refer to, but the Ham Spray trio were swimming freestyle in largely uncharted waters. While Lytton's and Carrington's partners came and went with easy regularity, Ralph Partridge was rather too single-minded in his approach. When Frances Marshall started appearing too often at Ham Spray, Uncle Lytton and Tante Carrington sought help from Julia to tip the cuckoo from the nest. Some slightly awkward conversations about possible London flat-sharing ensued before James and Alix Strachey came to the rescue by offering rooms in their house for Ralph and Frances to share during the week.

By this stage Julia must have been well aware of the unconventional choices being made by many members of her family. Julia remembered James Strachey asking "whether it is not unhealthy to fall in love i.e. to fix all the libido onto one person instead of separating it up & putting it on to all the different things of life."[282] Julia found her loyalties being torn in different directions; it must have been strange watching your father bring his mistress to Ham Spray while listening to your uncle's lovers discuss the painful results of too much anal sex. In many ways the lack of heterosexual pressure was a relief. Among the bevy of young male beauties on display, only Tommy showed any interest in Julia. Equally aroused by men and women, Tommy's affections were notoriously unrestrained. An intense love affair with Henrietta Bingham had run alongside relationships with Bunny Garnett, Duncan Grant, Eddy Sackville-West, and Angus Davidson. Lytton and Carrington were equally attracted to Tommy, and Virginia Woolf was amused by the passion he inspired in so many of her friends: "I had an interview with the devastation of all hearts, Stephen Tomlin, who is flying like Daphne . . . pursued by his lovers, to a refuge on the outskirts of London, where no one shall follow him, for really he says he is now half crazy: wishing to love, and to give, accepting every invitation, and then finding, what appals him, that people love him in return."[283]

Photographs of Tommy reveal a strikingly handsome profile; to Frances Marshall he was a "Roman emperor on a coin," with "fair straight hair brushed back from a fine forehead, a pale face, and grey eyes."[284] Similar in stature to Lawrence of Arabia, his stocky torso and muscular shoulders seemed perfectly shaped for a sculptor. Only the hypercritical Virginia Woolf noticed that his head was slightly too big for his short body. She compared him to a thrush or a woodpecker chirruping away with constant chatter. While his brother Garrow studied with grim concentration for the bar, Tommy had escaped the confines of an Oxford degree after two terms, released

to pursue a career in art. The carefree young sculptor seemed high on life and hungry for love. According to Gerald Brenan, "He could talk to anyone, pouring out a flood of ideas, good bad and indifferent but always stimulating. For talking was his link with others."[285] For Bunny Garnett, the charm lay in Tommy's ready smile, his endearing laugh:

> There was no one . . . whose laughter expressed a greater range of emotions. Tenderness, indulgence, confession, apology, accusation, forgiveness, criticism: all such states of mind were expressed in laughter: besides which he would laugh long and loud and merrily, or with tragic bitterness.[286]

Tommy lived a life of sensory extremes; when happy, his wild excitement was infectious, his energy mesmeric. When sad, he could be plunged into almost fathomless despair. He might be present for weeks, then withdraw in silence to his studio, refusing all contact. Tommy was eagerly expected at Ham Spray for Easter 1925; his apology letter to Lytton reveals a familiar pattern: "I found myself in such a welter of tangled affairs, and consequently in such a melancholy temper, that I could not think myself fit company for any holiday house. Also I picture to myself a large party; and for the present at banquets I seem only able to play the skull."[287] Tommy's episodes of depression became so severe in 1924–25 that he sought professional help. After an abortive session with Dr. Ernest Jones, he talked to James Strachey, who was horrified to discover the extent of Tommy's self-loathing:

> One of the things was that he felt the world was so disgusting that it actually sometimes made him vomit. It's very curious how a person like that can move about quite freely in our ordinary Bloomsbury world without anyone suspecting there's anything at all wrong with

him . . . And in fact he's got a whole mass of extremely pathological stuff quite consciously in his mind all the time.[288]

James Strachey sent Tommy to Dr. Glover, a fellow member of the British Psychoanalytical Society, and kept tabs on his progress: "I was glad to find G. almost as unnerved by him as I was [. . .] He considers T. pretty bad; with even traits of D.P. [dual personality]."[289] Tommy's Bloomsbury admirers would have been astonished at this diagnosis; the young man they saw at parties was renowned for his sociability, his sunny temper. Vanessa Bell would sit talking to him for hours and happily entertained him at Charleston. One autumn Tommy overlapped with Lytton's usual September visit; as Lytton reported to Roger Senhouse: "There has been no deficiency in conversation. We totter to bed at two o'clock in the morning, having ranged at large over the characters of our friends and the condition of the universe, and still uncertain as to the value of representation in art."[290]

Like Duncan Grant and Vanessa Bell, Tommy was intensely committed to his work. Sculpture was not a hobby but a calling—a passion that required dedicated application. He had spent a year training with Frank Dobson, familiar to Grant and Bell as a fellow member of the London Artists' Association and the London Group. At Dobson's recommendation, he also took a series of drawing classes at the Slade. For any young sculptor, branching out on your own is a nerve-racking business, and Tommy tackled the transition with gusto, hiring his own studio and seeking publicity wherever he could find it. Influenced by Constantin Brancusi and Henri Gaudier-Brzeska, Tommy produced a typical selection of abstract seated figures—as illustrated in a *Vogue* puff piece of November 1925: "one of the most promising sculptors of the younger generation," with a "great gift"[291] for portraiture. And it was as a creator of portrait busts that Tommy built his profile. There was a romantic

subtext to many of his early commissions: wealthy lovers Henrietta Bingham and Eddy Sackville-West both had their heads modeled by Tommy, while Bunny Garnett and Maynard Keynes clubbed together to pay for Duncan Grant's portrait to be cast in bronze. Head slightly tipped back, a gentle smile playing about the lips, there is a sensuous quality to the sculpture of Grant that both subject and commissioners must have thoroughly enjoyed.

Tommy's romantic attentions were notoriously fleeting, unlikely to cause any permanent disruption in Bloomsbury households. Even Bunny Garnett was impressed by the variety of Tommy's sexual encounters, the delicacy with which he handled the overlaps: "There can never have been a young man so run after and so unfailingly charming to all his pursuers."[292] Finding the sculptor missing when he turned up for a sitting one afternoon, Bunny wrote a speculative list of male and female conquests on the wall. Much amused, Tommy painted a large fig leaf over all the names, and it is this fig leaf, apparently a talisman of pride, that appears in the background of Tommy's *Vogue* photograph in 1925. This type of ribald humor delighted Lytton Strachey, who showered Tommy with ideas for provocative material. Their funniest joint creation was a figure of the young giant Pantagruel wiping his bottom with a goose's neck. Inspired by Lytton's favorite scene from Rabelais's work, the smiling giant seems happy with the sensation of soft feathers on his behind.

Lytton and Carrington found Tommy's company uplifting, his presence at Ham Spray a welcome distraction from other, more difficult emotional entanglements. Tommy and Carrington, having both been cast aside by Henrietta Bingham, found comfort in each other when rejected—and Lytton, too, turned to the sculptor whenever his relations with Philip Ritchie and Roger Senhouse faltered. In the summers of 1925 and 1926, Tommy virtually took up residence, leading Gerald Brenan to wonder whether he was being groomed to take Ralph Partridge's place. By this stage Lytton was wealthy

enough to offer a flow of tempting commissions to Tommy, and the subjects chosen were suitably sensuous: a weather vane showing a pair of mermaids embracing, and a half-naked nymph with a cascading horn of plenty. Nature-loving Carrington was particularly delighted with this figure of Balanis—the nymph of the ilex, one of the hamadryads who symbolized the spirits of trees. A jealous Gerald Brenan was torn between admiration for Tommy's obvious talent and a desire to expose his darker side:

> He could not bear to be alone, but clung to other people, asserting himself vigorously in their company and yet all the time dependent, lonely, demanding friendship and affection. One felt something chaotic and unhappy under his self-confident air and one also felt that his nature held depths and potentialities that were not shared by the other young men one met in Bloomsbury circles.[293]

FINDING LOVE AT HAM SPRAY

◆

Even in this setting of polyamory, Tommy and Julia began to fall for one another. Over the summer months of 1926, the volatile sculptor and the budding writer drew closer together. Carrington took on the role of go-between, passing on romantic messages:

> Tommy insisted on reading me Marvell's poems all last Monday. "Laments on Julia" "To my fair Julia" etc etc so I gathered from the expression in his voice, and the sadness of his eyes, that you have indented the young heart with your cold imprint. However it's a great consolation for me to have another lovesick bird to sing duets with on the loveliness of my Julia.[294]

Ham Spray was their regular meeting ground, with Lytton as benign older host. Julia and Tommy joined the favored group of attractive young people who appear in Lytton's photograph albums, lolling under the trees and basking in the approval of the "tall red-bearded figure with the exquisite hands, delicate yet looking so young for

his age."[295] Lytton took some of his little troupe to Garsington that summer; Ottoline snapped him sitting in a row of deck chairs with Carrington, Tommy, and psychologist Sebastian Sprott. These images show a cheerful Tommy gazing directly at the camera, wearing a jaunty bow tie. Carrington's reflective portrait, painted at a similar time, gives a more soulful impression: eyes downcast, gazing thoughtfully out of view. Successive later accounts of their relationship have depicted Tommy as a seductive lothario, Julia as the victim of his limitless appetites—a passive "muse" lured into dangerous emotional territory. This gendered view denies Julia's agency as a beautiful and determined woman, perfectly capable of making her own sexual choices, and with a clear sense of her emerging vocation as a writer. It also assumes an expectation of monogamy. Judging by their surviving correspondence, both were equally aware of the erotic power they could hold over others, stepping toward each other with open eyes. If anything, it was Tommy who sensed the ultimate vulnerability of his position, telling Julia, "I am afraid of you; afraid of your mockery, or your contempt, or worst of all, of frightening you away."[296]

Borrowing Lytton's Ham Spray writing paper, and Carrington's scratchy pen, Tommy wrote passionately revealing letters to Julia, confessing, "I seem to be in love with you, damn you." Julia's inscrutability made him uncertain of her response: "I really want to say what I think of you. But I will refrain, first because it would be of no interest to you, then because I could not express myself . . . But I think even if I could (which God knows is improbable) I would not disturb that icy & unspeakably beautiful equilibrium of yours by a little."[297] When Julia was in London, Tommy imagined her suddenly enlivened—gadding about with friends, drinking cocktails for breakfast. Ham Spray was haunted by her languid rural persona, her ghost lingering under the beech tree or lying on the lawn. Back in his studio, Tommy opened up to Julia about his depression, his

occasional inability to work. He was honest about the extremes he could be tipped into, admitting that "I have been horribly gloomy since I last saw you, & when I'm gloomy I do excessively foolish things."[298] At Tommy's suggestion, Julia went to see his psychoanalyst, Dr. Glover, presumably in order to give her a better understanding of his condition.

Julia seems to have been undeterred, either by Tommy's changeable moods or his ongoing desire for sex with male partners. Tommy took great pains to differentiate between the enduring love he felt for Julia and his sudden physical attraction to "amorous strangers." In Tommy's view, "those feelings are perfectly momentary—arise in 10 minutes and subside in two hours; this feeling I have about you has gone on for hours, days, months & saturates everything I do or think about."[299] The connections were not always with strangers— Tommy might go to the ballet with Duncan Grant, or have dinner with Bunny Garnett, with predictable results. His relations with Angus Davidson—a friend/lover since school days—ebbed and flowed. Angus acquired a portrait bust, and a plaster copy of the Ham Spray nymph; displayed like talismans in his Bloomsbury home alongside wall decorations by Duncan Grant, they duly appeared in illustrations for *Vogue* and the *Architectural Review*. Julia enjoyed juggling her own set of married male admirers, and must have had few illusions about Tommy's constancy: in one letter he begs her to save him from temptation; in others he apologizes abjectly for making "a brute of myself,"[300] expressing contempt and self-loathing for being "a skunk."[301]

Lytton and Carrington were equally uninterested in monogamy, but they liked the idea of two loved ones coming together, staying closer to the fold. Julia's stepmother had more conventional aspirations: "A ray of hope has at last appeared in the Julia situation. She is thinking of marrying at Christmas: the young man is exceedingly nice and I think it would be a mercy."[302] It's difficult to

know whether marriage was already under discussion when Julia and Tommy spent Christmas 1926 at Ham Spray; certainly no steps had been formally taken when they headed to Paris for three months in January 1927, or to stay with Vanessa and Duncan at Cassis for Easter. The situation escalated in May–June when Tommy's conservative parents found out what had been going on with Julia. Reluctant to lose his parental allowance, or the pretty cottage at Swallowcliffe in Wiltshire that had been rented for him, Tommy wrote to Julia suggesting that they tell his father they were going to get married. Julia's stepmother, Ray, oiled the wheels by agreeing to match the income already settled on Julia by a relation, meaning the young couple could start married life on a combined total of £600 per annum from both sides of the family.

Carrington was predictably delighted—asking Julia if she could be best aunt at the wedding, imagining herself wading through heaps of her despondent lovers, and praising Tommy's charms: "I fear you'll incur a great many enemies (ie Lytton) snatching the lovely Boy into your Swallow's nest."[303] Lytton was in fact rather sanguine, correctly assuming that the ceremony would only cause "a lull in the proceedings"[304] rather than a permanent break in his relations with Tommy. According to Virginia Woolf, Angus Davidson was the most deeply affected.

The wedding was held on July 22, 1927, in the Bloomsbury parish church, and Woolf reported to Vanessa Bell that "Julia was highly self-possessed," while "Angus Davidson glowered behind us. I dare say he takes it to heart."[305] The Woolfs hosted a wedding dinner that night in Tavistock Square, and Virginia sent an appropriately dismissive account to Eddy Sackville-West the next day: "We had Tommie and Julia to celebrate their wedding last night: it was in St Pancras at 2—the most dismal ceremony."[306] Had he been present, Eddy would have been even more upset than Angus, so Virginia was being kind to downplay the conviviality. The Tomlins went on a

round of summer visits while decorators worked at their new marital home at Swallowcliffe. Lytton's wedding present—a nuptial bed—was delivered amidst the chaos, and Tommy wrote apologizing for not being able to use it yet: "But we are both very grateful, dear Lytton, & will think of you often on the tenderest of occasions."[307]

Ham Spray interactions went on much as before, with flirtatious letters winging their way between Julia and Carrington, Tommy and Lytton. Lytton sent poems and endearments—"a kiss to the bridge of your nose"[308]—along with commissions and offers of loans. Carrington loved staying at Swallowcliffe, but Lytton preferred Tommy to come to him, suggesting evenings at Ham Spray, dinners in London, or short excursions à deux: "I would meet you in London or anywhere else and would take you by train or motor or foot to any place you might fancy."[309] Conscious of the crucial role her uncle played in keeping the Tomlin household financially afloat, Julia was always willing to exchange Tommy for Carrington. Swallowcliffe gained some murals as a result, while Ham Spray acquired a new sculptural relief, attached somewhat precariously to the gable end. Lytton loved to while away a summer afternoon distracting the sculptor from his work: "I think I shall sit arguing with Tommy about the nature of portraiture and artificiality—or something of that sort—he positively sometimes agrees with what one says, I find, which is stimulating."[310]

It was at Swallowcliffe that Julia found the time and space to focus on her writing. A diary from spring 1929 is filled with lyrical descriptions of village life:

Walked up the hill where the foxgloves grow in summer. The village road was a network of gleaming rivers, the little houses so wet in the fading light, and nobody about . . . The only sound to be heard was the high "Clink! Clink!" of the blacksmith's anvil. I saw a hot spurt of orange flame flare up inside the forge.[311]

Keen to keep on track, Julia resolves to start each entry with a tally of how many pages of work she's produced that day. February 7 has the highest score, with five and a half pages written before breakfast. Inspired alternatively by Chekhov and Trollope, Julia seems to be practicing different writing styles and different types of output, plays and short stories being the most popular. In her diary, pastoral scenes are interspersed with minutely observed accounts of interiors, or the conversations and clothes of visiting London friends: in one section, Julia is admiring the hazel copse across the valley, looking "diaphanous in the smoky air," while foxes chase each other over the fields, "their long tails streaming behind them."[312] In another section, Prue Coates-Trotter springs from the car, "a dazzling vision in a leopardskin coat trimmed with a forest of fluff, black satin shoes & a tiny pinshead hat crammed down over her snow white nose."[313] Social life provides a recurrent distraction. Wealthy neighbors give glimpses into a more luxurious world, hard not to envy when water is dripping through the studio roof, and Tommy has covered the dining room table with modeling clay for his latest sculpture.

Contrary to Julia's later bleak reflections on life at Swallowcliffe, there were long periods of peaceful creativity. When Tommy was well, all ran smoothly. Her diary reveals a daily pattern of creative practice, with Julia writing and Tommy busy in the studio. In January and February of 1929, diary entries reveal Tommy finishing a head of his sister Helen, cutting stone steps for his neighbors, and modeling a new figure of Anton Dolin dancing. Julia and Tommy go for peaceful walks together, entertain their friends, and discuss the latest press stories. They fantasize idly about what they'd do if someone suddenly gave them £100; Julia decides she would buy furniture or an Aubusson carpet, while Tommy wants a painting by Pissarro or Sisley. Sometimes they would pop up to London together, but more often Tommy would travel on his own, gaining tactfully separate space for male companionship. As Bunny Garnett explained

to Mina Kirstein, Tommy "lives in rustic bliss, occasionally visiting town for a debauch," adding, "I was very cross with him at the last of these & abused him violently, so I suppose my love for him is as warm as ever."[314]

When left on his own in London, Tommy's more destructive behavior could escalate quickly out of control. Alix Strachey remembered a party where "Tommy was deadly drunk ... His eyes glared like a madman's & he threw himself on man & woman alike. He ended up, I gather, by more or less raping Angus in public." Alix was using exaggerated language to make a point, but Tommy certainly caused an annoyance. Polyamory and bisexuality were standard in Bloomsbury (and familiar territory for Alix herself), but it was the exhibitionism and self-reproach she found hard to swallow: "Really I cannot understand his sexual attraction ... There is so much scorn for the other & contempt for himself, & public showing off & sadism & crudeness & squalor that the stomach rises at it."[315]

Julia was equally frustrated by Tommy's anguished sense of remorse, which she found deeply wearing. But, when safely back in Wiltshire, serenity would usually return. In June 1929, Roger Senhouse was staying with Eddy Sackville-West at Knole, and Lytton wrote him a long letter recording business as usual at Ham Spray: "Tommy came from Swallowcliffe in the afternoon, and seems in a very benign humour ... Julia appeared just now, dressed in a pale salmon pink dress with a hyacinth blue toque (is that how you spell it?)—she looks distinctly fascinating, with a fringe, and Carrington is painting her picture."[316] But unbeknownst to Lytton and Carrington, Julia had already met the man who was to send the marriage into a tailspin: Gilbert Debenham, son of the millionaire founder of Debenhams stores.

BREAKING OUT IN
NEW DIRECTIONS

◆

In March 1929, Julia was "ill in bed at Swallowcliffe, lying locked in the strong struggling embrace of my fever . . . the wind in a rage never ceased from flinging itself indignantly down the chimney."[317] Her doctor sent her to London to convalesce, and her friend Audrey Debenham offered a room in her parents' lavish home in Holland Park. Known locally as the "Peacock House," Debenham House was designed by the Arts and Crafts architect Halsey Ricardo. The exterior of the building was covered in blue and green polychrome tiles, the interior with gilded mosaics. The vast domed entrance hall was breathtaking, and Julia was equally impressed when her friend's brother popped his head round the door: "Tommy, Audrey and I waited in Audrey's upstairs sitting-room until her twin brother Gilbert made his appearance. He jabbered away as he ate his dinner— intelligent, witty, shy, excitable."[318]

Lady Debenham took a shine to Tommy and commissioned a bust of Gilbert for £60. Gilbert duly went to Swallowcliffe to sit for his portrait in July 1929, giving a reason for further contact between

him and Julia, who by this stage was starting to grow tired of Tommy's guilt-ridden escapades and the endless scrimping and saving to make ends meet in a damp cottage. Gilbert was five years younger than Julia and training to be a psychiatrist, so it's difficult to know whether she thought he might become a permanent replacement for Tommy or merely a passing distraction. Sir Ernest Debenham had recently sold the department store, acquiring a large estate in Dorset as well as the house in Holland Park, so there were obvious financial temptations. Julia began seeing Gilbert so often that Tommy started to feel their marriage was under threat, triggering a series of depressive episodes. Escalating in frequency, these gradually rendered their life at Swallowcliffe unbearable. When Tommy was ill, everything was turned on its head: he would weep and groan in despair or shout out randomly, cursing himself and the universe. Avoiding eye contact with his wife, he would stare out the window or wander aimlessly round the garden. Although he carried on going to the studio, Julia never knew whether he had been working or "sitting motionless, simply staring desperately ahead. Perhaps weeping."[319] In his worst moments Tommy would threaten suicide.

Few of their friends or relations realized what was going on, as Tommy had grown adept at assuming "an inspired charade of normality."[320] At the start of summer 1929, life proceeded pretty much as usual. Julia and Tommy both appeared in the home movies shot by Beakus Penrose at Ham Spray in August, and Tommy stayed on afterwards to start an exciting new commission: a portrait bust of Lytton himself. Carrington hoped it would give a boost to Tommy's profile, telling Julia, "I have great hope of starting Tommy on a grand career by means of the notoriety of your uncle's fame."[321] Lytton entered into the plan with gusto, placing the finished head in his ground-floor sitting room at 51 Gordon Square, and hosting a drinks party to launch it to a wider audience. He warned Tommy that he was going to ask "most of the influential inhabitants of Bloomsbury

to come and look at it," and Bunny Garnett reported positively on the results: "I went round to Lytton's room & found him laying out sherry glasses & stuffed olives; I had chanced on a private view of his bust which I think is the most distinguished & accomplished head you have ever done . . . The spectacles are I think a great success & very important."[322]

When the bust was first delivered to Gordon Square at the end of November, Lytton examined it carefully from every angle: "I think it is most impressive—almost menacingly so—and altogether, so far as I can judge, very successful." Lytton wasn't entirely sure about the beard, but he liked the spectacles and the way the coat was shaped around the neck. "The general impression is so superb, that I am beginning to be afraid that I shall find it rather difficult to live up to."[323] Lytton offered to write a word picture of Tommy in return: "Some day I shall do your portrait—an even more ticklish business, chiefly because, for some reason or another, the unseen is even more personal than the seen. But anyhow, it will be in a very select gallery, reserved for those whom I adore."[324] Clearly expressive of the mutual affection between artist and sitter, the bust gained an afterlife mutually supportive to both parties. Lytton lent the original for display in an exhibition organized by Roger Fry at the Leicester Galleries in March 1930, allowing Tommy to take three casts for sale. One of these casts, bought by the collector Brinsley Ford, was presented to the Tate Gallery after Lytton's death in 1932. Tommy suddenly found his work represented in a major national museum, and Lytton's image was preserved for posterity.

Just as Tommy's career seemed to be turning the corner, his domestic life unraveled. In the spring of 1930, Julia decamped to the South of France to stay with her aunt Dorothy Bussy. For the outside world, the story was that she had gone to Roquebrune to work on her novel. According to the note she pinned to the bundle of apologetic letters written to Tommy, the actual reasons were more dramatic:

Julia had left Swallowcliffe on account of her relationship with Gilbert Debenham.

Tommy and Julia's married life had become so miserable—filled with retaliatory behavior—that a change had to be negotiated. A furious Tommy had caused chaos with Duncan Grant and Eddy Sackville-West by seducing their joint love object, the American journalist Jimmy Sheean. A penitent Julia promised to reduce her contact with Gilbert to a more bearable level, suggesting that they move from Wiltshire to London. In May 1930, Julia wrote to Tommy claiming to be "truly longing to start a joint life with you again" and promising "that I do really love you. That I will never leave you unless you want me to, and that I believe we can help each other to be happy now, even though we have been through a miserable period, we shall be so very snug together again."[325]

For a young couple trying to make their marriage work, their next choice of home was rather surprising. Gilbert's artist sister Alison Debenham went to the South of France to study with Simon Bussy, so the Tomlins moved into her studio at 26 Yeoman's Row, Knightsbridge. Although convenient financially, it was disastrous maritally, as Julia started seeing Gilbert even more than before. By April 1931 Tommy was drinking heavily, and Julia headed off to Roquebrune for the second time feeling "stunned mentally and emotionally."[326] After Roquebrune she traveled to Italy with friends, reassuring Tommy that she had written to Gilbert from Elba "telling him that things had become too difficult and uncomfortable between us & that there would have to be a break & said a real, long break until such time as our feelings should have undergone some radical change; & we could meet in quite a different way altogether as ordinary friends."[327] Tommy had found a new two-bedroom flat for them to rent in a garden square in Notting Hill, and Julia was "looking forward to coming into the new rooms & starting our winter's working together very much."[328]

While Julia was away, Tommy hooked up with a young man known only by an initial—"H"—who was to be his on-off lover for the rest of his life. After meeting by chance in a cinema, Tommy asked H to model for him and then took him on as a studio assistant. Julia seems to have been aware from an early stage that H would become part of the package in the new apartment in Arundel Gardens, W11. Her letters include references to H making the flat "comfortable and snug"[329] for Tommy while she is away, wondering how he has taken to the new role of valet-chef. H sent a series of cheery notes to Tommy when he was staying at Ham Spray. Addressed ironically from "The Dogs' Home, W11," they are playful in tone—asking questions about Lytton and the Partridges, giving hints about messages H has been asked to pass on, sharing news about his working-class family in Wolverhampton.

Carrington seemed completely comfortable with the new domestic dynamic, giving H some impromptu cooking lessons when she was in London. She told Sebastian Sprott that H was "a charming sweetie, very much your style—I couldn't help wishing I was Tommy!"[330] According to Bloomsbury precepts, H could be acceptably absorbed within the marriage, as he posed no threat to the core relationship; Lytton certainly saw him in a subservient role, since he expected H to sleep in a servant's bedroom when Tommy brought him to Ham Spray. It was Gilbert who was seen as posing the real challenge, because he represented a total shift in partnership. When Julia returned to England in autumn 1931, Tommy was much happier with the situation, but Julia found it hard to adapt to the new regime.

The Tomlins' marriage did not survive the dissolution of the original Ham Spray household. Tommy was robbed by their untimely deaths of his two key mentors, Lytton and Carrington, and of his beloved brother Garrow, who was killed in an air crash, and his appetite for drink and drugs snowballed in the early 1930s. Friends were

shocked to see him looking pale and bloated, haunting the pubs of Fitzrovia and abandoning sculpture in favor of smaller-scale ceramics. Ironically, it was his last major sculptural piece—a portrait head of Virginia Woolf, modeled in July and August 1931—that earned him a posthumous reputation. Woolf wriggled like an eel trying to avoid the sittings, telling Lytton's sister, "The man I hate most in the world, your nephew Tomlin, has me by the hair; I waste afternoon after afternoon perched in his rat-ridden and draught-riddled studio: can't escape. If I do, the bonds of friendship are (he says, and I wish it were true) torn asunder . . . Day after day thrown into the pit, and all for a woman's face."[331]

Virginia's furious discontent was etched into the clay, creating an image of haunting potency. Woolf loathed the resulting bust, but it remains her most significant memorial, with versions at Charleston, Monk's House, and Sissinghurst. Thanks to the Virginia Woolf Society, a cast was also placed on a plinth near her former home in Tavistock Square.

By 1932, Julia also had reason to be grateful to the Woolfs: the Hogarth Press had agreed to publish her first novel, *Cheerful Weather for the Wedding*. Completed while she was on the run from Tommy and Gilbert in Roquebrune, the subject matter is appropriately bleak. Part comedy, part tragedy, the book gives a searing account of blighted love. On a frozen windswept day, a drunken bride marries a man she barely knows. In her desperation she spills ink over her wedding dress, the stain symbolizing the bitter secret she is hiding from her family: the previous year, pregnant by a former lover, she had fled abroad to give birth to twins, abandoning the babies to an uncertain future. The faithless lover appears at the wedding, compounding his betrayal by making wry observations and failing to come to the rescue. All of this might seem melodramatic had they not been experiences with which Julia was profoundly familiar: as

a tiny child she had accompanied her own mother to Rome for a secret birth. Ruby was pregnant by another man and had intended to hand the baby over for adoption. Dissuaded at the last minute by a chance encounter, she kept the baby but ended her marriage. The lover refused to stand by her, and Ruby was left exposed, dependent on the mercy of the Strachey family.

Carrington encouraged Julia to show the manuscript to Virginia Woolf in January 1932, but she was initially evasive, ignoring Virginia's letters: "I wrote to Julia immediately asking her to come, but have had no answer. Perhaps she's away, or perhaps, being a Strachey, and as astute as an eel, she's got wind of my intentions and won't come near me."[332] It may have been the sensitive nature of the material that made Julia reluctant to share, or she may have been wary of submitting her first completed work to someone she had so ruthlessly satirized. Woolf finally got hold of the text in March, pronouncing it a triumph: "It is extraordinarily complete and sharp and individual—I had no notion it would be so good. But I feel she may tear it up at any moment—She's so queer, so secret, and suppressed."[333] The book was published by the Hogarth Press in September 1932, and Julia became a posthumous credit to her uncle, with most of the reviews identifying her as Lytton Strachey's niece. Literary journals like the New Adelphi found it "brief, ironic, witty, but not slight,"[334] while the Evening News called it "impudently hard, brilliant, but with occasional plunges into sentimentality."[335] Dorothy Bussy, too, was delighted, writing to Julia that December:

> It is astonishing how much one can laugh when one is reading a book which is really excruciatingly painful. Do, go on—write another. How infinitely I prefer your style to any of our great lady novelists—and I'm not sure I don't include the great Mrs. W among them (Hush!)[336]

The book sold well on both sides of the Atlantic, and Julia kept a cuttings book to record her triumph. The *Bristol Evening Post* was keen to remind everyone that the Stracheys originally came from Somerset rather than Bloomsbury, publishing Julia's photograph under a big banner headline: "Literary success by member of Somerset family."[337] Thanks to Duncan Grant, a stylized version of Julia's face also appeared on the cover—her wide-spaced eyes staring disconsolately down, her small mouth pursed, the perfect image of a discontented bride. Grant was a last-minute substitute for Carrington, who had been working on a more intricate design, a torn-up draft of which survives amidst Julia's papers, a poignant reminder of the crucial role that Carrington had played in encouraging Julia's writing. Without Lytton's and Carrington's constant support, it is difficult to see how Julia would have had the persistence to produce a finished work. Conscious as she was of her own tendency to procrastinate, Carrington's letters were filled with gentle prompts to write, and offers of quiet refuge at Ham Spray: "My life has been frittered away without producing anything worth looking at. You must at least learn by my sad example & finish your novel. Lytton continually asks whether you are writing. He was such an admirer of your letter. I'll give you a spare room when you come to stay with us and we will be a hive of Bees, Buzzing from morning til night."[338] If only Carrington had survived long enough to see what a good example she and Lytton had set to their much-loved niece, and the way in which Julia took her advice to heart.

For a few passionate years in the twenties, Julia and Tommy's romance played a stirring role in many Bloomsbury lives; although their marriage may not have turned out as expected, their initial love affair was genuine and reciprocal, their efforts to pursue a consensually nonmonogamous union begun in apparent good faith. For Lytton and Carrington, they provided comfort and stimulation—a focus for loving attention, their youthful talents worthy of careful

nurture. Vanessa and Virginia were caught up in the drama, speculating on the potential outcomes; Duncan Grant was less engaged, but he always had a soft spot for Tommy, however badly he behaved. Frances Marshall was less forgiving when she produced her later memoir of Julia, pitching Tommy firmly as the troubled partner. Despite all the emotional fallout, each received the encouragement they needed to launch their careers, enriching others in Bloomsbury with their life experience, receiving care and guidance in return.

6

◆

Conversation and the Exchange of Ideas

THE CRANIUM CLUB

Fifteen identical typed letters winged their way across London in January 1925. Each contained a flattering invitation: "At the first meeting of the Cranium Club your name was proposed as a member carried by acclamation. I have, therefore, the honour of requesting that you join the club."[339] Stephen Tomlin headed the list of eight existing founder members, but Carrington correctly identified Bunny Garnett as the ringleader: "Bunny has formed a 'Cranium Club,' very exclusive, only the purest intellects . . . discussions on only abstract and literary subjects, no gossip, and no women allowed. Sherry to be drunk—with great ritual—from a SKULL . . ."[340] The formal letter makes no reference to sherry or skulls, but it does suggest that a club cellar will be formed and that dinners will take place once a month in a London restaurant. Women were not expected, and although the stated object was "conversation and the exchange of ideas,"[341] solemnity and sobriety were low on the agenda. With few pretensions or obligations, the Cranium Club became a source of joy for years to come, raising spirits, reinforcing connections.

Bunny's motives for launching the club were generous: he hoped to cheer up Tommy during a period of bleak depression. Intellectual stimulation was urgently required, along with the promise of a regular event to look forward to. The male friends of all ages "who mattered most"[342] were invited to join an informal dining club, with fees designed to suit even the most threadbare artist's budget. The younger generation did not always have the space or the funds to entertain their seniors on a regular basis; thanks to Garnett, Old and Young Bloomsbury could come together in cost-effective surroundings. The path was set for regular cross-fertilization of ideas.

Membership was fairly evenly split between the age groups, with Lytton Strachey, E. M. Forster, Eddy Sackville-West, and Sebastian Sprott all included in the first batch of invitations. Sebastian would wend his way by train from Nottingham, Eddy might travel into London from Kent, while Tommy was usually delighted to break off from whatever work was annoying him in the studio. Julia Strachey must have heaved a sigh of relief whenever the monthly summons appeared through the post, offering her husband the perfect antidote to gloom. Though they would later both become members, Lytton and Forster initially delayed their replies, nervous about dipping their toes in untested waters. Forster sought reassurance from Lytton as an old friend:

> I am convalescent myself and feel it is my duty to bring more joie de vivre into my life, but the Cranium Club is at present too much. Will you join? As you know I am in sympathy with some of the proposed codgers _but not all_. Perhaps later, when one feels ample, has been to a number of the Lower Quartets and lunch parties, the Club will fall into its place. At present I prefer the Reform.[343]

By contrast, Virginia Woolf's brother Adrian dove in with gusto, getting so drunk in March 1925 that he picked up a sex worker on

the way home to Gordon Square, waking up James Strachey with his clattering and banging. According to Ralph Partridge, drunkenness was very much the order of the day: "The Cranium met last night & they are all very sick and sorry for themselves this morning except Bunny who grows more prosperous & bloated every time he appears."[344] When Lytton finally plucked up the courage to attend in October 1926, he was pleasurably surprised by the experience: "It wasn't so bad, the food quite good, and the wine excellent. [George] Kennedy was interesting about architecture, [Charles] Sanger chatted about the Brontes, which was all that Nottingham [Sebastian Sprott] could desire."[345]

Literature, the arts, academia, psychology, publishing, journalism, the civil service, and the law were all represented on the first membership list. It was a truly intergenerational event; at least twenty years separated the oldest and youngest members. Raymond Mortimer might be found chatting to barrister Charles Sanger (b. 1871), or Sebastian Sprott with classicist John Sheppard (b. 1881). Sanger and Sheppard were fellow Cambridge Apostles who had known Lytton since the early 1900s; Raymond and Sebastian were much more recent friends. The company may have been variable, but the conversation was always invigorating. Carrington was being a bit ungenerous when she suggested that the club members would "try and discuss Einstein"[346] but end up standing round the piano, singing drunken laments. By 1927, Lytton had decided that the Cranium was the perfect pick-me-up for flagging spirits. Exhausted by the run of parties in July, he wrote to Tommy apologizing for missing the August dinner: "I wish I could come to the Cranium, but I hardly feel I shall be able to. My health continues to be extremely wobbly . . . I gaze at life from afar, a macaw in a cage." Sensing hope of recovery, he promised that at some point soon "the door will fly open. There will be a whizzing of wings, and the gay bird will dash about in every direction and (among other things) give your nose a nip."[347] By Sep-

tember, Lytton was making plans to meet Tommy in town: "Perhaps you will be in London for the Cranium on the 6th? If so, could we have an evening together on the 5th or 7th? . . . Dearest Tom Cat, I am always, your Lytton."[348]

Lytton could usually rely on other Stracheys being present—Oliver joined in 1925, and James in 1929. The club's name held a special appeal to the Strachey brothers, thanks to their grandfather's friendship with Thomas Love Peacock: "Mr. Cranium" was a character from Peacock's comic novel *Headlong Hall*. In the book, Squire Headlong assembles a gloriously eccentric group of intellectuals and artists at his decaying Welsh home, plying them with improbable amounts of alcohol. Spirited philosophical debates ensue as the protagonists assert the superiority of their individual creeds. Cranium's obsession is phrenology—the pseudoscientific study of human character and mental ability as expressed by the shape of the head—and he travels with a mysterious bag of human and animal skulls. Given any excuse, he lays them out for all to see, asserting that the human mind consists "of a bundle or compound of all the school of all different animals; and from the extra development of one or more of those, within the infinite types of mixture, result all the peculiarities of man or woman individual." Cranium compares a beaver with Sir Christopher Wren—"the organ of constructiveness"; a bullfinch with a violinist—"the organ of tune"; and a tiger with a murderer—"the organ of carnage." In his view, all human futures are determined by the "lumps and bumps, exuberances and protuberances, at the osseous compages of the sinicupt and occicupt."[349] Little known today, Peacock remained widely read in the 1920s, so Mr. Cranium would have been a familiar figure of fun. Carrington certainly knew enough about him to suggest that skulls might be used as drinking glasses, and the prospective members would all have clocked the allusion to intellectual revelry at Headlong Hall.

As the club was designed specifically to amuse Tommy, Bunny

Garnett may also have been making a sly allusion to his profession as a sculptor. Tommy had already carved all the lumps and bumps on Bunny's head, and he went on to produce portrait busts of several other members on the invitation list. Tommy's mentor, Frank Dobson, was one of those asked to join in 1925, and wealthy art patron Leo Myers was a founding member. Although the Cranium was intended to stimulate and entertain, there was an inevitable element of professional networking for all involved. Charles Prentice, a partner at Lytton and Bunny's publishers, Chatto & Windus, would have been a useful contact for many of the writers on the 1925 intake. For those seeking publicity, Raymond Mortimer provided helpful access to the press. Recently appointed university fellows could hobnob with more senior academics, architects might receive new commissions, and even the Birrell & Garnett bookshop might benefit, as most of the members were clients.

Dadie Rylands got wind of the club early on, pestering Lytton for information: "This new hankering after clubs & societies & sparkling dinners is regrettable—how does the Cranium progress, revolting name."[350] The implication is that Dadie was aching to join, but no one had suggested him at this stage. His name does seem to have finally been put forward in 1929, but is strangely absent from the round-robin that Bunny sent to all members in March that year. A letter from Eddy Sackville-West to Tommy indicates that blackballing was a strong possibility. The young man's ebullience was too much for some to bear. Eddy said that, on hearing Dadie's name, his first instinct had been to blackball, but then he had felt guilty as they were always civil face-to-face, and Dadie had had him to stay countless times in Gordon Square.

Whatever the currents running underneath, the club sailed serenely ahead. Bunny reported that the average attendance was eight members at a time, and that some drank more than others. By 1929 the initial subscription—intended to cover a lifetime membership—

of two guineas had been used up, so Bunny was asking for further contributions, though stressing that there was no penalty for not doing so: "This resolution did not aim at exacting subscriptions from the extremely sober or those who very seldom turn up."[351]

After an early flirtation with Tony's Restaurant in Old Compton Street, the Verdi Restaurant in Wardour Street became the preferred venue. Membership snowballed. Duncan Grant, Maynard Keynes, Leonard Woolf, and Roger Fry all joined, along with a host of younger compatriots. Opportunities for interconnection multiplied, and Bunny's happy-go-lucky format enjoyed lasting success: the club continues to thrive in the present day.

HEARING WOMEN'S VOICES

◆

However relaxed the atmosphere at the Cranium, there was one key missing element: women. For the older generation, another option was already available: Molly MacCarthy's Memoir Club, founded in 1920. Having fallen into abeyance in 1922, it was revived with new enthusiasm in 1928. Where the Cranium looked forward, with younger members in the majority, the Memoir looked firmly backward, focusing thoughts on earlier years. The original membership list was strictly Old Bloomsbury: Molly and her husban, Desmond, Vanessa and Clive Bell, Virginia and Leonard Woolf, Lytton Strachey, Duncan Grant, Maynard Keynes, and Roger Fry, plus Clive Bell's mistress (and Lytton's cousin), the short-story writer and socialite Mary Hutchinson, and diplomat Sydney Waterlow, a friend from Cambridge days. E. M. Forster joined soon after.

Although meetings were irregular, the literary output was impressive. Male and female members were encouraged to prepare papers for discussion after dinner—a familiar experience for men who had survived countless grillings at the Cambridge Apostles society,

but something new for Molly, Virginia, Vanessa, and Mary. Emotional honesty remained a priority, and sexual content (queer or straight) was refreshingly open. As Leonard Woolf described: "At each meeting of the 'Club,' members, in rotation, after a dinner, read a 'memoir' which was intended to be quite frank and truthful and was, therefore, almost always indiscreet."[352]

Critics of the Memoir Club have slammed it as a narcissists' playground—a self-indulgent opportunity for the older Bloomsberries to listen to each other's accounts of their past. How comfortable this experience really was remains debatable, bearing in mind the Bloomsbury taste for belittling irony and their commitment to telling the truth, however hurtful. The first set of female members seems to have taken the honesty in good humor, flourishing amidst the gently combative atmosphere: Virginia Woolf was entering her most productive phase; Vanessa Bell received some rare encouragement to write rather than paint, while Molly MacCarthy turned her early papers into a book, A Nineteenth-Century Childhood. They joined the growing number of twenties women making their mark in British literature and arts, reflecting the increased role of women in the postwar workforce and a new focus on the female as consumer. Middle-class women had more money to spend on books, magazines, and newspapers; advertising agencies were trying to catch their attention with flashy images; and manufacturers were designing new products for them to buy. The professions were slowly beginning to open their doors, and even Parliament became a possibility for the limited number of women given the vote in 1918.

July 1928 marked a further turning point for women's rights in the UK: Stanley Baldwin's Conservative government passed the Equal Franchise Act, giving all women over the age of twenty-one the right to vote, regardless of property ownership. At the next election British women may have represented the majority of the voting population (52.7 percent), but there was a huge way to go in other

The novelist Eddy Sackville-West, photographed c. 1921. (*Courtesy of Princeton University Library Special Collections/Graphic Arts/Paul Hyslop photograph album.*)

Eddy's elegant profile and delicately shaded eyelids captured by Stephen Tennant c. 1926. Eddy was a Wagner fan, so Tennant has also included some notes from the *Ring* cycle. (© *The Estate of Stephen Tennant. Private Collection.*)

Vogue, November 2, 1927: Eddy Sackville-West and Stephen Tennant photographed by Cecil Beaton amidst "a group of intelligent young persons." Left to right: Sacheverell Sitwell, Stephen Tennant, Rosamond Lehmann, Osbert Sitwell, Georgia Sitwell, Elinor Wylie, Cecil Beaton, Rex Whistler, Eddy Sackville-West, and Zita Jungman. (*Cecil Beaton Archive © Condé Nast.*)

Stephen Tennant photographed by Cecil Beaton wearing his pink Prince Charming costume from the "Great Lovers Through the Ages" pageant of May 1927. (*Cecil Beaton Archive © Condé Nast.*)

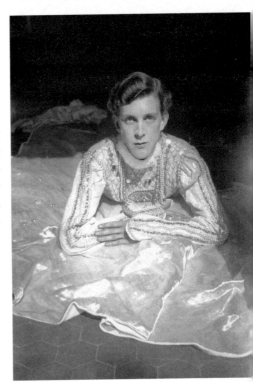

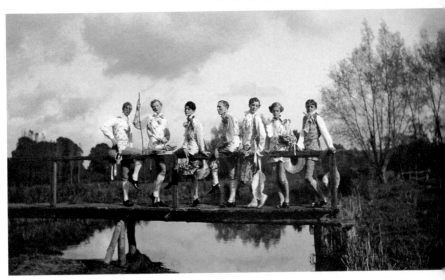

Stephen Tennant and his friends dressing up as shepherds and shepherdesses on the morning of October 17, 1927, and photographed by Cecil Beaton. That afternoon, Tennant went on to tea with Lytton Strachey, who was most amused, spreading the story round Bloomsbury. Left to right: Rex Whistler, Cecil Beaton, Georgia Sitwell, William Walton, Stephen Tennant, Teresa Jungman, and Zita Jungman. (*Cecil Beaton Archive © Condé Nast.*)

Writer Julia Strachey, sculptor Stephen Tomlin, and painter Dora Carrington at Ham Spray, standing beside Tomlin's "Nymph of the Ilex," c. 1925. (*Courtesy of Modern Archives Centre, King's College, Cambridge.*)

Dora Carrington, Stephen Tomlin, and Julia Strachey in the garden at Ham Spray, c. 1925. (*Courtesy of Modern Archives Centre, King's College, Cambridge.*)

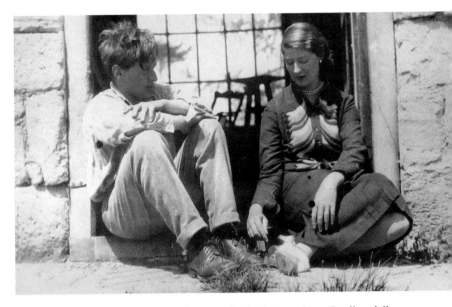

Stephen Tomlin and Julia Strachey outside Tomlin's studio at Swallowcliffe, c. 1927. (*Courtesy of Modern Archives Centre, King's College, Cambridge.*)

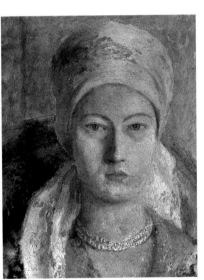

Julia Strachey painted by Dora Carrington, c.1925. Note the distinctive wide eyes and rosebud mouth. (*Alamy Stock Photo.*)

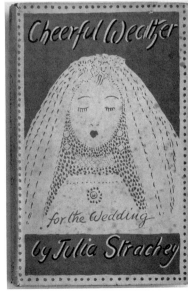

Julia Strachey painted by Duncan Grant for the cover of her book *Cheerful Weather for the Wedding*, 1932. (© *Estate of Duncan Grant. All rights reserved, DACS 2022.© The Bloomsbury Workshop, London/photo Bridgeman Images.*)

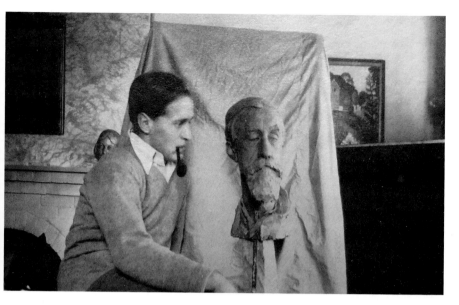

A legacy of Bloomsbury portraits: Stephen Tomlin at Ham Spray with his bust of Lytton Strachey, October 1930. (*Copyright © The Estate of Francis Partridge. Reproduced by permission of the Estate c/o Rogers, Coleridge & White Ltd London, UK.*)

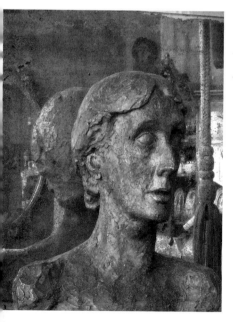

Stephen Tomlin's bust of Virginia Woolf, 1931. (*Courtesy of the Charleston Trust.*)

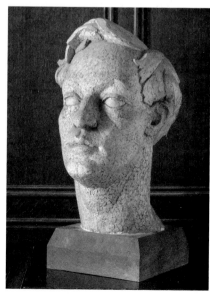

Stephen Tomlin's bust of Duncan Grant, 1924. (*© National Trust Images/photo John Hammond.*)

Garsington Manor, June 1922: Oxford student John Strachey (center, hands on hips) with his best friend, Eddy Sackville-West (second from right, facing camera). (© *National Portrait Gallery, London.*)

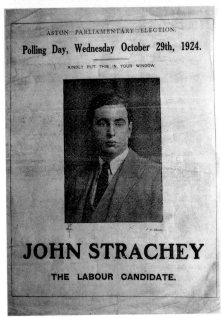

ASTON PARLIAMENTARY ELECTION.

Polling Day, Wednesday October 29th, 1924.

KINDLY PUT THIS IN YOUR WINDOW.

JOHN STRACHEY

THE LABOUR CANDIDATE.

John Strachey puts himself forward as the Labour candidate for Birmingham Aston, October 1924. (*Private collection.*)

John Strachey with his Labour party mentor, Oswald Mosley, at the Labour Party Conference, 1925. (*Getty Images/photo Haywood Magee.*)

John Strachey marries American heiress Esther Murphy in London, April 1929. Oswald Mosley was the best man (behind John, to right), and Esther's glamorous artist brother, Gerald Murphy, (behind John, to left) and his wife, Sara Murphy (far left), came over from France. (*London News Agency Photos Ltd.*)

John and Esther's honeymoon destination, August 1929: Gerald and Sara Murphy's Villa America at Cap d'Antibes, favored haunt of F. Scott Fitzgerald. (*Alamy Stock Photo.*)

The Stars and Stripes entrance sign for the Villa America, painted by Gerald Murphy. (© *Estate of Honoria Murphy Donnelly/ VAGA at ARS, NY and DACS, London 2022. Villa America, 1924, by Gerald Murphy/courtesy Myron Kunin Collection of American Art, Minneapolis, MN.*)

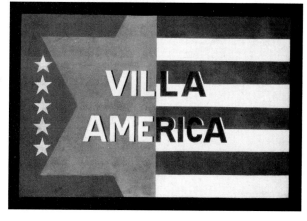

Alix Strachey's girlfriend Nancy Morris, who hosted the Hermaphrodite Party with Eddy Sackville-West in 1930. (© *Estate of John Banting/photo © Tate.*)

Alix Strachey during her period of sexual experimentation. Virginia Woolf questioned her sudden interest in nightclubs and dancing. (© *The Estate of Barbara Ker-Seymer/photo National Portrait Gallery, London.*)

IN "BERKELEY SQUARE."

MISS VALERIE TAYLOR

The talented young actress, who is playing the part of Miss Pettigrew in "Berkeley Square," the big success at the St. Martin's, which has been filling that theatre since October 6 last. As most people know, the play has as its central idea the transference of time, and the −−ro charges places with an eighteenth-century ancestor. Miss Valerie Taylor is a second cousin of the present Lord Willoughby de Broke. The late Lord Willoughby was very nearly as fond of amateur acting as he was of fox-hunting, and many was the play he produced and acted in at Compton Verney, and also elsewhere.

Actress Valerie Taylor in 1927, the year she came to the attention of Bloomsbury, while starring as Kate Pettigrew in *Berkeley Square*. (© *Yevonde Portrait Archive/ILN /Mary Evans Picture Library.*)

areas. When Virginia Woolf addressed female university students at Cambridge in October 1928, she chose the subject of women and fiction: Why had so few women become successful authors? Why were so few women acknowledged as great figures of British literature? The answer seemed to lie in marriage, motherhood, and domestic drudgery; without access to formal education, the ability to earn an independent living, or the opportunity to occupy a separate space in which to write, the path to female authorship had been blocked for centuries. Privileges that young men at the Cranium could take for granted were beyond the reach of their female counterparts. These were the arguments published in 1929 as *A Room of One's Own*, fitting in with wider contemporary debates regarding female economic independence and female preparedness for skilled work.

These were hot topics for Pippa Strachey and her sister-in-law Ray, both of whom worked for the London Society for Women's Service, which did its best to fill a gap by providing training schemes and campaigning for equal pay. Lytton's sisters had no doubt that women's voices were there to be heard: Pippa had campaigned tirelessly for suffrage before switching her focus to female employment; Pernel was the formidable principal of Newnham College, Cambridge, who had hosted Virginia Woolf when she came to deliver the lectures that became *A Room of One's Own*; the youngest sister, Marjorie, wrote books of varying quality, including *Savitri and Other Women*, a volume of folktales with female heroines. Brainpower tended to have a higher value than aesthetics in their reckoning, to the amusement of those with more stylish sensibilities. Julia Strachey must have been thinking of Virginia Woolf and her aunts when she wrote:

> We younger ones were rebelling against the super-cultured, dowdily dressed Bloomsburys—low-living and high-thinking, non-drinking and generally non-sensual generation above us—they

who, if not engaged to literature, dedicated themselves to a life of endless committee meetings and office work and striving for "womens rights" . . . We younger ones went more for the life of pleasure than for binding ourselves to "The Cause."[353]

Although Woolf and the Strachey sisters were not known for their fashion sense, describing them as nondrinking and non-sensual was distinctly unfair. Marjorie Strachey was an exuberant party-giver, prone to singing obscene versions of hymns when roused. On one much-discussed occasion she and Ralph Partridge performed one of the erotic encounters from Arthur Schnitzler's controversial play *La Ronde*. According to Vanessa Bell, the guests did their best to talk over the "very realistic groans made by Partridge . . . I don't think anyone enjoyed it. It was a great relief when Marjorie sang hymns."[354] Marjorie enjoyed mixing up the generations just as much as Lytton, and it was at one of her parties that Virginia Woolf remembered cross-examining Julia Strachey and meeting for the first time "a little thrush like creature called Tomlin who wants to sculpt me."[355] Woolf pretended to be annoyed by Julia and Tommy's attractive young friends—complaining that they filled rooms with their "bright Bugger-Bloomsbury up to date bragging"[356]—but as Frances Marshall wryly pointed out, Virginia tended to come down hard on earnest young writers, and soft on those who hailed from more pleasure-loving spheres. Debutantes and aristocrats were instantly appealing, particularly if romantic in appearance, prompting streams of fantastical imaginings.

Nobody seems to have stepped forward to set up a female version of the Cranium Club. However, once Woolf was safely installed in Tavistock Square, and Vanessa Bell at 37 Gordon Square, the sisters began to hold more of their own "evenings." Sometimes these were small, designed for the intimate exchange of views; on November 17, 1927, Vanessa wrote enticingly to Lytton: "Will you come to

a very small party here on Wednesday next . . . It will be of the old fashioned conversazione description with the ladies (& some of the gentlemen) chosen for their looks & the remaining gentlemen for their wit or genius. Please do come in all capacities."[357] Sometimes they were much larger, incorporating whoever might be lodging at No. 37, and their widening group of younger friends. It would be stretching the point to suggest that Virginia and Vanessa were host-ing a salon, as the intervals were irregular, but there was an element of experimentation in their activity. If queer male self-expression was ubiquitous in Bloomsbury, then queer women were equally likely to feel at home. In November 1928, Virginia wrote in her diary: "Last night was one of our evenings—apparently successful: Adrian, Hope, Christa, Clive, Raymond, Bunny, Lytton, Vita & Valery [sic] [Taylor] towards the end; & Elizabeth Ponsonby. People enjoyed it. Perhaps I didn't; perhaps I did. Half way through Lytton vanished (he lodges upstairs) brayed out of the room by Clive's vociferation."[358]

Virginia and Vanessa chose female guests who would fascinate and provoke—appealing to admirers of all genders and sexualities. There was a careful mixture of the familiar and the unfamiliar, the sensual and the sensational. Twenty-seven-year-old Elizabeth Pon-sonby had a reputation for extremes—a flamboyant "Bright Young Thing" at the height of her press popularity. Christa McLaren was a wealthy beauty in her thirties who connected writers and artists with the fashionable crowd, entertaining from her vast London house in South Street, Mayfair. Either woman could be relied on to add spice to an evening, and to issue invitations in return. Only a few months before, Ponsonby had teamed up with Eddie Gathorne-Hardy, Babe Plunket Greene, and Brian Howard to throw one of the most notori-ous parties of the twenties. Guests were told to come to St. George's Swimming Baths at 11:00 p.m. for dancing and cocktails. The invi-tation asked everyone to "wear a Bathing Suit and bring a Bath towel and a Bottle." The *Sunday Chronicle* was predictably disapproving:

> *Great astonishment and . . . indignation is being expressed in*
> *London over reports that in the early hours of yesterday morning*
> *a large number of Society women danced in bathing dresses to the*
> *music of a Negro band at a "swim and dance" gathering organised*
> *by some of Mayfair's Bright Young People.*[359]

Ever enthusiastic for youthful pleasures, Clive Bell had been one of the lucky older crowd who joined the poolside throng, jiving to the jazz band while they downed specially designed bathwater cocktails. The hostess would have been hard to miss: according to the *Daily Express*, "Miss Elizabeth Ponsonby looked most attractive in a silk bathing costume of which the lower part was red and the bodice rainbow-like with its stripes of blue and red." Stephen Tennant had been equally eye-catching in "a pink vest and long blue trousers."[360] Christa McLaren would never push boundaries like Ponsonby or Tennant, but she moved in similar social circles, comfortably sustained by her husband's industrial fortune. Christa knew exactly what sort of gossip Virginia liked to hear, supplying Woolf and her guests with regular doses. If holidaying in the Mediterranean with Osbert Sitwell, Stephen Tennant, and the Jungman sisters was beyond your budget, then vicarious access was easily available. Virginia was always delighted when Christa popped round: "She gave me what I adore—a long and detailed account of Zita Jungman's father, mother and marriage; which led to a vast panorama of the Sitwells, in Italy, Zita saying 'And I'll have a tray in my room,' the bath not locking, Lady Ida, Stephen Tennant with his old nurse—what I call, perhaps foolishly, 'real life.'"[361] Christa did go on to publish a novel and some memoirs, but in 1928 her reputation rested firmly on her friendships with others rather than her own literary achievements.

One of the other guests—Hope Mirrlees—had slightly more solid credentials in this area, capable of holding her own with any of the young men in the room: the Hogarth Press had published her

long poem *Paris*, while her three novels had been issued by William Collins & Sons. Hope's presence signaled a poignant absence. Her partner, Jane Harrison, had died earlier in the year, leaving Hope adrift for the first time since student days. Together since 1913, Harrison had been Hope's tutor at Newnham and her collaborator in translations of Russian texts. After three years in Paris, the couple had returned to London in 1925, setting up home in nearby Mecklenburgh Square. Woolf bumped into the grieving Mirrlees wandering the Bloomsbury streets in April 1928, and found herself torn between sympathy for Hope's recent loss and irritation with a writer whom she had always found slightly willful and self-satisfied: "She is her own heroine—capricious, exacting, exquisite, very learned, and beautifully dressed."[362] Like Christa McLaren, Mirrlees derived her generous income from industry. The McLaren family chaired the Tredegar Iron and Coal Company, while the Mirrlees family manufactured sugar-processing machinery and diesel engines. Hope was free to travel back and forth between England and France, indulging her enthusiasm for expensive motorcars and brightly colored, ultra-feminine clothes.

Molly MacCarthy's Memoir Club and Vanessa and Virginia's "evenings" brought women and men together on an equal footing. Although the Memoir Club gradually expanded to include younger members, at this stage the focus was firmly on those who had known each other prewar. Vanessa and Virginia's gatherings were more speculative, including women in their twenties and thirties who might provoke a reaction. Some were professionals—writers or artists already making their way—but others were famous for being famous, society figures with access to influence, potentially useful for building profiles, providing access to alternative viewpoints. Guests were as likely to explore female sexuality—the love of woman for woman—as they were to champion the cause of female achievement.

SAPPHISTS AND HERMAPHRODITES

November 1928 was a timely moment for Vanessa and Virginia to hold one of their "evenings." The obscenity trial for Radclyffe Hall's lesbian novel, *The Well of Loneliness*, had started at Bow Street on November 9, and run until the sixteenth. The Gordon Square party was on the twenty-seventh, so discussion of the outcome would have been unavoidable.

Virginia and Forster had led a fruitless effort to drum up a petition in support of Hall, co-signing a letter to the *Nation and Athenaeum* flagging the dangers of censorship for all authors. Virginia attended the first day of the trial, pausing afterwards to commiserate with Hall and her partner, Una Troubridge, who were worried about costs. Hall's motives in writing the novel were admirable—to give an honest portrayal of same-sex love between women that reflected all the latest thinking of sexologists such as Havelock Ellis and Richard von Krafft-Ebing. Where other novelists had relied on hints or allusions, Hall made direct references to sexual contact, ending with what appears to be a plea for recognition of female homosexuality as

an inborn state. The Conservative home secretary was horrified; the judge decided that the book was depraved and corrupt, and asked for it to be destroyed.

James Douglas, the editor of the *Sunday Express,* had been fulminating against *The Well of Loneliness* since August. While Begbie in *John Bull* had been terrified of the painted boy, Douglas seemed to have a special loathing of women in suits. Gender transgressions of the sort adopted by Hall and her heroine—using male first names, wearing masculine tailoring, favoring cropped hair—were all equally threatening. None of these were prosecutable offenses, so Douglas attacked the work as well as the lifestyle. Images of Hall in a dinner jacket and tie were shown alongside headlines denouncing "The Book that Should be Suppressed."[363] This woman was encouraging sympathy for the marginalized, and she must be stopped:

> The adroitness and cleverness of the book intensifies its moral danger. It is a seductive and insidious special pleading designed to display perverted decadence as a martyrdom inflicted upon these outcasts by a cruel society.[364]

Hall's response was trenchant: "Far from encouraging depravity," she wrote in the *Scotsman,* "my book is calculated to encourage mutual understanding between normal persons and the inverted, which can only be beneficial to both and to society at large. I am proud and happy to have taken up my pen in defence of the persecuted."[365]

The home secretary and the law may have been on Douglas's side, but Bloomsbury, young and old, stood with Radclyffe Hall. Virginia Woolf had to tread carefully, as her own novel *Orlando* could easily have been interpreted as a Sapphist tract. Luckily, the fanciful language and time shifts were distracting enough to evade hostile attention, even though Vita Sackville-West was clearly identified as the hero/heroine, her images used as illustrations for the book,

her name on the dedication page. Less than a month after *Orlando's* publication, Vita's presence at the November party would have been anticipated by all, and her views on *The Well of Loneliness* well known. With a distinctive appearance of the type calculated to annoy the *Sunday Express*, Vita was used to causing a stir. When eloping with the socialite Violet Trefusis, she had briefly adopted the male alter ego of Julian and wandered the streets of Paris dressed in men's clothes. In London, her long limbs tended to be draped in semi-feminine attire; in the countryside she adopted a deliberately androgynous uniform of breeches and high, laced-top boots. James Douglas drew his own conclusions about women in masculine dress:

> *I am well aware that sexual inversion and perversion are horrors which exist among us today. They flaunt themselves in public places with increasing effrontery and more insolently provocative bravado. The decadent apostles of the most hideous and loathsome vices no longer conceal their degeneracy and their degradation.* [366]

In typical swashbuckling form, Sackville-West arrived at Gordon Square that November evening with an attractive "plus one" on her arm. Valerie Taylor was a popular West End actress then starring in an Inspector Hanaud mystery at the Vaudeville Theatre after a year's successful run in a comedy at the Fortune. Taylor became best known for her recurring role as Kate Pettigrew in the hit show *Berkeley Square*, which launched in 1926 at the St Martin's Theatre in London, transferred to Broadway in 1929, and was eventually made into a movie in 1933 starring Leslie Howard. Publicity photographs from this period show her in two very different modes: swathed in heavy silks for the eighteenth-century scenes in *Berkeley Square*, or suited and crop-headed in jacket and tie, looking like the principal boy in a pantomime. Taylor's large eyes and delicate features were equally attractive whether topped by her own short curls or the

long powdered tresses of an eighteenth-century wig. Her androgynous beauty proved alluring to quite a few of the guests, female and male, at Vanessa and Virginia's "evening." Raymond Mortimer had been the most surprising convert, making a short-lived but definitely heartfelt declaration of love. As Carrington wrote to a friend: "Do you remember Raymond Mortimer? One of Lytton's Hoopoes . . . He is engaged to Valerie Taylor. Ah but will he marry her? Quite another question."[367]

Taylor's boyish charms sent ripples spreading in many directions. According to Dadie Rylands, even Lytton Strachey got excited when he met her at a lunch party in June 1927. Stephen Tomlin was confused by the sudden flurry of attraction: "The only times I saw Valerie Taylor (once on the stage, & once across the room at Dadie's party) I thought her lovely. But why have they all suddenly paid attention to her? There she was all the time wasn't she?"[368] The interconnections became predictably complex. Over the course of a few months, Taylor slept with Clive Bell; his mistress, Mary Hutchinson; Vita Sackville-West; Alix Strachey; and possibly Duncan Grant, who took her to the cinema, exchanging letters thereafter. Virginia Woolf reported on all the activity with delight, wondering idly to Vita whether she could be used to illustrate a character in *Orlando*: "Do you think Valerie Taylor would do for the Russian Princess, if disguised?"[369] In the end, it was Virginia's niece Angelica Bell who had been photographed for the book, but Taylor was one of the many thanked in the acknowledgments. For a short period she became a ubiquitous figure in Bloomsbury; Angelica remembered Valerie painting her mother's face blue for a cocktail party where everything had to be blue or green. When Eddy Sackville-West gave a dinner for Clive Bell, he invited both Vanessa and Valerie.

Open discussion of sexual relationships, regardless of gender or orientation, remained a core principle for Bloomsbury conversation in the twenties—a refreshing antidote to the coyness or innuendo

that tended to lurk elsewhere. Valerie found a rich seam of potential partners, and Virginia picked up some of the emotional pieces: "Raymond caterwauled like the most lamentable housetop cat. I suppose his affair is on the rocks. He has never been so unhappy he says."[370] While Raymond was pouring out his sorrows to Virginia, Valerie was confiding in Vita, who showed a rare moment of restraint: "She let him sleep with her, but I haven't told him that she wanted to sleep with me the next night at Oxford—I *didn't*, but that was no fault of hers."[371] When the engagement came to its inevitable end in May 1928, Eddy Sackville-West sent word to Virginia straightaway, and Virginia spread the news far and wide: "I had an amusing account from Eddy of the final rupture with Valery [*sic*] which took place at Long Barn . . . They reached a point where they couldn't speak to each other, so Vita was sent from room to room with notes, each sobbing loudly the whole time. It is now completely over, Eddy says, and both are much relieved."[372]

By 1929, Valerie was moving on to new pastures: she starred as Nina in a short revival of *The Seagull* with John Gielgud before heading to New York to reprise her role as Kate Pettigrew in the Broadway production of *Berkeley Square*. It's difficult to judge the impact of Bloomsbury's close brush with a rising figure in popular theatre, but it feels entirely in keeping with the spirit of the moment: there is a joyous sense of abandonment to the new in Virginia's accounts of this period. She writes of Raymond coming to see her after a flying lesson, and Clive telephoning her at midnight from a party, with Raymond and Christa hanging over his shoulder. It was exciting to use new technology, to meet people from different spheres.

Valerie Taylor was not the only representative of the British stage and screen to find comfort in Bloomsbury's inclusive atmosphere. On March 12, 1928, Virginia had met an even more celebrated young queer star: "I fell in love with Noel Coward, and he's coming to tea." Keen to share the pleasure, she wrote excitedly to her sister Vanessa:

"Did I tell you about Noel Coward? He is in search of culture, and thinks Bloomsbury a kind of place of pilgrimage. Will you come and meet him. He is a miracle, a prodigy. He can sing, dance, write plays, act, compose, and I daresay paint—He rescued his whole family who kept boarding houses in Surbiton, and they are now affluent, but on the verge of bankruptcy, because he spends so much on cocktails. If he could only become like Bloomsbury he thinks he might be saved."[373]

Coward's copy of *Orlando* gained a personal dedication from the author and a handwritten addition to the list of acknowledgments at the end.

By 1930, Frances Marshall felt that everything was going too fast. Bloomsbury had been "swallowed up in a sea of Buggery," causing the "middle aged and intelligent to fall in love and subjugation to the young and merely pretty."[374] Social activity was reaching such a frenzy that Frances longed for respite: as one of the few straight observers, her accounts take on rather a jaded tone. When James Strachey's wife, Alix, co-hosted a party with her lover Nancy Morris, Frances noticed that queer guests were in the majority: "Young man after young man pushed his pretty face round the door, and a crowd of truculent Lesbians stood by the fireplace, occasionally trying their biceps or carrying each other round the room."[375] Later that summer Nancy teamed up with Eddy Sackville-West for a hermaphrodite party, where everyone was asked to come after 11:00 p.m. dressed in drag. Frances made rather a token effort—putting on a moustache and bowler hat above her yellow silk dress—but everyone else entered the spirit with gusto:

> *Most of the young men had loaded themselves with pearls, powder and paint; the atmosphere was stifling and the noise . . . deafening. There is a vogue now for such parties as this: all the creative energy of the participants goes on their dress.*[376]

Eddy Sackville-West thrived in this supportive environment, helping others when required. Confidences were still exchanged with Virginia Woolf, but he also grew close to Alix, sharing his own feelings, listening to her as she experimented with her sexuality. Alix kept Eddy fully informed about Bloomsbury news whenever he was away: "Next Saturday there's to be a Dance of the Heavenly Bodies in fancy dress . . . It will be the usual thing, with the usual people, at the usual place."[377] Her letters document each stage of her attraction to Nancy, the butch, crop-haired sister of artist Cedric Morris. Alix seems to have assumed that Nancy was an experienced heartbreaker, and deferred to Eddy's superior understanding of queer relationships:

> I spent last week-end at Corfe with Nancy Morris & her friend & some other people. I liked it; but you must not fear for my morals. In fact, I received a slight shock. For it turns out that my new acquaintance, far from being a devil-may-care, hardened female, with a "racy" mind and wild manners, & debauched up to the hilt . . . is almost alarmingly nervous and sensitive, & surprisingly "sympatisch." I don't really quite know what to do about it; because when a person has, roughly speaking, a heart, one can't deal with them at all in the same way, & I'm afraid I've walked into this business quite vaguely with some idea of it's [sic] being "fun."[378]

A full-blown love affair ensued, with the apparent support of James and the wider Strachey family. There was a bizarre incident when Lytton, invited over specially to meet Nancy, refused to talk to her, as she had brought her bulldog. Alix refused to accept her brother-in-law's well-known dislike of dogs as an excuse, and asked him to apologize in writing. As she explained to Eddy, this was a brave gesture: "You see, Lytton is a great figure with me."[379]

Nancy opened doors to other queer circles: her brother Cedric

threw famously louche parties in his Great Ormond Street studio, often involving journalist Dorothy Todd and her partner, Madge Garland. Alix sent Eddy a suitably detailed account of one he missed:

> *Cedric had on an unbuttoned brocade waistcoat with a pair of black lace drawers underneath & soon curled up in his place on the sofa. James in a huge red wig & beard & orders, surveyed the scene & was often mistaken for Lytton (once, of course, by Clive); I was in a piece of sacking & danced beautifully & conscientiously. Nancy turned herself into a country curate with invisible eye-glasses & square toed boots, & got terribly abused by Todd for dancing with anyone besides her & with Garland for dancing with no one but Todd.*[380]

It was only a short walk from Gordon Square to Nancy's basement flat at 44 Mecklenburgh Square, and she and her dog became familiar figures. When Nancy and Eddy threw their joint party in July 1930, they made a perfect gender-reversed couple: Nancy was tall and heavily built, with a sharp Eton crop and a preference for tweed suits; Eddy was tiny and delicate, his eyelids tinted, and his clothing cut with a carefully flowing line. When Nancy left Alix for another woman, Eddy took on the role of trusted confidant. Early in their friendship, Alix had told Eddy that she longed to shed her protective carapace:

> *You know, I sometimes feel that all this "self-respect" & decency is a kind of dead surface one has grown to cover under & not be seen; & I'd like, just once, to pull it off & show what's really there in myself and others.*[381]

By November 1930 she was ready to lay her soul bare, and the anguish of the broken relationship springs from the page. A trusty

ally in times of adversity, Eddy acted as a sounding board and go-between. The young man who had suffered in the German clinic, and shared the agonies of his own doomed love affairs with Virginia Woolf, proved stronger than he looked; on this occasion it was the older person looking to the younger person for "sweetness and sympathy."[382] A subtle transition seemed to be taking place, a handover between the generations; where once Old Bloomsbury had taken the lead, Young Bloomsbury was starting to set the pace. The young people who had formed gender-reversed chorus lines for Maynard Keynes's amusement at Gordon Square were issuing their own invitations, staging their own transgressive performances. Eddy Sackville-West had spent a happy winter in Germany in 1928–29, sampling the revelatory LGBTQ nightlife of twenties Berlin. Clubs like the Eldorado held drag shows every night, and Eddy lost his heart to a delightful young man with "more S.A. [sex appeal] than anyone I've ever seen." In no time at all, Eddy was venturing further than he'd ever imagined: "The other day, in a mood of gaiety, he led me with his dog-lead in the street (at night) as we were on our way to dance at the Lokal. I nearly expired with ecstacy."[383]

7

The Coming
Struggle for Power

LEADING A DOUBLE LIFE

\diamondsuit

Eddy Sackville-West may have been happy to challenge gender conventions, but he had no wish to change the religious or political foundations of British society. For his best friend John Strachey, though, it was a different matter.

While they were at university, John experienced a "sudden and bewildering loss of faith in the whole moral, religious and social ideology which we had inherited." There were links between John's tolerance of difference, his acceptance of alternative approaches to sexuality, and his emerging political beliefs. He rejected "that whole unparalleled structure of repressions and taboos" that made up the "religious and moral superstructure of British upper class life."[384] While his friends were working their way through Proust, John was devouring Marx. The pampered youth who preferred chocolate cake for breakfast, and toured the Parisian theatres with Eddy Sackville-West, became a passionate convert to socialism.

Lytton Strachey's urbane young cousin was an unexpected class warrior. Although Scott Fitzgerald was exaggerating for effect when

he suggested that "It was characteristic of the Jazz Age that it had no interest in politics at all,"[385] John's activism remained a rarity in Bloomsbury circles. Of the older generation, only Leonard Woolf campaigned directly for the Labour Party, running committees and standing as a parliamentary candidate in 1922, and was a co-founder with Oliver Strachey of the left-leaning 1917 Club in Soho. Leonard had admired the spirit of the Russian Revolution, but he wanted the classes to come together rather than tear themselves apart; he wrote a book called *Socialism and Co-operation* for the National Labour Press in 1921, articulating his beliefs in a letter to a fellow supporter of the League of Nations Union: "Personally I think the class war and the conflict of class interests are the greatest curses, and that the first thing one should aim to do is abolish this."[386]

Leonard Woolf may have been a card-carrying member of the Labour Party, but his sympathies were not entirely out of step with Bloomsbury's prevailing liberal ethos. John Strachey's ideology quickly became more extreme. Lytton and his brother James seem to have stood on the sidelines, watching in amusement as John progressed with surprising speed from self-indulgent Oxford student to rabble-rousing Labour polemicist. In October 1924, John published his first manifesto:

> If you put Labour into Power you can transform England. I myself stand for the complete transformation of Society into a socialist commonwealth, as rapidly as possible. To that end, I advocate the immediate nationalisation of mines, railways, agriculture, banking, electric supply, and the total abolition of food taxes.[387]

The Gordon Square Stracheys waited with fascination to see how the Sutton Court Stracheys would react. The head of the family—John's uncle, a former Liberal minister raised to the peerage as Lord Strachie—was profoundly shocked, but those expecting fire-

works were disappointed. John's father, St. Loe Strachey, the ultra-conventional owner and editor of the *Spectator* magazine, proved phlegmatic in his response. If Labour was the party of the future, then John might be sensible to hitch his colors to the mast. The *Spectator* would remain firmly attached to its old allegiances, John would be free to pursue a different path.

Although John was beginning to see capitalism as thoroughly despicable, he was not quite ready to desert the world he had grown up in. Labour militants might have been surprised to discover that their new comrade had been Eddy Sackville-West's playmate at Eton and Oxford and a leading proponent of the "Cult of the Effeminate" espoused by so many of his wealthy contemporaries. There were tales of lavish lunches in his rooms at Magdalen College, with fine wines and flamboyant company. Thanks to Sackville-West, he had been exposed to the fin-de-siècle writings of Joris-Karl Huysmans, whose decadent hero des Esseintes owned a jeweled tortoise and once held a mourning dinner for his lost virility, with room and guests draped in funereal black velvet. Mourning and black velvet were recurring themes in French decadent literature. Decadents loved to combine theatricality with morbid humor and subversive eroticism—all features of the extravagant Oxford celebration "held for no particular reason in Magdalen"[388] in the winter of John's second year, the invitation to which read:

> *The Host now declines to accept responsibility for the success or failure of this party; this depends on the Gentlemen, who are all requested to leave as soon as they feel bored.*[389]

Surviving copies of the menu are covered with closely packed signatures, implying that most stayed on afterwards to enjoy "Bridge, Bacarat [sic], Scandalous talk and Music."[390] John Strachey, Eddy Sackville-West, Philip Ritchie, and Roger Senhouse were all present

that night; the evening ended with a series of elaborate toasts. One speaker congratulated the host for providing everything apart from a beautiful naked girl beside each chair. A second speaker sprang up to declare that this would have been entirely pointless, as there were only two people in the room who were interested in women. According to one fellow guest, no one demurred.

Oxford contemporaries remembered John as a bon viveur with confirmed aesthetic tendencies, prone to sipping crème de menthe while wearing a red brocade dressing gown. Stories of him carrying a ladies' handbag down Oxford High Street are likely to be apocryphal, but John definitely had a taste for snappy headgear and two-tone shoes. Lytton Strachey and Duncan Grant would bump into him at Garsington Manor, an affable member of the queer friendship group centered around Sackville-West, Ritchie, and Senhouse. At this stage John's passion was for acting rather than politics, and Eddy preserved a touching selection of mementos from their shared student days: playbills for John and Roger's productions at the Magdalen Dramatic Society, scripts for sketches written by John, and cartoons drawn by their mutual friend John Rothenstein. John was endlessly tolerant of Eddy's idiosyncracies, sitting through interminable Wagner concerts, encouraging his friend to submit pieces of writing for publication in the *Spectator*. Impressed by John's intelligence and maturity, the father of one contemporary found the absence of adolescent aggression unnerving: "I rather wonder if he is lacking in some fundamental male characteristics."[391]

Lytton Strachey jumped to the obvious conclusions about his cousin's sexuality. Wandering through Oxford on a May evening in 1922, Lytton bumped into John on a bicycle:

> He said he'd been to Vienna and seen James [Strachey]. Vienna, he said was "entirely homosexual," no women in the streets— only painted young men—"Oh, entirely homosexual?"—"Did

that suit you?" I couldn't help asking . . . "No—no—as a matter of fact that sort of thing doesn't." "Ah! Goodbye then, my dear fellow"—![392]

John's interest in women was a surprise to Lytton, and a rarity in Eddy's circle at Oxford—even more so when it stretched beyond friendship to actual sexual encounters. He developed a chameleon-like ability to move between groups, entirely comfortable in the company of gay men but equally open to relationships with women.

Julia Strachey was reported to find John "excessively amiable to nearly everybody";[393] he invited her to join the lunches in his rooms at Magdalen and star in the melodramas and burlesques he wrote for the Dramatic Society. Julia's friends became John's friends, too, and flapper Elizabeth Ponsonby was one of the many "wild girls"[394] who enjoyed his sensitive approach. Bundles of letters survive from 1921–22, written while Elizabeth was struggling to fulfill her dream of being an actress, performing in repertory at Nottingham, and going for auditions at the Old Vic in London. The contents are surprisingly candid. One particularly aggressive lover keeps appearing in her dressing room, throwing her roughly against the wall. Another shoots the bulbs out of her lights with a revolver. Elizabeth mentions in passing that her mother had once thought that John might marry her, but then abandoned this idea as she had obviously lost all her mystery.

Other correspondence from the twenties reveals a refreshingly open attitude to different sexual choices. "Bob" and "Archie" write flirtatiously to John from Tangier, explaining how hard it has been to keep their hands off each other, quite apart from all the beautiful Moroccan boys. "Betty" shares her regrets for lost lesbian loves before casually mentioning that she's due to be married on February 17, and would John be an usher? A married female lover writes to John from Athens suggesting that he should have other mistresses

while she is away and asking earnest questions about the Praxiteles statue of Hermes: Should it be interpreted as hermaphrodite or homosexual? What is the current thinking? John seems to have lent an equally caring ear to male and female friends, demonstrating an impressive range of listening skills.

After a near-death experience with peritonitis in 1922, John became more thoughtful, impressing the poet Richard Church when they met at the Strachey home:

> Sitting next to me at the luncheon table was . . . John Strachey, just down from Oxford. I found him . . . receptive and courteous. He had the habit of leaning forward to listen more intimately to the person with whom he was in conversation . . . It gave me confidence. To my astonishment I found myself talking, and being listened to, while a pair of dark, shrewd, somewhat melancholy eyes scrutinized me with increasing interest.[395]

By the time John moved into a London flat with Eddy Sackville-West in 1924, old friends were beginning to discover that their compatriot had acquired some unusual interests. St. Loe Strachey probably regretted getting his son to edit a volume of *Spectator* articles entitled *The Economics of the Hour*, as the subject became a recurring obsession. Julia Strachey remembered a bleak walk through Hyde Park with Elizabeth Ponsonby, listening to John's endless explanations of economic theory. Desperate to bring a conversation about different forms of currency to a close, she blurted out, Marie Antoinette–style: "Couldn't we all have postal orders?"[396]

It was economic analysis that drew John toward Labour activism, triggering long conversations with Elizabeth Ponsonby's father, Arthur, a former Liberal MP who had transitioned to Labour in 1922. Arthur Ponsonby took John to the offices of the more radical Independent Labour Party and encouraged him to write articles for their

journal, entitled *What Youth Is Thinking*. John could still be spotted playing croquet at Garsington or chatting at Bloomsbury parties with Eddy and the Oxford cohort, but his convictions were taking him in a different direction. Like Saint Paul on the road to Damascus, John underwent a thoroughgoing conversion. Puzzled family members found him talking about the condition of the people and fair dealing between the classes. His sister Amabel followed him down the same ideological path, worrying all the while that they would both be seen as class traitors.

Throughout this period John was leading rather a strange double life. Having put himself forward as a Labour candidate for the general election of 1924, he was adopted by the working-class constituency of Birmingham Aston. Leaving his flatmate Eddy sleeping off the results of whichever party he'd been to the night before, John would catch the early train from Euston to pound the campaign trail. The terraced streets of Aston were a world away from Kensington, where John and Eddy's apartment overlooked the gardens of the Natural History Museum. Stepping out of their tall stuccoed building, the pair were perfectly positioned for strolls around Hyde Park or concerts at the Royal Albert Hall. When Eddy was away, John lent his room to whichever of their queer friends was most in need. Art historian Adrian Stokes moved in for three weeks in 1924, reveling in the chance to live surrounded by Eddy's beautiful things. John may have been campaigning for the redistribution of wealth, but for now he was content to enjoy the proceeds of the capitalist system: Eddy's allowance came from the Sackville family, while John relied on payments from the *Spectator* to survive.

There was a certain irony to the idea of a Labour firebrand deriving his income from a right-wing political journal, but this didn't seem to trouble John, who saw the funding purely as a means to an end. His cousins Lytton and James had followed a similar path, writing pieces for the *Spectator* despite disagreeing with its political

stance. James had even spent several years working for John's father as St. Loe's private secretary, until their differing views on the First World War forced a parting of ways. The rupture was awkward but far from permanent: the brothers rejected St. Loe's ideas while remaining affectionate toward him as a man. As James wrote in the introduction to his volume of Lytton's *Spectator* essays:

> *The younger members of our own family applied the term "Spectatorial" to any particularly pompous and respectable pronouncement. At the same time we were very fond of St Loe, who was the kindest of friends and a most entertaining companion, and was in many ways far from "Spectatorial" in real life. He had, in particular, a highly romantic admiration for the Strachey family.*[397]

Lytton was equally capable of appearing pompous, particularly when teasing young relations. John's sister Amabel found him daunting: "I remember asking Lytton Strachey one day when he seemed fairly communicative if he re-wrote much. In that high precise voice came the answer with his usual little pause 'It comes out—in faultless sentences.'"[398] Eddy Sackville-West thrived on this type of dismissive Bloomsbury humor, but John Strachey sought stimulation elsewhere. While Eddy was busy cozying up to Virginia Woolf and Duncan Grant over tea in Tavistock Square, his flatmate was traveling up and down to Birmingham to nurture his prospective constituency. Having failed to get elected in 1924, John was determined to try again, retaining the loyalty of the Aston Labour Association. As his father pointed out:

> *You have now got your neck well into the political collar and you will never get it out again, or want to. That is a safe thing to say of anyone who voluntarily goes into politics. It is the most attractive and exciting thing in the world.*[399]

Lytton and James took a more personal approach to social change. They had been pacifists during the First World War, challenging the moral conventions of the previous generation and embracing the new psychology of Sigmund Freud. Their dissent was embodied in individual action, and they never sought a more general improvement to society through political lobbying. Leonard Woolf hosted local Labour meetings at his home with Virginia, who recorded that their neighbors thought they were "red hot revolutionaries."[400]

The twenties were a period of strange extremes. While consumption boomed for the middle classes, financial distress was a recurring issue for those working in Britain's declining heavy industries, with communities concentrated in the Midlands and the North. As well as campaigning for the industrial working class, John Strachey took on voluntary roles as editor of the *Socialist Review* and the *Miner*. In May 1926 he became the only member of the Strachey family to be arrested for supporting the General Strike, in which coal miners were demanding better conditions and better wages, and the Trades Union Congress voted to defend their interests. John was part of the Birmingham Trade Union Emergency Committee, fined for causing disaffection through the printing of a daily strike bulletin.

The General Strike felt rather remote for many in Bloomsbury; Stephen "Tommy" Tomlin sent Lytton a detached account of upper-class police volunteers filling time while awaiting action: "I have felt very disordered by these public commotions . . . it has been curious to see the elegantly dressed special constables practising their Charleston step at the street corners."[401] Virginia and Leonard were more directly engaged in the action, with Leonard writing articles for the Labour Party, and Virginia gathering signatures to support the archbishop of Canterbury's settlement proposals. There is a breathless sense of urgency in her reports to Vanessa Bell: "Either there will be peace today or strike going on for several weeks. It beggars description. Recall the worst days of the war. *Nobody* can settle

to anything—endless conversations go on—rumors fly—petitions to the Prime Minister are got up."[402]

John Strachey placed himself firmly on the side of the striking workers in 1926, and as the twenties progressed, his radicalism hardened. If the Soviet Union provided the ideal example of a Marxist regime, then personal experience was required: in 1928, Strachey traveled to the Don Basin to visit the mines; later he went to Leningrad, Moscow, and Kiev. The Hogarth Press issued the resulting pamphlet, *What We Saw in Russia*, co-written with Aneurin Bevan and George Strauss. By this stage John's extremist views were becoming notorious; as Osbert Sitwell concluded in the *Weekend Review*, "Those who know Mr Strachey are aware that his spiritual home is in Moscow rather than London."[403]

ATLANTIC CROSSINGS

◆

Eddy Sackville-West published his first two novels while living with John; when Strachey's own first book came out, the subject was firmly aligned with his left-wing agenda: *Revolution by Reason: An Account of the Financial Proposals Submitted to the Labour Movement by Mr. Oswald Mosley*. It's hard to imagine many of their Oxford friends rushing to pick up a polemic on socialist economics, and harder still to know what they made of Mosley, who had campaigned for an adjoining seat in Birmingham and became John's Labour Party mentor. The charismatic future leader of the British Union of Fascists had yet to show his true colors. With his eye firmly fixed on the main chance, Mosley had already deserted one party—the Conservatives—in favor of Labour, where he was becoming a fast-rising star; he seemed to have no problem combining socialist principles with an expensive lifestyle, confidently putting forward ideas for reforming the economy while spending his wife Cimmie's American retail fortune. John was excited by Mosley's fervor, sticking ever closer to his friend once he became MP for Smethwick in

the Midlands, learning at the sharp end exactly how much invest-
ment was needed to help Labour candidates win by-elections. Until
the socialist utopia was established, capitalist methods were there to
be exploited.

Away from the prying eyes of Midlands voters, John's double life
continued unabated. When the Mosleys hired grand villas in Ven-
ice or Antibes, John would go with them for the summer. When
the Mosleys bought a country home at Savay Farm in Buckingham-
shire, John became a regular guest, lounging by the swimming pool
with a bizarrely alternating cast list of Labour Party activists and
Bright Young Things. On one memorable night Cecil Beaton and
Stephen Tennant found a box of Edwardian evening dresses belong-
ing to Mosley's mother-in-law; after putting them on, they "did the
most fantastic dances as passed description for effeteness, tho' bril-
liance was in every line."[404] The craze for home movies was at its
height, and John Strachey was captured on film by Mosley cavorting
alongside Beaton and Tennant. John played a rustic vying for the
attentions of Cimmie Mosley, while Beaton appeared as the madam
of a brothel. Tennant took the role of a blind beggar boy dressed in
rags who sits on a riverbank making daisy chains before drowning
himself in the river. To the outside world, John seemed to be living a
charmed existence. The truth was more prosaic: John inherited less
than he expected when his father died in 1927, and the prospective
parliamentary candidate for Birmingham Aston moved back in with
his mother to make ends meet.

Convinced that he needed to earn more money to campaign
successfully as a Labour MP, John tried all sorts of different strate-
gies. He had already done a series of BBC broadcasts with populist
philosopher Cyril Joad, co-authoring the resulting volume of *After-
Dinner Philosophy*. In a bold new move, he headed to New York to
cash in on the high fees offered by the American lecture circuit. In
October 1928, John wrote excitedly to Lytton Strachey to warn his

cousin that he had dropped Lytton's name to Baroness de Hueck, a successful public speaker who was going to help him get bookings in the States. John timed his trip perfectly, as Lytton's *Elizabeth and Essex* was about to launch in America. Raymond Mortimer was in New York in January 1929, sending Lytton a firsthand account of the reactions:

> *Except for Lindbergh, you are the most popular man in New York. John Evelyn Strachey gets offers to lecture, merely because he bears your name . . . Hatless girls in the queues of theatres clutch Elizabeth and Essex and schoolmasters birch little boys for not being able to parse your paragraphs. So of course I shall say no ill of the Americans. Indeed, I am glad I came, for New York is various and beautiful, and full of surprises.*[405]

Lytton never went to America himself, so John's presence can only have added to the promotion of the Strachey brand. John's father had lectured at Yale and Harvard, and reviewed books for the *New York Times*, so there was already a degree of East Coast familiarity with the name. When in New York, John stayed with an old friend from Oxford: Joseph Brewer, now an editor at the publisher Payson & Clarke. Within weeks of arriving in America, John had been introduced to one of the new authors signed up by Brewer: Esther Murphy, whose *Life of Lady Blessington* "was scheduled for future publication."[406] Renowned for being the life and soul of any party, Esther was tall, single, and exceedingly rich. Like Cimmie Mosley, her fortunes were linked to an American retail empire. While Cimmie's grandfather Levi Leiter had co-founded Marshall Field & Company, Esther's father, Patrick Murphy, had acquired the Mark Cross leather goods brand, expanding the stores from Boston to New York and London. With factories in the Midlands, and a flagship outlet at 89 Regent Street, Mark Cross was promoted in the States as an

English maker of leather goods and gloves. By a strange coincidence the Mark Cross works were in Walsall, less than ten miles away from John Strachey's prospective parliamentary seat at Birmingham Aston.

John could hardly believe his good fortune: Esther's outlook was progressive and international, her circle as queer and creative as his own. She had traveled between Paris and New York since the early twenties, befriending the "Lost Generation" of American authors, many of whom had taken up temporary residence in France. Esther was particularly close to Scott and Zelda Fitzgerald, spending a memorable Christmas on Long Island with them and their friends John Dos Passos, Edmund Wilson, and Gilbert Seldes. In New York she would attend the informal salon hosted by Muriel Draper, a writer and social activist best known for her 1929 book *Music at Midnight*. In Paris she was a regular at Natalie Barney's weekly literary salon, where avant-garde writers mixed with members of the more traditional Académie Française; Barney started a rival "Académie des Femmes" to honor female authors, connecting Esther with writers such as Colette and Gertrude Stein and journalists like Djuna Barnes. Djuna produced an affectionate satire of the Barney salon in 1928, in which Esther appears as "Bounding Bess, noted for her enthusiasm for things forgotten," absorbed by "great Women in History . . . last seen in a Cloud of Dust, hot foot after an historic fact."[407] John found himself absorbed within a group of transatlantic writers and artists whose appetite for hard drinking and hard living put Young Bloomsbury to shame.

Seduced equally by the Mark Cross millions and the glamour of bohemian New York nightlife, John proposed to Esther. Their engagement was announced in February 1929: the *New York Times* trumpeted "Bachelor Heiress to Wed Kin of Lord";[408] *Time* magazine was more interested in John's relationship to Lytton Strachey, pitched as the biographer of Queen Victoria and Queen Elizabeth;

the *New York Journal*'s Cholly Knickerbocker column—famous for coining the term "café society"—covered the engagement and all the subsequent events. Esther's parents threw a formal drinks party for several hundred people at their Park Avenue apartment, and celebrations continued thereafter; according to writer and composer Max Ewing, "On the following nights it will be the same hundreds saying the same thing at Sarah King's or Muriel Draper's and elsewhere."[409] The pace of Esther's conversation could be exhausting, but this didn't seem to stop the flow of invitations. Arriving at one of the many events thrown in Esther's honor, acerbic writer Carl Van Vechten asked "why in heaven's name a party should be given for Miss Esther Murphy, who attended more parties than any living woman, never going to less than three a night."[410]

John and Esther had more in common than might immediately be supposed. Left-leaning without being a committed Marxist, Esther was entirely receptive to John's political views. Intellectually they seemed well matched: as well as being an aspiring biographer, Esther wrote book reviews for the *New York Tribune*, impressing contemporaries with her analytical approach. Frustrated by living at home with their parents, both longed for a more independent existence. Neither was physically attractive in the conventional sense, their features so striking that they tended to provoke strong reactions. John's mother had Sephardic Jewish ancestry, passing features to her son that led to persistent antisemitic comments. Lytton Strachey called St. Loe's wife "Oriental Amy,"[411] while Carrington saw John in terms of racist caricature: "A very tall, monstrously fat Jew, a Beardsley character . . . the drawing of the fop in Under the Hill by Beardsley."[412] Esther was mocked for her height, her prominent chin, and her masculinity. Critic Edmund Wilson compared her unfavorably to her brother: "All the masculine traits seem to be concentrated in Esther and all the feminine ones in Gerald."[413] Encouraged since early childhood to voice her opinions, Esther's confi-

dence challenged typical gender norms. Author and academic Lloyd Morris created a character in *This Circle of Flesh* who is thought to have been modeled on Esther: "She was a trifle too tall and a trifle too heavy. She had the figure of a Valkyrie, the broad and candid face of a plain boy, with a boy's brown hair, close cut. She had the warm, friendly, impersonal manners of a boy, likewise."[414]

Behavior that would have been seen as commanding or authoritative in a man was often interpreted as overbearing in a woman. Max Ewing remembered how hosts "would occasionally bring up a strange gentleman or a beautiful blonde and present them, but they would soon disappear, frightened away by the incomparable but intolerant onslaught of Esther Murphy's eloquence."[415] Those who stuck around long enough discovered that kindness was one of her overriding characteristics. Muriel Draper could forgive any amount of garrulity from someone who would write the next day declaring, "You were superb and magnificent last night as indeed you always are, what a particular and fortunate dispensation I think it is that I happen to be your contemporary."[416] Esther was also tolerant of difference, whether sexual or political. If her Catholic parents were likely to be shocked by her guests, then Esther would borrow a friend's apartment for the evening. Max Ewing lent his rooms at the top of the Life Building for a divorce party in honor of Emily Vanderbilt. Ewing was one of the young gay men who gathered round Muriel Draper and Carl Van Vechten, covering the walls of his walk-in closet with an ever-changing "Gallery of Extraordinary Portraits." Exhibited to the public at an Upper West Side gallery in 1928, the photographs form a visual representation of Esther's circle. Portraits of their friends are mixed with homoerotic images of bodybuilders, boxers, dancers, and athletes. Among the gay and lesbian icons on display were a range of British figures: Oscar Wilde, Radclyffe Hall, Cecil Beaton, and Vita Sackville-West, appearing rather appropriately in a pose from *Orlando*.

Queer friendship groups were familiar territory for John, who had spent years living with Eddy Sackville-West, and counted the bisexual MP Bob Boothby as one of his intimates. Esther's sexual interest in women was stronger than John's equivalent interest in men, but it was not a source of conflict. Bisexuality was par for the course in Bloomsbury circles, with John's cousins James and Alix providing a model example of how a marriage could be sustained alongside other same-sex relationships. Even though rumors of prospective engagements had surfaced in the past, Esther's female friends were surprised by the announcement. After two years of obsessive (and mostly unrequited) love for Parisian hostess Natalie Barney, Esther was released to start a new life with a new person in a new country. Barney claimed to find the news "startling and revelatory," fishing rather tactlessly for confirmation that Esther had actually tried sleeping with a man before committing: "I must rejoice with you that you not only foresee but experience happiness . . . I am glad that you recall our meeting not too bitterly . . . just how your nature may sanction this nouveau regime is a thing already ascertained?"[417]

John sent a long letter of explanation to one of his own former lovers—the French journalist Yvette Fouque:

I'm going to marry a girl called Esther Murphy—New York, Irish descent, extremely intelligent, not pretty, 6 feet tall, with some money and a very, very good person indeed. She, I think, loves me very much. This, my dearest Yvette, is if you will believe me, not foolishness, not mere lachete, or resignation to the lure of the dollar, but a deeply felt, and absolutely necessary development of my life. Of course, the fact that she has money is vitally important to me—ah, you know me well enough to know that—but please, please believe me that I have not foolishly rushed at the money, sacrificing too much for it. She is a deeply civilised, deeply and passionately intellectual person, to whom the cultural heritage of

man is life itself. She knows French literature and history, I really believe, as well as you do, and English literature and history far better than I do. She is the only other woman I have ever met whose intellectual equality I could never question . . . I know this marriage will inevitably strengthen and help my life. It will give me the objective ability to go in wholly for politics and also a certain inner strength to do so.[418]

Everything seemed set for a partnership of true equals, very much in the Bloomsbury mold, where gender was seldom seen as a barrier to intellectual or artistic achievement.

HONEYMOON AT
THE VILLA AMERICA

◆

With the British general election timetabled for May 1929, John was keen to move quickly. Esther and her family headed hotfoot to London for an April wedding. The *New York Times* noted that it was a quiet and simple affair, with "only the couple's relatives and close friends in attendance." Oswald Mosley, "the Labourite Member of Parliament,"[419] acted as best man, and Lord Strachie, the bridegroom's uncle, was also present. What the article gives no hint about is how the wider Strachey clan reacted to meeting Esther's glamorous brother and sister-in-law, Gerald and Sara Murphy. *Tender Is the Night* had yet to be written, so there would have been no possibility of guessing their future significance as character sources for Scott Fitzgerald. Thanks to Duncan Grant and Clive Bell's interest in the Parisian art world, the Stracheys may have had a bit more of a sense of Gerald's growing reputation as an American artist in Paris: his training with Natalia Goncharova, his friendships with Pablo Picasso and Fernand Léger, his attention-grabbing pictures at the Salon des Indépendants. If all else failed,

their ownership of a villa at Antibes would have provided a helpful shared topic for conversation: the Mosleys rented one there every summer, Lytton's sister lived farther along the coast at Roquebrune, while Duncan and Vanessa had their little place at Cassis. A London press agency photographer captured the wedding party chatting happily outside the Carlton Hotel; Gerald and Sara are smiling on the left, Esther and John facing toward the camera in the center, with Oswald Mosley just visible behind them. Everybody is covered in rice; Mosley had apparently told John's nieces to "throw it upwards, it hurts more."[420]

After the wedding, Gerald and Sara returned to their home in Paris, and the Murphy parents sailed back to New York. Postponing their honeymoon, John and Esther went straight to Birmingham Aston to start campaigning. According to John's biographer, Patrick Murphy had agreed to settle a satisfactory sum on his daughter, and the Mark Cross money could be put to immediate good use. In the May edition of the *Aston Labour News*, John declared, "I am almost overwhelmed by the enthusiasm of the campaign. Never have I seen Aston so determined on anything as on the election of a Labour representative on May 30th."[421] Esther issued her own leaflet, addressed to "The Women Electors of Aston." Her photograph appeared on the front cover, and the text made a personal appeal: "I am writing to you as a woman voter, in order to ask you to vote for my husband, John Strachey . . . I know his grasp of the problems which confront women, and his keen realisation of the urgent necessity of improving the living conditions of the people of Great Britain."[422]

Known colloquially as the "Flapper Election," 1929 was the first one in which British women under thirty were allowed to vote. Cimmie Mosley campaigned for her own seat in Stoke-on-Trent, and Esther did her best to support John in Birmingham, appearing beside him on platforms and speaking when required. According to Miss Berry in the *Aston Labour News*, John was shaping up to be the

perfect candidate: "I should never dream of giving my vote to any-one except the Labour man. No wide-awake young woman will ever support Liberals or Tories. John Strachey is the choice of the new women voters."[423] John was duly elected to Birmingham Aston with a majority of 1,558. Cimmie Mosley succeeded in Stoke-on-Trent, and Oswald Mosley romped home in Smethwick. Ramsay MacDonald's Labour government took office. John had high hopes; in an article for the *Socialist Review* he had already claimed that a new morality "would inevitably follow from a socialistic society: men would become either savages or socialists."[424]

As soon as the celebrations were over in Birmingham, John and Esther moved into the tall eighteenth-century house that Patrick Murphy had bought for them in Westminster. Conveniently close to the Houses of Parliament, Lord North Street runs directly into ultra-smart Smith Square, home to the Mosleys when they were in town, and the site of Stephen Tennant's extraordinary silver room. It's hard to know what John's working-class constituents would have made of the elegantly paneled interiors, ideal for political entertaining. And they would have been equally perplexed by the young couple's self-indulgent next step: Parliament was not due to meet again until the autumn, so John and Esther set off on their delayed honeymoon. After driving slowly down through France, they were due to end their journey at Cap d'Antibes, staying with Gerald and Sara in the Villa America. John braced himself for a deep dive into the American expat community.

So many myths have grown up around the Murphys and the South of France that it can be hard to separate fact from fantasy. Although they didn't invent the summer season on the Riviera, they were certainly among the pioneers. Gerald's Yale friend Cole Porter led the way, but it was the Murphys who came back year after year, helping to make the place popular with an international crowd. As Gerald explained:

We really owe Antibes to Cole Porter, who always had a great flair about places. He took Chateau de la Garoupe one summer in spite of the fact that no one went to the Riviera in the summer. Tourists would leave the moment it began to get warm . . . We fell in love with it right away.[425]

The Murphys liked it so much that they bought a small belle epoque villa—the Chalet des Nielles—and gave it a thorough New World makeover. American architects Hale Walker and Harold Heller added a second story with a flat-roofed sundeck, inserting mirrored fireplaces on the lower floors to reflect light from the big picture windows. Outside there were cheery yellow shutters and striped awnings, and a terrace shaded by a tall linden tree. The renamed Villa America, complete with brightly painted Stars and Stripes entrance sign, was ready for guests in July 1925; Esther Murphy and Scott Fitzgerald were among the crowd who visited that summer. As Fitzgerald ironically concluded in a letter to his friend John Peale Bishop:

There was no-one at Antibes . . . Except me, Zelda, the Valentinos, the Murphys, Mistinguett, Rex Ingram, Dos Passos, Alice Terry, the Macleishes, Charlie Bracket, Maud Kahn, Esther Murphy, Marguerite Namara, E. Phillips Oppenheim, Mannes the violinist, Floyd Dell, Max and Chrystal [sic] Eastman, ex-premier Orlando, Etienne de Beaumont—just a real place to rough it, to escape from all the world.[426]

Although the Murphys did entertain some of the artists they met in Paris—Picasso, Léger—most of their guests at Villa America were fellow Americans, and many arrived with introductions from Esther. The Fitzgeralds were a case in point; when they first set sail for France in 1924, Esther had suggested they look up her brother

and sister-in-law. Scott's heavy drinking and Zelda's obsessive be-
havior caused occasional blips in the friendship, but the two families
remained close for many years, connecting both in Paris and An-
tibes. Esther must have been looking forward to introducing her new
husband to her old friends, and, sure enough, Scott's personal ledger
records meeting both Stracheys and Murphys in August 1929. By
this stage the Fitzgeralds were renting a villa a little bit farther along
the coast at Cannes, and Scott was sending Hemingway a regular up-
date on the summer's events. According to the letters, Scott saw the
Murphys regularly, and they did a wonderful job cheering up Ameri-
can journalist Dorothy Parker, who was recovering from a broken
love affair: "The Murphys have given their whole performance for
her this summer and I think, tho she'd be the last to admit it, she's
had the time of her life."[427] No sooner had Parker departed than
the Stracheys arrived, followed shortly afterwards by Hemingway's
sister-in-law, Jinny Pfeiffer. Villa America was definitely living up to
its name.

It's hard to imagine that John was not impressed by meeting
the celebrated author of *This Side of Paradise* and *The Beautiful and
Damned*. What he thought of Gerald and Sara is harder to inter-
pret. The Murphys' modernism had a hard-edged, industrial quality,
very different from the playfulness of Bloomsbury. Gerald Murphy
painted huge canvases "depicting a futurist idea of the power of ma-
chinery."[428] Sara Murphy favored black, white, and metal for her
interiors—the only color provided by ceramics or textiles. John may
have perched rather nervously on the steel chairs upholstered in
shiny satin, or the iron garden furniture picked out in silver radiator
paint. The daily routine ran with well-oiled precision. In the morn-
ing Gerald painted in his studio while the children had their lessons.
At twelve the house party would gather on the beach for exercises
and swimming—walking or driving the short distance to Plage de la
Garoupe. Lunch would be followed by a siesta, then a trip, usually

rounded off by a swim at the Hotel du Cap. When not eating out, Gerald would mix cocktails on the terrace, a regulation two per person, before dining under the linden tree. On the surface, everything must have seemed as smooth and efficient as the ordered mechanical world of Gerald's pictures: turbines, engine rooms, the giant steaming funnels of an ocean liner. Even *Cocktail*—his iconic portrayal of a Jazz Age drinks tray complete with shaker, cigars, corkscrew, and lemon—follows a rigid geometric grid.

By the time John and Esther arrived at Villa America in August 1929, some of the restraints were beginning to loosen. Gerald was working on a slightly more organic piece—*Wasp and Pear*—described in detail in his artist's notebook; the wasp clings to the lush green pear, poised as if to sample the ripened fruit.[429] Riviera life encouraged a more relaxed expression of sensuality. Gerald enjoyed showing off his muscular body on the beach, performing elaborate calisthenics in his swimwear or sailing in the nude, wearing nothing but a jaunty sailor's cap. When clothed, he adopted the "jolly marin wear"[430] favored by Edward Burra, Jean Cocteau, and many other queer visitors to the Riviera: striped sailor tops, rope-soled espadrilles, and knitted caps. Man Ray photographed him naked on his boat—the *Picaflor*—while Picasso echoed his distinctive form in images of exercising bathers. Esther had always felt free to express her bisexuality, but Gerald's inhibitions were only released when he took a course of Jungian therapy. He began to make approaches to young men who sailed with him in the summer, sharing romantic reflections on their physical beauty:

> *the way the hair grows on your neck, the loose Greek mould of your body, your staring at the passing foam on the water, what brown looks like near you, the skin on your hands, your silence, your sudden height when you stand up. Should one remember these and a thousand more secret things?*[431]

A CHANGING WORLD

—————————◆—————————

John and Esther's honeymoon visit represented a last moment of family happiness before chaos descended. There was a sense of flying too close to the sun: in October 1929, Gerald and Sara's eldest son was diagnosed with life-threatening tuberculosis; in the same month the American stock market crashed, with devastating consequences for the Mark Cross brand. The Villa America remained a place for brief escape, but the days of long lazy springs and summers on the Riviera were gone. The Stracheys returned to London, while Gerald and Sara traveled across northern Europe, taking their sick child from clinic to clinic. Patrick Murphy struggled to keep Mark Cross afloat in New York as colleagues tumbled around him. The American Jazz Age had come to a sudden and bitter end; the ensuing European downturn was less dramatic but equally long-term. Deeply conscious of the impending economic crisis, John Strachey spoke rousingly in Parliament about unemployment in the capitalist world. If America was in decline, then trade with Russia would be vital.

John spent August 1930 trailing round factories in the Soviet

Union rather than basking in the sun on the Cap d'Antibes. John's Young Bloomsbury friends were less aware of the issues at stake, cushioned from the impact of the Great Depression by their incomes from writing or painting, which seemed little affected by the recent financial reversals. Few had major investments to lose, and cheap holidays in the South of France were still affordable for groups of young men who clubbed together to share a house. Eddy Sackville-West was one of many who headed to a borrowed villa at La Napoule for three months in the spring of 1930; Eddy hoped to work on his new novel, *Simpson*, while artists John Banting and Roland Penrose were expecting to paint. The poet Brian Howard and his lover Sandy Baird joined the stream of visitors passing through. When cash ran short, Eddy wrote to Raymond Mortimer to call in a loan: "Do send me that cheque soon, darling: the bank is threatening to cut me off & John [Banting] hasn't a penny, so that all the housekeeping devolves on Sandy and me."[432] Eddy managed to get some writing done despite the emotional dramas; as he concluded with some satisfaction to Raymond:

> *The weather here is heavenly, baking sun & glittering sea. Life has altogether its exhilerations* [sic], *since the lunacy continues de plus belle without disturbing Simpson, who is racing along. I really don't know how I manage to do it. A new situation has arisen between Sandy & me about an exceedingly good-looking, but undoubtedly louche young American, called Fred Healy. We are determined not to quarrel about it.*[433]

Old Bloomsbury tended to have more investments at risk, but they were able to carry on watching the young with amusement from the sidelines. Former *Vogue* fashion editor Madge Garland had a flat at rue d'Antibes in Cannes, which was only a few miles down the coast from La Napoule, and Clive Bell decided to rent the flat for six weeks in

the summer of 1930, sending wry accounts of the various goings-on. Bell was with his new lover, Benita Jaeger, a young German Jewish sculptress who loved to dance at the Gargoyle Club and wore sheer dresses apparently made of little more than two scarves sewn together. Clive and Benita happily observed the queer shenanigans at La Napoule; several members of the party were also sending letters to Lytton Strachey—thanking him for money, suggesting he come out to join them. John Banting gave Lytton a lingering description of the joys available:

> It is not yet overwhelmingly hot though I am able to write this on the terrace stripped to the waist in the most deliciously smooth warm sunlight. It is like early summer until three o'clock and after that like autumn. Eddy arrived yesterday. Clive is in Cannes (five miles off) and Sandy Baird is coming here next week . . . So that I can offer you plenty of society as bait—or solitude, which is possible in the village. It is so situated that one can either take several steps to the "Carlton" or several in the opposite direction into mountains of unearthly splendor and beauty—or equally happily sit here looking at the sea.[434]

While his friends were all sunning themselves at La Napoule, John Strachey was fighting for the political and economic future of the country. Oswald Mosley was the minister charged by the Labour government with finding a solution to the growing unemployment problem, and John was working as his political private secretary. When Mosley's recommendations were rejected, he resigned in disgust, launching his own political movement in February 1931. John switched to Mosley's New Party, hoping to negotiate a better future for the workingman. The decision was profoundly misguided. Mosley made less and less effort to hide his fascistic leanings, and by July 1931 most of the Labour MPs who had joined him resigned their

membership. Left without a party, John fought the October 1931 general election as an "Independent Workers" candidate but the seat fell to the Tories, and John disappeared into the political wilderness. With hindsight it seems extraordinary that Oswald Mosley was ever able to tempt a man of John's convictions away from the Labour Party, but Mosley was famously mesmeric, and amid the chaos of 1931 his New Party briefly seemed to offer a brighter future.

The Strachey marriage, already under pressure, spiraled into freefall. Esther found herself back in America, nursing first her father, then her mother, through terminal illness. John rekindled a previous relationship, abandoning Esther in New York immediately after her father's funeral to set up home with his lover in a cottage in Sussex. According to the writer Sybille Bedford, "The whole thing went to pieces en grand," with John "letting her down, her beloved father dying, then her mother's illness, the Mark Cross Company. Gerald being impossible. Suddenly no money."[435]

The Gordon Square Stracheys, preoccupied with Lytton's declining health, paid less and less attention to what their radical young cousin was up to. John's growing determination to split from Esther and marry his lover, Celia Simpson, was another perplexing step. Open marriages were common in Bloomsbury, but divorce was rare; even Julia Strachey remained married to Stephen Tomlin despite their eventual decision to live separate lives. Esther's lack of interest in sex with men, her desire for relationships with women, were issues accommodated within many Bloomsbury relationships. John's friend Joseph Brewer reflected the prevailing ethos when he suggested, "If it is the question of sleeping together that bothers you, let me say, the more I see of marriage . . . the less it seems to depend on this . . . the sex business, if sensibly and rationally handled, can be quite adequately arranged within or without its bounds."[436] According to Joseph, Esther was equally pragmatic, feeling that other aspects of a shared domestic life were much more important;

providing John was discreet, alternative sexual solutions could easily be found.

Esther had put up with a lot while living with John in London. Having moved in vibrant intellectual circles in New York and Paris, she was used to women voicing their opinions and finding an audience. By comparison, Mosley's clique seemed sexist and Eurocentric; they had extraordinarily little interest in American affairs, and expected women to take a back seat in political conversations. There is a depressing account of Esther breaking down in tears after an interminable lunch at Savay Farm, having sat entirely silent while all the men held forth; as John explained afterwards to Mosley, "That was because, in America, everyone listens to her."[437] As soon as she went back to the States, her frustrations were unleashed; Esther poured out her views "on the politics of all the world"[438] to her New York friends, and lunched in Southampton with Andrew Mellon, secretary of the US Treasury. Amabel Strachey's sympathies were firmly with her sister-in-law, who had gamely set out to talk about the American form of government at a New Party by-election despite the way she had been treated: "She is a hero and a goddess. I have seen a good many great women, but never one to surpass Esther, and never one so vulnerable, and inexperienced and exposed to the hard fate of being a human being."[439]

While Esther recharged her batteries in New York, John sought help from a psychoanalyst, thrashing about for a new way to earn a living. With Parliament off the table, writing seemed the obvious answer. Eddy Sackville-West's *Simpson* had done fairly well in 1931, winning the Femina Vie Heureuse prize for his detached account of the life of a nanny. Strachey chose a much more inflammatory subject for his new piece: *The Coming Struggle for Power: An Examination of Capitalism*. Published in 1932, *The Coming Struggle for Power* was described by the editor of the *New Statesman* as "the most single influential Marxist publication"[440] produced in the UK. Amusing and

easy to read, it reached a surprisingly broad audience for a work of political analysis. Left-wing publisher Victor Gollancz was pleased with the sales, and John was relieved to have found an alternative source of income. Even Strachey's old friend and sparring partner, the Tory MP Bob Boothby, was impressed:

> I've read the book with the greatest interest and congratulate you on your achievement. It is the first time the materialistic theory has ever been presented to the British public in readable form . . . it is a superb intellectual performance. Needless to say I disagreed with most of it.[441]

Reflecting on John's legacy, Labour cabinet minister Richard Crossman felt the book had a lasting impact:

> To the Socialist generation of the 1930s, the Coming Struggle for Power came as a blinding illumination. Suddenly they saw the class war with Strachey's abstract extremism, jumped with him to the conclusion that capitalism was a doomed failure, and rushed to the army of the Socialist revolution.[442]

By the time John's book was published in 1932, Esther had regained some of her verve. Virginia Woolf would have been impressed by her independence. Muriel Draper reported that Esther did not depend on John "emotionally, intellectually, or actually," nor did she see him as "the one hope and solution of her life."[443] What she wanted was equality, and if this could not be achieved by staying married, then they were better apart. Bob Boothby bumped into Esther when he was in New York and found her willing to forgive John's disappearance immediately after her father's funeral. A bargain had been broken—John should have stayed, as he'd accepted

her father's money—but Esther was forbearing. Esther told Bob that her life was in New York and Paris:

> *You should have seen her at a cocktail party last night. Right at the top of her form . . . She has, I think, lonely moments. But only moments. She can, and will, recapture the only sort of life which could ever have made her happy.*[444]

By choosing politics as an arena, John Strachey had already pushed well beyond the comfort zone of his Young Bloomsbury friends. By choosing Esther, he had ventured even further—into the international world of the Lost Generation of American authors and their expat community in Paris and the Riviera. But neither of these experiments were total failures. They shared the same root cause—the rejection of the traditional social and moral ideology of the British upper classes, the desire to find an alternative way of living. In this regard John was more philosophically aligned with his Old Bloomsbury relations than might have been supposed, but he never succeeded in rousing them to direct political action, nor did he trigger an immediate exodus to the United States. Lytton and Virginia were content to let their publications speak for themselves, building an audience for Bloomsbury in America that survives to this day, unburdened by the British preoccupation with the subtle nuances of class privilege.

EPILOGUE

◆

Looking back on the twenties from the gloomy depths of 1931, Scott Fitzgerald decided that the Jazz Age "leaped to a spectacular death in October, 1929."[445] John Strachey followed the roller-coaster ride all the way to its end—marrying a US heiress just before the Wall Street crash, then watching his fortune and his glittering political future ebb slowly away. John's Bloomsbury friends and relations did not suffer such dramatic losses in 1929, but they knew the world was changing around them. As the optimism of the twenties gave way to the harsh reality of the thirties, many faced uncertainty. Old Bloomsbury had drawn energy from their young admirers, and given them support in return. Together they had pioneered an inclusive way of living not seen again for another century—a brief flowering of intergenerational acceptance, pushing at gender boundaries, flouting conventions, embracing sexual freedom. In the chill climate of the thirties, self-expression came to be seen as exhibitionism, and the sense of bravura faded away. The pace of activity had been exciting but self-destructive; members of Young Bloomsbury were left ex-

hausted, with many focusing on their own emotional survival, rather than the production of a lasting creative output.

Mass unemployment and hunger marches provided a sobering backdrop. If the press were already hostile to "painted boys" and "women in suits," now they turned against the "Bright Young Things" and any social or artistic expression that hinted at frivolity. Adaptation of behavior was required, and for many in Bloomsbury the turning point came with the premature deaths of Lytton and Carrington in 1932. Shock waves of grief flowed inexorably from Ham Spray; bleaker days seemed to lie ahead, but there was comfort to be found in a shared approach to adversity.

As Lytton lay dying of cancer, his chosen family and his biological family gathered around him. Ralph and Carrington occupied their usual position in the main house; siblings and friends stayed nearby, moving back and forth as requested. Virginia relayed Vanessa Bell's description of the local hotel, "filled with Stracheys reading detective novels in despair":

> In comes Ralph. Silence. "Would you like to come, Pernel?" Pernel elongates herself & goes to get ready. "Gently fading away?" says Oliver. Ralph nods . . . Carrington moving about scarcely knowing people; Pippa violently self-controlled . . . Tommie helping, too.[446]

If Bloomsbury had modeled a way of living, now they modeled a way of dying—with all your loved ones around you, young and old, queer and straight. Feelings ran high, but no one was deliberately set aside or pushed away; ties of affection held the same status as ties of blood. Lytton's strength ebbed and flowed over the month of January 1932, with telephone bulletins reaching those who could not be there in person. Virginia felt they were all teetering on the brink; one minute Lytton was better, the next weaker—it was "like having

the globe of the future perpetually smashed—without Lytton—& then, behold, it fills again."[447] On the morning of January 21, four days before Virginia's fiftieth birthday, Lytton finally slipped away. His possessions passed to those who loved him, giving equal honor in death to those who had supported him in life. Ham Spray had already been registered in Ralph's name. Carrington received Lytton's capital—£10,000—all his paintings, and his natural history books. To Roger Senhouse went Lytton's pre-1841 antiquarian books, with the book plates engraved by Carrington. James Strachey acted as his brother's literary executor, inheriting the copyrights and the remainder of the personal estate—including the letters sorted so carefully by Sebastian Sprott.

However supportive the Bloomsbury framework, however inclusive the careful planning of queer inheritance, nothing could console Carrington for the loss. Her and Ralph's role as grieving partners to Lytton seem to have been tacitly understood, and respected, by all involved. While Ralph's misery was noisily expressive—with outbursts of wild sobbing—Carrington's was dangerously contained. Lytton meant more to her than anyone on earth, and life was going to be insupportable without him. Her first attempt at suicide came while Lytton was still on his deathbed: the nurse had unwisely told her he was unlikely to survive the night, so she crept into the locked garage in the early hours of the morning. Ralph woke in time to pull her from the car before she could asphyxiate herself, but this was an ending postponed, not preempted. For the remaining weeks of her life she sorted bleakly through Lytton's things, responding to letters of condolence, offering tokens of remembrance. On March 11 she wrapped herself in Lytton's yellow dressing gown and shot herself with a borrowed gun. It was Bunny Garnett who drove Ralph from London at breakneck speed so that he could see his wife before she died, and Stephen Tomlin who went round to the Woolfs to share the tragic news.

One of the saddest moments in Bloomsbury history became one of their finest. Any remaining boundaries between the generations were set aside as they mourned together; there was a shared refusal to allow Carrington's life to be defined by her death, a desire to honor the memory of a profoundly irreverent spirit. Over the coming years, relationships shifted, friendships drifted apart, but the sense of "family" remained. As Young Bloomsbury grew up, Old Bloomsbury found itself exposed to new pressures. Success led to inevitable accusations of complacency; the tide of fashion was moving on, and it took very little effort for journalists to score cheap points by portraying the former avant-garde as privileged self-promoters. Clive Bell and Desmond MacCarthy retained their positions as leading critics, but they were seen increasingly as voices of the establishment rather than the new wave. Duncan Grant and Vanessa Bell found their output dismissed as decorative and whimsical, suffering humiliatingly low sales from their *Music Room* exhibition of 1932. Lytton Strachey's *Eminent Victorians* was still admired, but his *Elizabeth and Essex* came to be seen in the same frothy light. Only Virginia Woolf remained a figure of respect—both for her own work and her encouragement of new writing through the Hogarth Press.

For some, the double tragedy at Ham Spray foreshadowed an uncertain future; for others, it signaled new beginnings. Ralph Partridge and his lover Frances Marshall married in 1933 and they decided to stay on at Ham Spray, living amidst Lytton's and Carrington's things, perpetuating their memory through daily contact with their intimate possessions. Continued occupation was an act of celebration, an act of love; although the building had been Ralph's joint home since 1924, every surface had been decorated by Carrington. Many of the works of art had been created by Carrington herself; the rest had been collected or commissioned by Lytton—from Duncan Grant, from Stephen Tomlin, or from other artist friends. Ralph's inheritance was complex; via Carrington he received all of Lytton's

money, his paintings and sculptures, and all of the photograph albums recording their years at Ham Spray. Frances took over Carrington's role as resident photographer, and the results are uncanny. The same groups of Bloomsbury friends stand in the same rooms or sit around tables on the same lawns. But the two key creative figures are missing—the writer and the artist have gone, superceded by what Virginia Woolf described as a "rough parody"[448] of the old regime. Excited by nudity, Ralph was prone to appearing stark naked bearing a cup of tea and pursuing labored conversations about genitalia.

Julia Strachey was one of the lucky few who thrived in the immediate aftermath: her first book, *Cheerful Weather for the Wedding*, came out in November 1932, achieving her long-held ambition to be a published author. She embarked on a series of affairs with wealthy lovers and took a job at Barbara Ker-Seymer's photography studio in Mayfair. Ker-Seymer's albums reveal a happy and smiling Julia dressed in ever more glamorous clothes, surrounded by the many friends and relations who came to have their portraits taken at the studio. She was a frequent visitor to Ham Spray, bringing different lovers at different times of year, before finding a more permanent attachment with a much younger man. Stephen Tomlin, never popular with either Partridge, found himself unwelcome in his former Eden. When Julia struck out on her own in 1934, emboldened by support from Ralph and Frances, Tommy was left to his own devices. Drink and drugs gradually took their toll on an already weakened system, and he died at the age of thirty-five from septicemia. Virginia Woolf remembered the curious contrasts: the "great gift for making people love him," the "profound distaste and uneasiness," the tendency to get "wound up in the miserable intricacies of his own psychology."[449] For Bunny Garnett, the joy always outweighed the despair:

There are in all circles figures universally beloved, at whose approach the faces of men and women brighten . . . Stephen Tomlin

was one of those figures of terrific charm, with whom most ordinary people frankly fell in love, irrespective of age or sex . . . his portraits were extraordinarily full of character."[450]

Julia inherited Tommy's property, but Bunny promoted his artistic legacy, bringing key works together in a shrine-like display at his home in Cambridgeshire. Today many of his pieces are in public collections, providing some of the best-known images of Bloomsbury figures. Tommy's bust of Virginia Woolf stares out from a pedestal in Tavistock Square, and from the garden wall at Monk's House, now owned by the National Trust. Another version sits in Duncan Grant's studio at Charleston, reflected in a mirror so she can be viewed from all angles. His bronze head of Lytton Strachey can be seen at the Tate Gallery and at Charleston; his portrait of Duncan Grant has a version in the National Portrait Gallery and another at Knole—acquired by Eddy Sackville-West for his rooms in the Gatehouse Tower. The sculptures feel timeless and monumental, expressing the differing relationships between carver and sitter, the subtleties of their individual personalities. Tommy usually modeled his pieces in clay or plaster before casting in bronze. Occasionally he worked in stone, and this was the material chosen for the brooding head of Bunny Garnett that lies in wait for the unwary modern visitor to Charleston. Leaning forward over hunched shoulders, he looks ready to pounce.

Lytton had once encouraged Ralph Partridge to break free from his family's restrictive career ambitions. His impact on Roger Senhouse was equally profound: in 1935, Senhouse finally escaped from his hated job in the City, pairing up with Fredric Warburg to rescue a publishing house from receivership. Secker & Warburg became well-known as the publishers of George Orwell's *Animal Farm* and other works of the anti-Stalinist left. Lytton would have been equally interested in their promotion of French authors—including

a series of fine translations of Colette and Simone de Beauvoir by Roger himself.

Eddy Sackville-West carried on writing through the thirties, winning the James Tait Black Memorial Prize for A *Flame in Sunlight*, his 1936 biography of Thomas De Quincey. Raymond Mortimer, evolving into a leading literary critic under the tutelage of Desmond MacCarthy, tended to be more generous in praise than his master. As literary editor for the *New Statesman*, and a long-term reviewer for the *Sunday Times*, his feedback could be very helpful. Bunny Garnett was equally supportive, particularly where friends were concerned. Reviewing Eddy's De Quincey biography for the *New Statesman*, Bunny decided "Mr Sackville-West has succeeded brilliantly because he was not content to look at the Opium-eater intelligently with a 'fresh eye,' but [was] ready to plunge deep into his subject, study it profoundly and live with it for a long time."[451]

Although Sebastian Sprott and Dadie Rylands followed traditional academic career paths, their personal lives remained determinedly unconventional. Dadie nurtured the dramatic talents of successive generations of students at King's College, Cambridge, leaving a voluminous archive of letters filled with delicious hyperbole. In term time, Sebastian Sprott worked diligently away at the University of Nottingham, becoming a professor in 1948. In the holidays and at weekends, Sebastian teamed up with E. M. Forster and J. R. Ackerley to explore queer nightlife in London. Snobbish contemporaries seemed surprised by their lack of class prejudice, their willingness to consider relationships with working-class men. Sebastian was even criticized for allowing young men who had recently been released from prison to stay in his Nottingham home. In later life he abandoned "Sebastian," the rather pretentious nickname adopted when he joined the Cambridge Apostles, reverting to Jack—a step closer to his more prosaic original forenames: Walter John Herbert. Forster supported his friend loyally over the years, topping up

his income and eventually making Sprott a significant beneficiary of his will.

Legacies of this type provide an enduring record of the queer families established at a time when biological families were the only frameworks given official status. Raymond Mortimer's primary beneficiary was his long-term lover Paul Hyslop, with whom he shared a house in London. Eddy Sackville-West's arrangements were more complex. While the bulk of his financial estate went to a cousin, his personal collections went to three of the most important men in his life: his books to Raymond Mortimer, his modern paintings to the artist Eardley Knollys, his piano and his gramophone records to the music critic Desmond Shawe-Taylor. Along with Eddy, each owned a quarter share of an attractive Georgian house in the village of Long Crichel in Dorset. They came together at weekends, creating what diarist James Lees-Milne described as an atmosphere of "hilarity from beginning to end":

> Unlike Garsington, it was quite unselfconscious. You were left alone. There was nothing organized. And there was never any nonsense about tete-a-tete conversations. Everyone joined in.[452]

Edward Le Bas painted a gloriously harmonious conversation piece of the four Long Crichel boys relaxing on the sofas in their cozy sitting room. James Lees-Milne waxed lyrical in his description of early visits:

> Eardley, Desmond and Eddy live a highly civilised existence here. Comfortable house, pretty things, good food. All the pictures are Eardley's, and a fine collection of modern art too. After dinner Desmond read John Betjeman's poems aloud, and we all agreed they would live.[453]

Eminent figures from the world of literature and the arts could often be encountered—E. M. Forster, Graham Sutherland, Somerset Maugham, Benjamin Britten—but it was equally amusing to be there on your own, particularly if you understood the meaning of words like "callipygian" when applied to classical sculpture. (The *Callipygian Venus*, or "Venus of the Beautiful Buttocks," had famously been admired by John Evelyn in January 1645—"that so renowned piece of a Venus pulling up her smock, and looking backwards at her buttocks.")[454] Frances Marshall was slightly intimidated when she first came to stay, but returned on many occasions:

> It struck me at once that what made the company of the four members of the Long Crichel quartet so highly enjoyable was that each played his individual and very different part in delighted awareness of the other three—as of course every quartet should.[455]

Had he survived to see it, Lytton Strachey would have found much to admire in the home co-created by two of his Oxford young men. There was a generosity of spirit in their endeavor, a sense of intellectual aspiration, and more than a touch of the familiar: Stephen Tomlin's bust of Eddy stood welcomingly in the hall, and Grants and Bells were hung liberally on the walls. Raymond and Eddy had spent their formative years in Old Bloomsbury, immersed in a confidently rebellious culture. For Maynard Keynes there had been a sense of defiance in breaking new ground: "We repudiated entirely customary morals, conventions and traditional wisdom. We were . . . immoralists."[456] Young Bloomsbury learned early on that the unacceptable was acceptable, and found fewer barriers to strike down.

ACKNOWLEDGMENTS

My thanks go firstly to the Strachey cousinhood, who opened their doors, dived headfirst into trunks, rummaged through piles of papers, and shared stories over the dinner table. From Sussex to Snowdonia, from Wimbledon to New Zealand, I'm tremendously grateful to you all. Particular thanks go to Samia Al-Qadhi, for providing access to her grandfather's archive, and to Rachel Garden, for sharing her insights into Amabel Williams-Ellis, John St. Loe Strachey, and Amy Strachey. I'd also like to thank Robin Llywelyn and the curator at Portmeirion, Rachel Hunt, for their research into the work of Stephen Tomlin and Simon Bussy at Portmeirion. Sincere thanks to my father, who provided unceasing encouragement and dredged deep into the collective family memory, giving me a completely new perspective on the life of Julia Strachey. I am profoundly indebted to all those who have guided me regarding permissions for quotations from members of the Strachey family. I would especially like to thank Paul Levy, Mark Le Fanu, the Strachey Trust, the Society of Authors, Lavinia Grimshaw, Charles Wentzel, the Women's Library

ACKNOWLEDGMENTS

at LSE, Pippa Harris, Tamsin Armour, Rachel Garden, Samia Al-Qadhi, Amy Jenkins, and Henry Strachey.

Special thanks must also go to the descendants, relations, chosen families, literary executors, and copyright holders of all the other Bloomsbury figures mentioned in the book; so many of you have helped me during the writing process. I am particularly grateful to Oliver Garnett, the grandson of David Garnett, who shared his research on Stephen Tomlin and kindly provided comments on my Julia Strachey chapter. Sophie Partridge and Virginia Nicholson gave me much-needed encouragement when I was writing during the COVID-19 lockdown, and Gill Coleridge guided me on permissions for quotations from Dora Carrington, Ralph Partridge, and Frances Partridge. I'd like to thank Richard Shone regarding permission for Eddy Sackville-West, and Norman Coates for providing a magical tour of the pictures collected by Eddy Sackville-West and Eardley Knollys. Thanks go to David Tennant, Ivan Tennant, and Emma Tennant for their help with Stephen Tennant. I'd also like to thank Patricia McGuire for her thoughtful guidance at King's College Archive, and Francois Chapon for advising me on Natalie Barney. I am grateful to all of the following: Sarah Baxter at the Society of Authors; Dr. S. O. Lucas; Dan Fenton at Peters, Fraser & Dunlop; Safae El-Ouhabi at Rogers, Coleridge and White; Marva Jeremiah at Penguin Random House; Mary Kitto at the Jack Lander Foundation; the Hanbury Agency; Dan Trujillo at the Artists Rights Society; Alex Kane at WME Entertainment; Louis Jaquet at DACs; and Isobel Howe at the Authors League Fund.

I am deeply indebted to previous generations of Bloomsbury scholars and archivists, who ensured that so many relevant images, letters, and diaries are available both online and in print. I'd like to thank Paul Levy, the editor of Lytton Strachey's letters, and Anne Chisholm, the editor of Carrington's letters, for their guidance in the early stages of my project. Jennifer Holmes, Michael Bloch, and

Susan Fox were extremely generous in sharing information on Julia Strachey gathered during their respective research into the lives of Ray Strachey and Stephen Tomlin. Professor Maggie Humm kindly read through chapter 1 and gave me feedback on the early days of Bloomsbury. I am also grateful to Nathaniel Hepburn and Dr. Darren Clarke at Charleston, the National Trust team at Knole, Dr. Mark Hussey, Professor Allan Hepburn, Simon Fenwick, Alexandra Harris, and James Beechey.

I am sincerely grateful to my editors, Lisa Highton, Kate Craigie, and Peter Borland, and assistant editor Charlotte Robathan, for all their input and advice, and to my agent Martin Redfern for his support and encouragement. At John Murray Press, I am indebted to Charlotte Hutchinson, who arranged the publicity for the book, and Juliet Brightmore, who provided excellent picture research. I'm also extremely grateful to Susannah Stone, who researched the literary copyrights.

Finally, a great many thanks go to my husband, Harry, and my child, Cas, for bearing with me as I followed in the footsteps of previous Stracheys and buried myself in Bloomsbury. Cas, this book is for you, and for all those who push beyond the binary.

NOTES

1 Carole Marks and Diana Edkins, *The Power of Pride: Stylemakers and Rulebreakers of the Harlem Renaissance*, Crown, 1999, p. 158

2 Lincoln Kirstein, *Mosaic*, Farrar, Straus & Giroux, 1994, p. 61

3 Duncan Grant to Mina Kirstein, 12 August 1923, quoted in Emily Bingham, *Irrepressible: The Jazz Age Life of Henrietta Bingham*, Farrar, Straus & Giroux, 2015, p. 101

4 Collective term used to describe early members of the Bloomsbury Group, used by Virginia Woolf as the title for her 1928 paper for the Memoir Club, and by many members of the group in letters and publications thereafter.

5 *Vogue*, July 1925, p. 52, quoted in Nicola Luckhurst, *Bloomsbury in Vogue*, Cecil Woolf, 1998, p. 7

6 Duncan Grant exhibition review by Sir Claude Phillips, *Daily Telegraph*, 16 February 1920

7 Quentin Bell, *Bloomsbury*, Phoenix Giant, 1997, p. 85

8 *Vogue* editorial, late October 1925, p. 55, quoted in Carolyn Hall, *The Twenties in Vogue*, Octopus Books, 1983, p. 32

9 Frances Partridge, *Love in Bloomsbury*, Tauris Parke Paperbacks, 2014, p. 92

10 Ibid., p. 76

11 Duncan Grant exhibition review by Sir Claude Phillips, *Daily Telegraph*, 16 February 1920

12 *The Diary of Virginia Woolf*, Volume II, 7 November 1922, p. 211

13 Clive Bell, *Old Friends, Personal Recollections*, Cassell, 1988, p. 132

14 Molly MacCarthy coined the term "Bloomsberries" c. 1910/11. See Hugh and Mirabel Cecil, *Clever Hearts: Desmond & Molly MacCarthy*, Victor Gollancz, 1991, p. 115

15 *Vogue*, 1927, quoted in Hall, op. cit., p. 32

16 Virginia Woolf, *Moments of Being*, Triad, 1986, p. 200

17 Press release for the Gargoyle Club, 16 January 1925, quoted in Michael Luke, *David Tennant and the Gargoyle Years*, Weidenfeld & Nicolson, 1991, p. 2

18 *The Diary of Virginia Woolf*, Volume V, 22 November 1938, p. 188

19 *Vogue*, book review by Raymond Mortimer, early March 1924, p. 63

20 Frances Partridge, *Love in Bloomsbury*, op. cit., p. 92

21 Raymond Mortimer, *Sunday Times*, 11 November 1956, quoted in Michael Yoss, *Raymond Mortimer: A Bloomsbury Voice*, Cecil Woolf, 1998, p. 4

22 Raymond Mortimer to Lytton Strachey, June 1927, Strachey Papers, British Library, Add Ms 60678

23 *The Letters of Virginia Woolf*, Volume 4, Letter 2218, 15 August 1930, p. 200

24 Dadie Rylands to Lytton Strachey, 3 March 1923, Strachey Papers, British Library, Add Ms 60695

25 Alix Strachey to Eddy Sackville-West, 31 October 1927, Eddy Sackville-West Papers, British Library, Add Ms 68905

26 *The Diary of Virginia Woolf*, Volume III, 19 April 1925, p. 10

27 *The Diary of Virginia Woolf*, Volume II, 19 February 1923, p. 235

28 Pippa Strachey to Constance Strachey, 22 October 1919, collection of Nino Strachey

29 Julia Strachey quoting Alys Pearsall-Smith, from Frances Partridge, *Julia: A Portrait of Julia Strachey by Herself and Frances Partridge*, Little, Brown, 1983, p. 50

30 Marjorie Strachey, "Reminiscences of Bloomsbury," typed autograph essay, read by Marjorie Strachey to the Ulster Garden Club, Kington, New York, 17 June 1954, Dale Steffey Books, Bloomington, Indiana

31 Virginia Woolf, *Moments of Being*, pp. 200–201

32 Ibid., p. 201

33 Vanessa Bell, *Notes on Bloomsbury*, reprinted in S. P. Rosenbaum (ed),

The Bloomsbury Group: A Collection of Memoirs, Commentary and Criticism, University of Toronto, 1975, pp. 79–80

34 Desmond MacCarthy, *The Influence of Henry James: Lytton Strachey's Cambridge*, reprinted in ibid., p. 32

35 Vanessa Bell, *Notes on Bloomsbury*, reprinted in ibid., p. 79

36 Clive Bell, *Old Friends, Personal Recollections*, p. 129

37 Virginia Woolf, *Roger Fry: A Biography*, Vintage, 2003, p. 178

38 Lytton Strachey to Leonard Woolf, 26 January 1906, Paul Levy (ed), *The Letters of Lytton Strachey*, Farrar, Straus & Giroux, 2005, p. 95

39 Virginia Woolf, *Roger Fry*, p. 194

40 Leonard Woolf to Janet Case, 27 December 1914, quoted in Victoria Glendinning, *Leonard Woolf: A Life*, Pocket Books, 2007, p. 189

41 *Burlington Magazine*, Vol. 28, No. 152, November 1915, p. 80

42 *Illustrated Sunday Herald*, 24 October 1915, p. 17

43 Ibid.

44 Clive Bell, *Old Friends*, p. 128

45 Clive Bell to Lytton Strachey, c. 1911, Levy, op. cit., p. 205

46 Ibid.

47 Lytton Strachey to Bernard Swithinbank, 1 July 1905, ibid., p. 71

48 Clive Bell to Lytton Strachey, c. 1911, ibid., p. 205

49 Clive Bell, *Old Friends*, p. 131

50 *The Letters of Virginia Woolf*, Volume 2, Letter 1336, 25 December 1922, p. 596

51 Dora Carrington's diary, 11 February 1932, David Garnett (ed), *Carrington: Letters and Extracts from Her Diaries*, Jonathan Cape, 1970, p. 491

52 *The Diary of Virginia Woolf*, Volume I, 6 June 1918, p. 153

53 Dora Carrington to Mark Gertler, August 1916, quoted in Gretchen Gerzina, *Carrington: A Life of Dora Carrington, 1893–1932*, Oxford University Press, 1990, p. 89

54 Julia Strachey, "Carrington, A Study of a Modern Witch," from Frances Partridge, *Julia: A Portrait of Julia Strachey by Herself and Frances Partridge*, pp. 119–20

55 Ibid.

56 Ralph Partridge to Lytton Strachey, 3 February 1920, Strachey Papers, British Library, Add Ms 60690

57 *The Letters of Virginia Woolf*, Volume 3, Letter 1456, 4 September 1924, p. 129

58 Ralph Partridge poem, addressed to Lytton Strachey, Strachey Papers, British Library, Add Ms 60690

59 *The Diary of Virginia Woolf*, Volume I, 24 January 1919, pp. 235–36

60 Cyril Connolly quoted in Michael Holroyd, *Lytton Strachey: A Critical Biography. Volume II: The Years of Achievement (1910–1932)*, Heinemann, 1968, p. 329

61 *The Diary of Virginia Woolf*, Volume I, 24 January 1919, pp. 235–36

62 Ibid., 22 January 1919, p. 234

63 Ibid., p. 235

64 *The Diary of Virginia Woolf*, Volume II, 13 February 1920, p. 18

65 Roger Fry in the *New Statesman*, 21 February 1920, quoted in Frances Spalding, *Duncan Grant: A Biography*, Pimlico, 1998, p. 225

66 Clive Bell in the *Athenaum*, 6 February 1921, quoted in ibid, p. 225

67 Tate Gallery catalogue entry for *Venus & Adonis*, 1972

68 David Garnett, *The Familiar Faces*, Chatto & Windus, 1962, pp. 1–2

69 Frances Partridge, *Love in Bloomsbury*, pp. 77–78

70 Ibid., pp. 91–92

71 *The Letters of Virginia Woolf*, Volume 3, Letter 1524, 24 January 1925, p. 155

72 *The Diary of Virginia Woolf*, Volume II, 4 June 1923, p. 243

73 *The Letters of Virginia Woolf*, Volume 3, Letter 1534, 5 February 1925, p. 154

74 Cecil Beaton's diary, quoted in D. J. Taylor, *Bright Young People: The Lost Generation of London's Jazz Age*, Vintage, 2008, p. 211

75 Hugo Vickers, *Cecil Beaton: A Biography*, Primus, 1985, p. 89

76 Cecil Beaton, 12 January 1927, quoted in ibid., p. 90

77 Dora Carrington to Gerald Brenan, 27 September 1924, quoted in Gerzina, op. cit., p. 210

78 Lytton Strachey MS Poem, Sotheby's Charleston Catalogue, 21 July 1980, lot 284, quoted in Cecil and Cecil, op. cit., p. 217

79 Maurice Bowra, *Memories*, Weidenfeld & Nicolson, 1966, quoted in Michael De la Noy, *Eddy: The Life of Edward Sackville-West*, Bodley Head, 1988, p. 80

80 Dadie Rylands to Lytton Strachey, 17 September 1927, Strachey Papers, British Library, Add Ms 60695

81 *The Letters of Virginia Woolf*, Volume 3, Letter 1719, 18 February 1927, p. 335

82 Ibid., Letter 1725, 8 March 1927, p. 343

83 Ibid., Letter 1846, 21 January 1928, p. 448

84 Lytton Strachey to James Strachey, 26 November 1921, quoted in Robert Skidelsky, *John Maynard Keynes: The Economist as Saviour, 1920–1937*, Papermac, 1994, p. 92

85 Lytton Strachey to Ralph Partridge, 24 June 1922, quoted in Michael Holroyd, *Lytton Strachey: A Critical Biography*, p. 459–60

86 Lytton Strachey to Dora Carrington, 1 January 1924, Levy, op. cit., p. 532

87 Ibid.

88 John Forrester and Laura Cameron, *Freud in Cambridge*, Cambridge University Press, 2017, p. 197

89 Lytton Strachey to Sebastian Sprott, 7 May 1926, Levy, op. cit., p. 552

90 Frances Partridge, quoted in Peter Jones (ed), *George Humphrey Wolferstan Rylands 1902–99: A Memoir*, King's College Cambridge, 2000, p. 30

91 *The Letters of Virginia Woolf*, Volume 3, Letter 1486, July 1924, p. 120

92 Cecil Beaton, quoted in Robin Muir, *Cecil Beaton's Bright Young Things*, National Portrait Gallery, 2020, p. 43

93 *The Diary of Virginia Woolf*, Volume II, 11 September 1923, p. 266

94 *The Diary of Virginia Woolf*, Volume II, 15 October 1923, p. 271

95 *The Letters of Virginia Woolf*, Volume 3, Letter 1515, 29 November 1924, p. 145

96 Lytton Strachey to Mary Hutchinson, 26 August 1927, Levy, op. cit., p. 573

97 Duncan Grant quoted in Simon Watney, *The Art of Duncan Grant*, John Murray, 1990, p. 55

98 *The Letters of Virginia Woolf*, Volume 3, Letter 1520, 26 December 1924, pp. 149–50

99 Ibid.

100 *The Diary of Virginia Woolf*, Volume II, 13 December 1924, p. 324

101 Dora Carrington to Julia Strachey, Summer 1926, Anne Chisholm (ed), *Carrington's Letters*, Chatto & Windus, 2017, p. 298

102 Dora Carrington to Gerald Brenan, quoted in Michael Holroyd, *Lytton Strachey*, Vintage, 1995, p. 575

103 Dimitri Mirsky, *The Intelligentsia of Great Britain*, trans. Alex Brown, Victor Gollancz, 1935, p. 113

104 *The Letters of Virginia Woolf*, Volume 3, Letter 1807, 3 September 1927, p. 419

105 Lytton Strachey to Dora Carrington, 16 April 1925, Levy, op. cit., p. 544

106 *Vogue*, October 1925, quoted in Hall, op. cit., p. 20

107 *Vogue*, February 1925, op. cit., p. 65

108 Raymond Mortimer, "Revelation of a Tortured Soul," *Sunday Times*, 21 November 1965, quoted in Yoss, op. cit., p. 5

109 Duncan Grant to Vanessa Bell, April 1925, quoted in Spalding, op. cit., p. 314

110 *The Diary of Virginia Woolf*, Volume III, 27 June 1925, p. 33

111 Vanessa Bell to Raymond Mortimer, 19 April 1925, Regina Marler (ed), *Selected Letters of Vanessa Bell*, Bloomsbury, 1993, pp. 284–85

112 Raymond Mortimer and Dorothy Todd, *The New Interior Decoration*, B. T. Batsford, 1929, p. 28

113 *The Diary of Virginia Woolf*, Volume II, 5 September 1923, p. 264

114 George "Dadie" Rylands to Lytton Strachey, 26 December 1929, Strachey Papers, British Library, Add Ms 60695

115 George "Dadie" Rylands, quoted in Pamela Todd, *Bloomsbury at Home*, Pavilion Books, 1999, p. 83

116 Michael Holroyd, *Lytton Strachey: A Critical Biography*, p. 486

117 Public General Acts 48–49 Vict, London, 1885, 6, Section 11

118 Public General Acts 2–3 Geo V, London, 1912, 91–2, Sections 5, 7

119 Roy Harrod, *The Life of John Maynard Keynes*, Macmillan, 1951, pp. 317–38

120 Frances Partridge, *Love in Bloomsbury*, p. 172

121 David Garnett, *The Familiar Faces*, p. 11

122 Ibid., p. 12

123 Dora Carrington to Gerald Brenan, 1 June 1923, Anne Chisholm (ed), *Carrington's Letters*, p. 248

124 Ibid.

125 Clive Bell, "The Creed of an Aesthete," *New Republic*, January 1922

126 Ibid.

127 *The Diary of Virginia Woolf*, Volume II, 15 December 1922, pp. 216–17

128 *The Diary of Virginia Woolf*, Volume II, 9 January 1924, p. 283

129 *The Diary of Virginia Woolf*, Volume III, 14 September 1925, p. 42

130 *The Letters of Virginia Woolf*, Volume 3, Letter 1456 to Janet Case, April 12, 1924, p. 97

131 *The Diary of Virginia Woolf*, Volume II, 15 December 1922, p. 217

132 *The Diary of Virginia Woolf*, Volume III, 28 February 1927, p. 129

133 *The Diary of Virginia Woolf*, Volume III, 5 September 1926, p. 108

134 *The Diary of Virginia Woolf*, Volume III, 19 April 1925, p. 10

135 *The Diary of Virginia Woolf*, Volume II, 28 July 1923, p. 250

136 *The Letters of Virginia Woolf*, Volume 3, Letter 1628, 13 April 1926, p. 254

137 *The Letters of Virginia Woolf*, Volume 3, Letter 1530, 31 January 1925, p. 160

138 *The Diary of Virginia Woolf*, Volume III, 4 April 1930, p. 299

139 Raymond Mortimer to Lytton Strachey, 6 November 1931, Strachey Papers, British Library, Add Ms 60681

140 Ibid.

141 Lytton Strachey to Dora Carrington, October 1924, Levy, op. cit., p. 540

142 James Strachey to Alix Strachey, 27 October 1924, Perry Meisel and Walter Kendrick (eds), *Bloomsbury/Freud: The Letters of James and Alix Strachey, 1924–25*, Chatto & Windus, 1986, p. 99

143 James Strachey to Alix Strachey, 22 December 1924, ibid., p. 157

144 Ibid.

145 James Strachey to Alix Strachey, 13 June 1925, ibid., p. 280

146 Julia Strachey, "Notes on Virginia Woolf," Julia Strachey Papers, UCL Special Collections, A43

147 Muriel Gee (sister of Hermione Baddeley), quoted in Luke, op. cit., p. 32

148 1925 Press Release for the Gargoyle Club, quoted in ibid., p. 2

149 *Tatler*, 23 October 1929, quoted in Mark Hussey, *Clive Bell and the Making of Modernism*, Bloomsbury, 2021, p. 282

150 Clive Bell to Vanessa Bell, 20 May 1928, quoted in ibid., p. 268

151 *Daily Telegraph*, January 1925, quoted in Luke, op. cit., p. 32

152 *The Diary of Virginia Woolf*, Volume III, 28 March 1929, p. 219

153 *Time and Tide*, 27 June 1931

154 Lady Ottoline Morrell's journal, 23 July 1931, quoted in Spalding, op. cit., pp. 309–310

155 "The Nightlife of London: Society's Post-Prandial Amusements: Dance Clubs and Cabaret Shows," *Illustrated London News*, 25 December 1926, pp. 128–29

156 *Vogue*, July 1927, op. cit.

157 Dora Carrington to Saxon Sydney Turner, Anne Chisholm (ed), *Carrington's Letters*, pp. 318–19

158 Ibid.

159 Ibid.

160 Ibid.

161 Ibid.

162 Lytton Strachey to Mary Hutchinson, 19 July 1927, Levy, op. cit., pp. 567–68

163 Edward Burra reporting Billy Chappell's account of the party, Jane Stevenson, *Edward Burra: Twentieth-Century Eye*, Jonathan Cape, 2007, p. 81

164 Nancy Mitford to Heywood Hill (undated), quoted in Taylor, op. cit., p. 27

165 Lytton Strachey to Mary Hutchinson, 19 July 1927, Levy, op. cit., pp. 567–68

166 Dora Carrington to Saxon Sydney Turner, Anne Chisholm (ed), *Carrington's Letters*, pp. 318–19

167 Ibid.

168 Ibid.

169 *The Diary of Virginia Woolf*, Volume II, 18 November 1924, p. 322

170 Frances Partridge quoted in Joan Russell Noble (ed), *Recollections of Virginia Woolf by Her Contemporaries*, Penguin, 1972, p. 75

171 Frances Partridge reporting Virginia Woolf's words, quoted in ibid.

172 Alix Strachey, quoted in ibid., p. 112

173 Mary Hutchinson to Vita Sackville-West, quoted in Victoria Glendinning, *Vita: The Life of Vita Sackville-West*, Penguin, 1984, p. 178

174 *The Letters of Virginia Woolf*, Volume 3, Letter 1780, 4 July 1927, p. 395

175 *The Letters of Virginia Woolf*, Volume 3, Letter 1760, 22 May 1927, p. 381

176 *The Diary of Virginia Woolf*, Volume III, 4 September 1927, pp. 153–54

177 *The Diary of Virginia Woolf*, Voume III, 23 July 1927, p. 149

178 Ibid.

179 Logan Pearsall-Smith to Cyril Connolly, 17 November 1926, quoted in Cecil and Cecil, op. cit., p. 218

180 Lytton Strachey to Mary Hutchinson, 19 July 1927, Levy, op. cit., p. 567

181 Lytton Strachey to Mary Hutchinson, 26 August 1927, Levy, op. cit., p. 573

182 *The Letters of Virginia Woolf*, Volume 3, Letter 1395, 24 May 1923, p. 44

183 *The Diary of Virginia Woolf*, Volume II, 18 November 1924, p. 322

184 Ibid.

185 Frances Partridge, *Love in Bloomsbury*, p. 101

186 Lytton Strachey to Roger Senhouse, 30 July 1930, Levy, op. cit., p. 625

187 Lytton Strachey to Dadie Rylands, 12 November 1927, quoted in Michael Holroyd, *Lytton Strachey*, p. 590

188 Lytton Strachey to Dorothy Bussy, February 1929, quoted in ibid., p. 616

189 *The Diary of Virginia Woolf*, Volume III, 20 September 1927, pp. 156–57

190 Ibid., 6 June 1927, p. 138

191 Ibid., p. 138

192 *The Letters of Virginia Woolf*, Volume 3, Letter 1945, 22 October 1928, p. 549

193 Ibid.

194 Ibid.

195 *The Letters of Virginia Woolf*, Volume 3, Letter 1663, August 1926, p. 266

196 *The Letters of Virginia Woolf*, Volume 3, Letter 1718, 18 February 1927, p. 332

197 Ibid., Letter 1735, 23 March 1927, p. 353

198 Ibid., Letter 1578, October 1926, p. 298

199 Ibid., Letter 1711, 31 January 1927, p. 320

200 Ibid., Letter 1624, 16 March 1925, p. 248

201 Ibid., Letter 1524, 24 January 1925, p. 155

202 Vita Sackville-West to Harold Nicolson, Spring 1926, quoted in Glendinning, *Vita*, p. 162

203 Vita Sackville-West to Harold Nicolson, August 1929, quoted in ibid, p. 217

204 Lytton Strachey to Roger Senhouse, 28 August 1926, quoted in De la Noy, op. cit., p. 111

205 *The Letters of Virginia Woolf*, Volume 4, Letter 2218, 15 August 1930, p. 200

206 *The Letters of Virginia Woolf*, Volume 3, Letter 1820, 9 October 1927, p. 428

207 Maurice Bowra, *Memories*, Weidenfeld & Nicolson, 1966, quoted in De la Noy, op. cit., p. 81

208 Eddy Sackville-West, "Sketches for an Autobiography: Prelude to Music," 1946, quoted in ibid., p. 6

209 Virginia Woolf, *Orlando*, Penguin, 1993, p. 12

210 Virginia Woolf, *Orlando*, p. 51

211 Virginia Woolf, *Orlando*, p. 27

212 Vita Sackville-West to Virginia Woolf, 29 May 1927, quoted in De la Noy, op. cit., p. 115

213 *The Letters of Virginia Woolf*, Volume 3, Letter 1524, 24 January 1925, p. 155

214 *John Bull*, 25 June 1925, p. 11

215 *John Bull*, 13 June 1925, p. 18

216 Matt Houlbrook, "The Man with the Powder Puff in Interwar London," *Historical Journal*, 50, 1, 2007, p. 158

217 John Rothenstein, *Summer's Lease: Autobiography, 1901–1938*, Hamish Hamilton, 1965, pp. 76–77

218 Molly MacCarthy to Dolly Ponsonby, undated, 1922 or 1923, quoted in Cecil and Cecil, op. cit., p. 216

219 *The Letters of Virginia Woolf*, Volume 3, Letter 1641, Friday, 1926, p. 267

220 Lytton Strachey to Dora Carrington, 3 June 1923, quoted in Michael Holroyd, *Lytton Strachey*, p. 523

221 Ibid.

222 Kyrle Leng to Eddy Sackville-West, January 1924, quoted in De la Noy, op. cit., p. 93

223 From the diary of Eddy Sackville-West, 2 February 1924, quoted in ibid., p. 94

224 Kyrle Leng to Eddy Sackville-West, quoted in ibid., p. 93

225 From the diary of Eddy Sackville-West, 19 March 1924, quoted in ibid., p. 97

226 From the diary of Eddy Sackville-West, 25 March 1924, quoted in ibid., p. 97

227 From the diary of Eddy Sackville-West, 28 March 1924, quoted in ibid., p. 98

228 *Daily Chronicle*, 1925, quoted in De la Noy, op. cit., p. 102

229 *The Letters of Virginia Woolf*, Volume 3, Letter 1906, 24 June 1928, p. 511

230 *The Letters of Virginia Woolf*, Volume 3, Letter 1675, 22 September 1926, p. 294

231 Duncan Grant to Eddy Sackville-West, 2 August 1926, British Library, Add Ms RP9336, quoted in Spalding, op. cit., p. 170

232 *Daily Express*, 14 September 1928, quoted in Philip Hoare, *Serious Pleasures: The Life of Stephen Tennant*, Hamish Hamilton, 1990, p. 100

233 *Sphere*, 16 June 1928, quoted in ibid., p. 109

234 *Vogue* caption for Cecil Beaton's photograph of Stephen Tennant's guests at Wilsford, November 1927

235 Ibid.

236 *The Diary of Virginia Woolf*, Volume III, 4 April 1930, p. 299

237 Stephen Tennant to Elizabeth Lowndes, 12 September 1927, quoted in Hoare, op. cit., p. 87

238 *Vogue* description of Stephen Tennant's room, March 1926, quoted in ibid., pp. 63–64

239 *Westminster Gazette*, May 1927, quoted in ibid., p. 76

240 Hugo Vickers (ed), *Cocktails & Laughter: The Albums of Loelia Lindsay*, Hamish Hamilton, 1983, p. 35

241 From the diary of Cecil Beaton, 15 January 1927, quoted in Hoare, op. cit., p. 69

242 Stephen Tomlin to Julia Strachey, June 1927, Julia Strachey Papers, UCL Special Collections, D3

243 Lytton Strachey to Roger Senhouse, 17 October 1927, Levy, op. cit., p. 577

244 Ibid.

245 Sacheverell Sitwell to Stephen Tennant, 18 October 1927, quoted in Hoare, op. cit., p. 93

246 Lytton Strachey to Roger Senhouse, 17 October 1927, Levy, op. cit., p. 577

247 Lytton Strachey to Stephen Tomlin, 16 August 1929, Julia Strachey Papers, UCL Special Collections, D2

248 Lytton Strachey to Roger Senhouse, 4 November 1929, Levy, op. cit., p. 612

249 Dora Carrington to David Garnett, June 1930, David Garnett (ed), *Carrington: Letters and Extracts from Her Diaries*, p. 445

250 Stephen Tennant to Lytton Strachey, 5 December 1929, BL Add Ms 60732

251 Stephen Tennant to Lytton Strachey, 18 June 1930, BL Add Ms 60732

252 Stephen Tennant to Lytton Strachey, July 1930, Strachey Papers, British Library, Add Ms 60732

253 From filmed interview with Stephen Tennant, Nicholas Haslam, and the Earl of Pembroke, summer 1985, quoted in Hoare, op. cit., p. 94

254 Ibid.

255 Eddy Sackville-West to Clive Bell, 5 April (year not given), quoted in De la Noy, op. cit., p. 112

256 Alexander Pope, *Epistle to Dr. Arbuthnot*, January 1735

257 Julia Strachey, "Notes on Virginia Woolf," Julia Strachey Papers, UCL Special Collections, A43

258 Lytton Strachey to Dora Carrington, 24 September 1925, Levy, op. cit., p. 550

259 Lytton Strachey to Roger Senhouse, 22 September 1927, ibid., p. 576

260 Stephen Tomlin to Lytton Strachey, 13 May 1926, Strachey Papers—20th Century, British Library, Add Ms 60732

261 Lytton Strachey to Dora Carrington, 25 September 1925, Levy, op. cit., p. 549

262 Dora Carrington to Gerald Brenan, 10 July 1925, Anne Chisholm (ed), *Carrington's Letters*, p. 293

263 Dora Carrington to Julia Strachey, undated letter, Julia Strachey Papers, UCL Special Collections, B1/1

264 Dora Carrington to Gerald Brenan, 1926, quoted in Michael Holroyd, *Lytton Strachey*, p. 575

265 *Oriental Herald & Colonial Review*, Vol. 7, 14 June 1825

266 Julia Strachey, "Indian Bungalow," in Frances Partridge, *Julia: A Portrait of Julia Strachey by Herself and Frances Partridge*, p. 22

267 Lady Strachey to Jack Strachey, BL MS Eur F127/483, quoted in Barbara Caine, *Bombay to Bloomsbury: A Biography of the Strachey Family*, Oxford University Press, 2005, p. 166

268 Vanessa Bell to Duncan Grant, 7 January 1927, Marler, op. cit., pp. 300–301

269 Julia Strachey's notebook, in Frances Partridge, *Julia: A Portrait of Julia Strachey by Herself and Frances Partridge*, p. 105

270 Dora Carrington to Julia Strachey, Spring 1926, Anne Chisholm (ed) op. cit., p. 305

271 Alix Strachey to James Strachey, 25 May 1925, Meisel and Kendrick (eds), op. cit., p. 275

272 Julia Strachey quoted in Frances Partridge, *Julia: A Portrait of Julia Strachey by Herself and Frances Partridge*, p. 98

273 Barbara Strachey quoted in Jennifer Holmes, *A Working Woman: The Remarkable Life of Ray Strachey*, Matador, 2019, p. 209

274 Ray Strachey diary, quoted in ibid., p. 210

275 Dora Carrington to Gerald Brenan, 27 December 1926, Anne Chisholm (ed), *Carrington's Letters*, p. 310

276 Dora Carrington to Julia Strachey, Summer 1925, ibid., p. 297

277 Ibid.

278 Ibid.

279 Barbara Strachey Halpern, Review of *A Portrait of Julia Strachey* in *Russell: The Journal of Bertrand Russell Studies*, Winter 1983–84, p. 178

280 Julia Strachey, "Notes on Virginia Woolf," Julia Strachey Papers, UCL Special Collections, A43

281 Julia Strachey Minute Book, Julia Strachey Papers, UCL Special Collections, A10

282 From the diary of Julia Strachey, Julia Strachey Papers, UCL Special Collections, A5

283 *The Letters of Virginia Woolf*, Volume 3, Letter 1608, 7 January 1926, p. 226

284 Frances Partridge, *Love in Bloomsbury*, p. 138

285 Gerald Brenan, *Personal Record, 1920–72*, Jonathan Cape, 1974, pp. 154–55

286 David Garnett, *The Familiar Faces*, pp. 1–2

287 Stephen Tomlin to Lytton Strachey, 15 April 1925, Strachey Papers—20th Century, British Library, Add Ms 60732

288 James Strachey to Alix Strachey, 27 November 1924, quoted in Meisel and Kendrick (eds), op. cit., p. 131

289 James Strachey to Alix Strachey, 4 December 1924, ibid., p. 136

290 Lytton Strachey to Roger Senhouse, quoted in Michael Holroyd, *Lytton Strachey: A Critical Biography*, p. 527

291 *Vogue*, November 1925

292 David Garnett, *The Familiar Faces*, pp. 12–13

293 Brenan, *Personal Record*, pp. 154–55

294 Dora Carrington to Julia Strachey, Summer 1926, Anne Chisholm (ed), *Carrington's Letters*, p. 306

295 F. L. Lucas, quoted in Michael Holroyd, *Lytton Strachey: A Critical Biography*, p. 488

296 Stephen Tomlin to Julia Strachey, undated letters from Ham Spray and Heath Studio, Julia Strachey Papers, UCL Special Collections, E1

297 Ibid.

298 Ibid.

299 Ibid.

300 Ibid.

301 Ibid.

302 Ray Strachey, October 1926, quoted in Frances Partridge, *Julia: A Portrait of Julia Strachey by Herself and Frances Partridge*, p. 107

303 Dora Carrington to Julia Strachey, mid-July 1927, David Garnett (ed), *Carrington: Letters and Extracts from Her Diaries*, p. 370

304 Lytton Strachey to Mary Hutchinson, 19 July 1927, Levy, op. cit., p. 567

305 *The Letters of Virginia Woolf*, Volume 3, Letter 1789, 23 July 1927, p. 401

306 Ibid., Letter 1790, 23 July 1927, p. 402

307 Stephen Tomlin to Lytton Strachey, 25 August 1927, Strachey Papers, British Library, Add Ms 60732

308 Lytton Strachey to Stephen Tomlin, 2 October 1927, Julia Strachey Papers, UCL Special Collections, D1

309 Ibid., 27 August 1928

310 Lytton Strachey to Roger Senhouse, 16 June 1929, Levy, op. cit., p. 599

311 Julia Strachey's diary, 6 February 1929, quoted in Frances Partridge, *Julia: A Portrait of Julia Strachey by Herself and Frances Partridge*, p. 112

312 Swallowcliffe Diary January–March 1929, Julia Strachey Papers, UCL Special Collections, A2

313 Ibid.

314 David Garnett to Mina Kirstein, December 1928, quoted in Michael Bloch and Susan Fox, *Bloomsbury Stud: The Life of Stephen "Tommy" Tomlin*, M.A.B., 2020, p. 149

315 Alix Strachey to Eddy Sackville-West, 31 October 1928, quoted in De la Noy, op. cit., p. 116

316 Lytton Strachey to Roger Senhouse, 16 June 1929, Levy, op. cit., p. 599

317 Julia Strachey's diary, Spring 1929, quoted in Frances Partridge, *Julia: A Portrait of Julia Strachey by Herself and Frances Partridge*, p. 112

318 Ibid., p. 113

319 Julia Strachey, "The Return," quoted in ibid., p. 127

320 Ibid., p. 126

321 Dora Carrington to Julia Strachey, Julia Strachey Papers, UCL Special Collections, B1/3

322 Bunny Garnett to Stephen Tomlin, 1 December 1929, Julia Strachey Papers, UCL Special Collections, D3

323 Lytton Strachey to Stephen Tomlin, Julia Strachey Papers, UCL Special Collections, D2

324 Ibid.

325 Julia Strachey to Stephen Tomlin, 20 May 1930, quoted in Frances Partridge, *Julia: A Portrait of Julia Strachey by Herself and Frances Partridge*, p. 114

326 Julia Strachey to Stephen Tomlin, 6 April 1931, quoted in ibid., p. 115

327 Julia Strachey to Stephen Tomlin, Julia Strachey Papers, UCL Special Collections, E2

328 Ibid.

329 Ibid.

330 Dora Carrington to Sebastian Sprott c. 1931, quoted in Bloch and Fox, op. cit., p. 172

331 *The Letters of Virginia Woolf*, Volume 4, Letter 2408, 22 July 1931, p. 360

332 *The Letters of Virginia Woolf*, Volume 5, Letter 2509, 18 January 1932, p. 7

333 Ibid., Letter 2542, 2 March 1932, p. 29

334 *New Adelphi*, 22 November 1932

335 *Evening News*, 22 November 1932

336 Dorothy Bussy to Julia Strachey, 12 December 1932, Julia Strachey Papers, UCL Special Collections, I/2

337 *Bristol Evening Post*, 18 December 1932

338 Dora Carrington to Julia Strachey, 1 July 1929, David Garnett (ed), *Carrington: Letters and Extracts from Her Diaries*, p. 412

339 Typed Cranium Club letter dated 4 January 1925, signed by Alec Penrose as Treasurer, examples surviving in the Strachey Papers, British Library, and Eddy Sackville-West's Papers, Knole

340 Dora Carrington to Alix Strachey, 4 February 1926, Anne Chisholm (ed), *Carrington's Letters*, pp. 288–89

341 Ibid.

342 David Garnett, *The Familiar Faces*, Chatto & Windus, 1962, p. 38

343 E. M. Forster to Lytton Strachey, 1 February 1925, Strachey Papers, British Library, Add Ms 60666

344 Ralph Partridge to Lytton Strachey, 8 January 1926, Strachey Papers, British Library, Add Ms 60690

345 Lytton Strachey to Dora Carrington, 9 October 1926, Levy, op. cit., p. 557

346 Dora Carrington, quoted in Michael Holroyd, *Lytton Strachey*, p. 546

347 Lytton Strachey to Stephen Tomlin, 26 August 1927, Julia Strachey Papers, UCL Special Collections, D2

348 Lytton Strachey to Stephen Tomlin, September 1927, ibid.

349 Thomas Love Peacock, *The Works of Thomas Love Peacock, Headlong Hall*, Richard Bentley, 1875, pp. 54–57

350 Dadie Rylands to Lytton Strachey, 19 March 1925, Strachey Papers, British Library, Add Ms 60695

351 David Garnett Cranium Club Letter, 25 March 1929, Julia Strachey Papers, UCL Special Collections, D3

352 Leonard Woolf, Review for the *Listener*, 1949, quoted in S. P. Rosenbaum, *The Bloomsbury Group Memoir Club*, Palgrave Macmillan, 2014, p. 12

353 Julia Strachey, "Notes on Virgina Woolf," Julia Strachey Papers, UCL Special Collections, A43

354 Vanessa Bell to Roger Fry, 1924, quoted in Anne Chisholm, *Frances Partridge: The Biography*, Weidenfeld & Nicolson, 2009, p. 88

355 *The Diary of Virginia Woolf*, Volume II, 25 December 1924, p. 327

356 *The Letters of Virginia Woolf*, Volume 3, Letter 1546 to Vanessa Bell, 3 April 1925 p. 176

357 Vanessa Bell to Lytton Strachey, Strachey Papers, British Library, Add Ms 60659

358 *The Diary of Virginia Woolf*, Volume III, 28 November 1928, p. 324

359 *Sunday Chronicle*, 1928, quoted in Taylor, op. cit., p. 4

360 *The Daily Express*, 14 July 1928, quoted in D. J. Taylor, *Bright Young People*, Vintage Books, 2008, p. 3

361 *The Diary of Virginia Woolf*, Volume III, 19 February 1929, p. 326

362 *The Letters of Virginia Woolf*, Volume 3, Letter 1574, 1 September 1925, p. 200

363 *Sunday Express*, 19 August 1928

364 Ibid.

365 *Scotsman*, 24 August 1928

366 *Sunday Express*, 19 August 1928

367 Dora Carrington to Dorelia John, Christmas 1927, Anne Chisholm (ed), *Carrington's Letters*, p. 328

368 Stephen Tomlin to Julia Strachey, June 1927, Julia Strachey Papers, UCL Special Collections, E1

369 *The Letters of Virginia Woolf*, Volume 3, Letter 1820, 9 October 1927, p. 428

370 *The Letters of Virginia Woolf*, Volume 3, Letter 1867, 5 March 1928, p. 465

371 Vita Sackville-West to Harold Nicolson, 1927, quoted in Victoria Glendinning, *Vita: The Life of Vita Sackville-West*, p. 185

372 *The Letters of Virginia Woolf*, Volume 3, Letter 1893, 9 May 1928, p. 496

373 Ibid., Letter 1870, 12 March 1928, p. 471

374 Frances Partridge to Phil Nichols, August 1927, quoted in Anne Chisholm, *Frances Partridge: The Biography*, p. 126

375 Frances Partridge Diary, 28 March 1930, Frances Partridge, *Love in Bloomsbury*, p. 170

376 Frances Partridge Diary, 4 July 1930, ibid., p. 172

377 Alix Strachey to Eddy Sackville-West, 19 March (year not given), British Library, Add Ms 72708

378 Alix Strachey to Eddy Sackville West, 15 November 1927, British Library, Add Ms 72708

379 Alix Strachey to Eddy Sackville-West, 31 October 1928, British Library, Add Ms 72708

380 Alix Strachey to Eddy Sackville-West, 31 May (year not given), British Library, Add Ms 72708

381 Alix Strachey to Eddy Sackville-West, 31 October 1927, British Library, Add Ms 72708

382 Alix Strachey to Eddy Sackville-West, 19 November 1930, British Library, Add Ms 72708

383 Eddy Sackville-West to Raymond Mortimer, 5 November 1928, quoted in De la Noy, op. cit., pp. 133–34

384 John Strachey, "The Education of a Communist," *Left Review*, December 1934

385 F. Scott Fitzgerald, "Echoes of the Jazz Age," *Scribner's Magazine*, Volume 90, November 1931, pp. 459–65

386 Leonard Woolf to Lord Robert Cecil, quoted in Hermione Lee, *Virginia Woolf*, Vintage, 1997, p. 460

387 John Strachey, Labour Manifesto for Birmingham Aston, October 1924

388 Typed invitation and program with signatures, Eddy Sackville-West Papers, British Library, Add Ms 68905

389 Ibid.

390 Ibid.

391 Arthur Ponsonby's diary, 8 August 1921, quoted in Hugh Thomas, *John Strachey*, Eyre Methuen, 1973, p. 19

392 Lytton Strachey to Dora Carrington, 16 May 1922, Levy, op. cit., p. 514

393 Hugh Thomas reporting Julia Strachey's remarks, Thomas, op. cit., p. 19

394 Amabel Williams-Ellis, *All Stracheys Are Cousins*, Weidenfeld & Nicolson, 1982, p. 72

395 Richard Church, extract from *The Voyage Home*, quoted in Williams-Ellis, op. cit., rear leaf of the dust jacket

396 Julia Strachey, quoted in Thomas, op. cit., p. 36

397 James Strachey, preface to Lytton Strachey, *Spectatorial Essays*, Chatto & Windus, 1964, p. 7

398 Lytton Strachey, quoted in Williams-Ellis, op. cit., p. 89

399 John St. Loe Strachey to John Strachey, 15 October 1924, quoted in Thomas, op. cit., p. 44

400 *The Letters of Virginia Woolf*, Volume 6, Letter 3597, 6 April 1940, p. 391

401 Stephen Tomlin to Lytton Strachey, Strachey Papers, British Library, Add Ms 60732

402 *The Letters of Virginia Woolf*, Volume 3, Letter 1635, 12 May 1926, p. 260

403 Osbert Sitwell, "Say What He Will," *Weekend Review*, 1 August 1931

404 Lady Ravensdale, May 1928, quoted in Hugo Vickers, *Cecil Beaton: A Biography*, p. 103

405 Raymond Mortimer to Lytton Strachey, 12 January 1929, Strachey Papers, British Library, Add Ms 60678

406 Payson & Clarke press release, quoted in Lisa Cohen, *All We Know: Three Lives*, Farrar, Straus & Giroux, 2012, p. 45

407 Djuna Barnes, *Ladies Almanack*, New York University Press, 1992, p. 32

408 *New York Times* engagement announcement, 20 February 1929

409 Max Ewing, letter postmarked 7 March 1929, Max Ewing Papers, Yale

Collection of American Literature, Beinecke Rare Book & Manuscript Library, quoted in Cohen, op. cit., p. 60

410 Carl Van Vechten, quoted by Max Ewing in a letter to his parents, 9 May 1928, Max Ewing Papers, quoted in Cohen, op. cit., p. 10

411 Michael Holroyd, *Lytton Strachey*, p. 156

412 Dora Carrington to Lytton Strachey, autumn 1923, David Garnett (ed), *Carrington: Letters and Extracts from Her Diaries*, p. 265

413 Edmund Wilson, *The Sixties*, Farrar, Straus & Giroux, 1992, p. 62

414 Lloyd Morris, *This Circle of Flesh*, Harper & Brothers, 1932, pp. 52–53

415 Max Ewing to Mrs. Alice Manning, postmarked 15 March 1927, Max Ewing Papers, quoted in Cohen, op. cit., p. 49

416 Esther Murphy to Muriel Draper, mid-1920s, quoted in Cohen, op. cit., p. 50

417 Natalie Barney to Esther Murphy, late February 1929, quoted in Cohen, op. cit., p. 58

418 John Strachey to Yvette Fouquet, 22 February 1929, quoted in Thomas, op. cit., pp. 71–72

419 *New York Times*, 24 April 1929

420 Oswald Mosley, 24 April 1929, as reported by Susan Williams-Ellis, quoted in Thomas, op. cit., p. 73

421 *Aston Labour News*, 25 May 1929

422 Leaflet, "Parliamentary General Election, to the Women Electors of Aston," May 1929, Esther Murphy Strachey quoted in Cohen, op. cit., p. 61

423 *Aston Labour News*, 25 May 1929

424 John Strachey "The New Generation: The Necessity of Socialism," *Socialist Review*, 15 February 1929

425 Gerald Murphy interviewed by Tomkins c. 1960, quoted in Deborah Rothschild, *Making It New: The Art and Style of Gerald and Sara Murphy*, University of California Press, 2007, p. 47

426 F. Scott Fitzgerald to John Peale Bishop, postmarked 21 September 1925, quoted in Amanda Vaill, *Everybody Was So Young: Gerald and Sara Murphy, a Lost Generation Love Story*, Broadway Books, 1999, p. 163

427 F. Scott Fitzgerald to Ernest Hemingway, 9 September 1925, quoted in ibid., p. 210

428 Frederick Murphy to Mrs. Patrick Murphy, Rothschild, op. cit., p. 37

429 Gerald Murhpy's notebook, quoted in Vaill, op. cit., p. 211

430 William Chappell (ed), *Well, Dearie! The Letters of Edward Burra*, Gordon Fraser, 1985, pp. 36–37

431 Gerald Murphy to Richard Cowan, quoted in Rothschild, op. cit., p. 116

432 Eddy Sackville-West to Raymond Mortimer, 4 March 1930, in De la Noy, op. cit., p. 136

433 Ibid., p. 137

434 John Banting to Lytton Strachey, Strachey Papers, British Library, Add Ms 60656

435 Sybille Bedford interview with Lisa Cohen, 29 March 2000, quoted in Cohen, op. cit., p. 66

436 Joseph Brewer to John Strachey, 4 April 1932, quoted in Thomas, op. cit., p. 116

437 John Strachey to Oswald Mosley, quoted in Thomas, op. cit., p. 71

438 Max Ewing to his parents, postmarked 15 September 1931, Max Ewing Papers, Yale Collection of American Literature, Beinecke Rare Book & Manuscript Library, quoted in Cohen, op. cit., p. 66

439 Amabel Williams-Ellis to John Strachey, quoted in Cohen, op. cit., p. 67

440 Kingsley Martin, "A Social Democrat," *New Statesman and Nation*, 30 March 1940, p. 436

441 Robert Boothby to John Strachey, 1932, quoted in Thomas, op. cit., p. 133

442 Richard Crossman, *The Charm of Politics*, Hamish Hamilton, 1958, p. 140

443 Muriel Draper to John Strachey, 1932, quoted in Thomas, op. cit., pp. 115–16

444 Robert Boothby to John Strachey, 1932, quoted in ibid., pp. 126–27

445 F. Scott Fitzgerald, "Echoes of the Jazz Age," *Scribner's Magazine*, Vol 90, November 1931, p. 459

446 *The Diary of Virginia Woolf*, Volume IV, 1 January 1932, p. 61

447 Ibid., 21 January 1932, p. 64

448 *The Diary of Viriginia Woolf*, Volume IV, 12 November 1933, p. 188

449 *The Diary of Virginia Woolf*, Volume V, 10 January 1937, p. 48

450 David Garnett, obituary of Stephen Tomlin, *Times*, 16 January 1937

451 David Garnett, Review of Eddy Sackville-West's biography of De Quincy in the *New Statesman*, quoted in De la Noy, op. cit., p. 163

452 James Lees-Milne in conversation with Michael De la Noy, op. cit., p. 244

453 James Lees-Milne, *Caves of Ice: Diaries 1946–1947*, Michael Russell, 2004, entry for 18 January 1947, p. 127

454 Philip Francis (ed), *John Evelyn's Diary: A Selection from the Diary*, Folio Society, 1963, p. 58

455 Frances Partridge, *Everything to Lose: Diaries 1945–1960*, Victor Gollancz, 1985, p. 100

456 John Maynard Keynes, "My Early Beliefs" (1949), in S. P. Rosenbaum, *The Bloomsbury Group: A Collection of Memoirs, Commentary and Criticism*, pp. 48–64 (quoted line at p. 61)

SELECT BIBLIOGRAPHY

Anscombe, Isabelle: *Omega and After, Bloomsbury and the Decorative Arts* (Thames & Hudson, 1984)

Barlow, Clare *Queer British Art, 1867–1967* (Tate Publishing, 2017)

Beaton, Cecil *The Wandering Years, 1922–39: Cecil Beaton's Diaries, Book 1* (Sapere Books, 2018)

Bell, Quentin *Bloomsbury* (Phoenix Giant, 1997)

Bell, Quentin, and Nicholson, Virginia *Charleston: A Bloomsbury House and Garden* (White Lion, 2018)

Bell, Vanessa *Selected Letters of Vanessa Bell*, edited by Regina Marler (Bloomsbury, 1993)

Bingham, Emily *The Jazz Age Life of Henrietta Bingham* (Farrar, Straus & Giroux, 2015)

Bloch, Michael and Fox, Susan *Bloomsbury Stud: The Life of Stephen "Tommy" Tomlin* (M.A.B., 2020)

Caine, Barbara *Bombay to Bloomsbury: A Biography of the Strachey Family* (Oxford University Press, 2005)

Carrington, Dora *Carrington: Letters and Extracts from Her Diaries*, edited by David Garnett (Jonathan Cape, 1970)

Carrington, Dora *Carrington's Letters*, edited by Anne Chisholm (Chatto & Windus, 2017)

Carter, Miranda *Anthony Blunt, His Lives* (Pan Books, 2002)

Cecil, Hugh, and Cecil, Mirabel *Clever Hearts: Desmond & Molly MacCarthy* (Victor Gollancz, 1991)

Chisholm, Anne *Frances Partridge: The Biography* (Weidenfeld & Nicolson, 2009)

Cohen, Lisa *All We Know: Three Lives* (Farrar, Straus & Giroux, 2012)

Crab, John *Decadence: A Literary Anthology* (British Library, 2017)

De Gruchy, John Walter *Orienting Arthur Waley* (University of Hawai'i Press, 2003)

De la Noy, Michael *Eddy: The Life of Edward Sackville West* (Bodley Head, 1988)

Dejardin, Ian, and Milroy, Sarah (eds) *Vanessa Bell* (Philip Wilson, 2017)

Dennison, Matthew *Behind the Mask: The Life of Vita Sackville-West* (William Collins, 2015)

Desalvo, Louise, and Mitchell, Leaska (eds) *The Letters of Vita Sackville-West and Virginia Woolf* (Cleiss Press, 2004)

Dunn, Jane *Virginia Woolf and Vanessa Bell: A Very Close Conspiracy* (Virago, 2001)

Egremont, Max *Siegfried Sassoon: A Biography* (Picador, 2005)

Forrester, John, and Cameron, Laura *Freud in Cambridge* (Cambridge University Press, 2017)

Fry, Roger *Duncan Grant* (Hogarth Press Living Painters Series, 1924)

Garnett, David *The Familiar Faces* (Chatto & Windus, 1962)

Gerzina, Gretchen *Carrington: A Life of Dora Carrington, 1893–1932* (Oxford University Press, 1990)

Ginger, Andrew *Cecil Beaton at Home: An Interior Life* (Rizzoli, 2016)

Glendinning, Victoria *Leonard Woolf: A Life* (Simon & Schuster, 2006)

Glendinning, Victoria *Vita: The Life of Vita Sackville-West* (Pocket Books, 2007)

Hall, Carolyn *The Twenties in Vogue* (Octopus Books, 1983)

Hamer, Emily *Britannia's Glory: A History of Twentieth-Century Lesbians* (Cassell, 1996)

Hastings, Selina *Rosamond Lehmann* (Vintage, 2003)

Helt, Brenda, and Detloff, Madelyn (eds) *Queer Bloomsbury* (Edinburgh University Press, 2016)

Hill, Polly, and Keynes, Richard (eds) *Lydia & Maynard: The Letters of Lydia Lopokova and John Maynard Keynes* (Papermac, 1992)

Hoare, Philip *Serious Pleasures: The Life of Stephen Tennant* (Hamish Hamilton, 1990)

Holmes, Jennifer *A Working Woman: The Remarkable Life of Ray Strachey* (Matador, 2019)

Holroyd, Michael *Lytton Strachey* (Vintage, 1995)

Holroyd, Michael *Lytton Strachey: A Critical Biography. Volume II: The Years of Achievement, 1910–1932* (Heinemann, 1968)

Houlbrook, Matt "The Man with the Powder Puff in Interwar London" (*Historical Journal*, 50, 1, 2007, pp. 145–71)

Houlbrook, Matt *Queer London: Perils and Pleasures in the Sexual Metropolis, 1918–1957* (University of Chicago Press, 2005)

Houseman, John *Run Through: A Memoir* (Touchstone, 1980)

Humm, Maggie *Snapshots of Bloomsbury: The Private Lives of Virginia Woolf and Vanessa Bell* (Rutgers University Press, 2005)

Humm, Maggie (ed) *Virginia Woolf and the Arts* (Edinburgh University Press, 2010)

Hussey, Mark *Clive Bell and the Making of Modernism* (Bloomsbury, 2021)

Jones, Peter *George Humphrey Wolferstan Rylands, 1902–99: A Memoir* (King's College, Cambridge, 2000)

King, James *Roland Penrose: The Life of a Surrealist* (Edinburgh University Press, 2016)

Kirstein, Lincoln *Mosaic: Memoirs* (Farrar, Straus & Giroux, 1994)

Knights, Sarah *Bloomsbury's Outsider: A Life of David Garnett* (Bloomsbury, 2015)

Lee, Hermione *Virginia Woolf* (Vintage, 1997)

Lehmann, John *Leonard and Virginia Woolf at Monk's House* (National Trust Studies, 1985)

Lehmann, John *Virginia Woolf and Her World* (Harvest, 1977)

Luckhurst, Nicola *Bloomsbury in Vogue* (Cecil Woolf, 1998)

Luke, Michael *David Tennant and the Gargoyle Years* (Weidenfeld & Nicolson, 1991)

Mackrell, Judith *Bloomsbury Ballerina* (Weidenfeld & Nicolson, 2008)

MacCarthy, Fiona, and Collins, Judith *The Omega Workshops, 1913–1919: Decorative Arts of Bloomsbury* (Crafts Council, 1984)

Meisel, Perry, and Kendrick, Walter (eds) *Bloomsbury/Freud: The Letters of James and Alix Strachey, 1924–25* (Chatto & Windus, 1986)

Meyers, Jeffrey *Scott Fitzgerald* (Harper Perennial, 2014)

Misak, Cheryl *Frank Ramsey: A Sheer Excess of Powers* (Oxford University Press, 2020)

Moffatt, Wendy *E. M. Forster: A New Life* (Bloomsbury, 2011)

Mortimer, Raymond *Try Anything Once* (Hamish Hamilton, 1976)

Mortimer, Raymond, and Todd, Dorothy *The New Interior Decoration* (B. T. Batsford, 1929)

Muir, Robin *Cecil Beaton's Bright Young Things* (National Portrait Gallery, 2020)

Newman, Michael *John Strachey (Lives of the Left)* (Manchester University Press, 1989)

Nicholson, Virginia *Among the Bohemians: Experiments in Living, 1900–1939* (Penguin, 2003)

Noble, Joan Russell (ed) *Recollections of Virginia Woolf by Her Contemporaries* (Penguin, 1972)

Partridge, Frances *Everything to Lose: Diaries, 1945–1960* (Victor Gollancz, 1985)

Partridge, Frances *Friends in Focus* (Chatto & Windus, 1987)

Partridge, Frances *Julia: A Portrait of Julia Strachey by Herself and Frances Partridge* (Little, Brown, 1983)

Partridge, Frances *Love in Bloomsbury* (Tauris Parke Paperbacks, 2014)

Reed, Christopher *Bloomsbury Rooms: Modernism, Subculture and Domesticity* (Yale University Press, 2004)

Reed, Christopher "Design for (Queer) Living: Sexual Identity, Performance and Décor in British *Vogue*, 1922–26 (*GLQ: A Journal of Lesbian and Gay Studies*, 12:3, 2006, pp. 377–403)

Roberts, John Stuart *Siegfried Sassoon, 1884–1957* (John Blake, 2005)

Rosenbaum, S. P. (ed) *The Bloomsbury Group: A Collection of Memoirs, Commentary and Criticism* (University of Toronto Press, 1975)

Rothenstein, John *Summer's Lease: Autobiography, 1901–1938* (Hamish Hamilton, 1965)

Rothschild, Deborah *Making It New: The Art and Style of Gerald and Sara Murphy* (University of California Press, 2007)

Sackville-West, Edward *The Ruin: A Gothic Novel* (W. Heinemann, 1926)

Sanders, Charles Richard *Lytton Strachey: His Mind and Art* (Yale University Press, 1957)

Sanders, Charles Richard *The Strachey Family, 1588–1932* (Duke University Press, 1953)

Seymour, Miranda *Ottoline Morrell: Life on the Grand Scale* (Faber & Faber, 2008)

Sheean, Vincent *Personal History* (Doubleday, Doran and Company, 1935)

Shone, Richard *The Art of Bloomsbury* (Tate Gallery, 1999)

Shone, Richard *Bloomsbury Portraits* (Phaidon, 1976)

Shone, Richard, and Collins, Judith *Duncan Grant, Designer* (Bluecoat Gallery, Liverpool, and Brighton Museum, 1980)

Skidelsky, Robert *John Maynard Keynes: The Economist as Saviour, 1920–1937* (Papermac, 1994)

Slocombe, Emma *The Reluctant Heir: Edward Sackville-West at Knole* (National Trust Collections Annual, 2016)

Spalding, Frances *The Bloomsbury Group* (National Portrait Gallery, 2014)

Spalding, Frances *Duncan Grant: A Biography* (Pimlico, 1998)

Spalding, Frances *Vanessa Bell: Portrait of the Bloomsbury Artist* (Weidenfeld & Nicolson, 1983)

Spalding, Frances *Virginia Woolf: Art, Life and Vision* (National Portrait Gallery, 2014)

Stephenson, Andrew "'Our Jolly Marin Wear': The Queer Fashionability of the Sailor Uniform in Interwar France and Britain" (*Fashion, Style & Popular Culture*, Vol. 3, No. 2, 2016, pp. 157–172)

Strachey, Amy *St. Loe Strachey: His Life and His Paper* (Victor Gollancz, 1930)

Strachey, Barbara *The Strachey Line: An English Family in America, India and at Home from 1570 to 1902* (Victor Gollancz, 1985)

Strachey, John St. Loe *The Adventure of Living* (Hodder & Stoughton, 1922)

Strachey, John St. Loe *The River of Life* (Hodder & Stoughton, 1924)

Strachey, Julia *Cheerful Weather for the Wedding* (Hogarth Press, 1932)

Strachey, Lytton *The Letters of Lytton Strachey*, edited by Paul Levy (Farrar, Straus & Giroux, 2005)

Strachey, Lytton *Lytton Strachey by Himself*, edited and introduced by Michael Holroyd (Abacus, 2005)

Strachey, Lytton *The Really Interesting Question and Other Papers*, edited by Paul Levy (Weidenfeld & Nicolson, 1972)

Strachey, Lytton *The Shorter Strachey*, selected and introduced by Michael Holroyd and Paul Levy (Oxford University Press, 1980)

Strachey, Lytton *Spectatorial Essays*, with a preface by James Strachey (Chatto & Windus, 1964)

Strachey, Richard *A Strachey Boy* (A. Wheaton & Co, 1979)

Strachey, Richard *A Strachey Child* (Peter Owen, 1980)

Sturgis, Matthew *Passionate Attitudes: The English Decadence of the 1890s* (Macmillan, 1995)

Taylor, D. J. *Bright Young People: The Rise and Fall of a Generation, 1918–40* (Vintage, 2008)

Thomas, Hugh *John Strachey* (Harper & Row, 1973)

Thomasson, Anna *A Curious Friendship: The Story of a Bluestocking and a Bright Young Thing* (Macmillan, 2015)

Thompson, Noel *John Strachey: An Intellectual Biography* (Macmillan, 1993)

Todd, Pamela *Bloomsbury at Home* (Pavilion, 1999)

Tomkins, Calvin *Living Well Is the Best Revenge* (Museum of Modern Art, New York, 2013)

Turner, Sarah A. M. *Percy Moore Turner: Connoisseur, Impresario & Art Dealer* (Unicorn, 2018)

Vaill, Amanda *Everybody Was So Young: Gerald and Sara Murphy, a Lost Generation Love Story* (Broadway Books, 1998)

Vickers, Hugo *Cecil Beaton: A Biography* (Primus, 1985)

Wade, Francesca *Square Haunting: Five Women, Freedom and London Between the Wars* (Faber & Faber, 2020)

Wagner-Martin, Linda *Zelda Sayre Fitzgerald: An American Woman's Life* (Palgrave Macmillan, 2004)

Watney, Simon *The Art of Duncan Grant* (John Murray, 1990)

Williams-Ellis, Amabel *All Stracheys Are Cousins* (Littlehampton, 1983)

Woolf, Leonard *Downhill All the Way: An Autobiography of the Years 1919 to 1939* (Mariner Books, 1989)

Woolf, Virginia *The Diary of Virginia Woolf*, edited by Anne Olivier Bell and Andrew MacNeillie, Volumes 2–5, 1920–1941 (Hogarth Press, 1978–84)

Woolf, Virginia *The Letters of Virginia Woolf*, edited by Nigel Nicolson and Joanne Troutman, Volumes 3–6, 1923–1941 (Hogarth Press, 1977–80)

Woolf, Virginia *Orlando* (Penguin, 1993)

Woolf, Virginia *A Room of One's Own* (Hogarth Press, 1929)

Yoss, Michael *Raymond Mortimer: A Bloomsbury Voice* (Cecil Woolf, 1998)

MANUSCRIPT SOURCES

Thanks to the Strachey Trust, the largest holding of twentieth-century Strachey papers can be found at the British Library. These include letters to Lytton from his siblings, and from the multiple members of Young Bloomsbury. Also in the British Library manuscripts collection are letters from Duncan Grant and Alix Strachey to Eddy Sackville-West. Julia Strachey's papers are housed in UCL Special Collections (including letters to and from Stephen Tomlin), with further material in the Berg Collection at the New York Public Library. Accounts of her parents' difficult marriage and bitter divorce can be found in letters from Oliver Strachey in the British Library and the Women's Library at LSE. Papers relating to Eddy Sackville-West and John Strachey are held in the private collection at Knole, and further John Strachey material has been retained by his descendants. The core collection of Strachey family papers, relating to their history at Sutton Court from the 1640s to 1986, is deposited at the Somerset Heritage Center in Taunton. Lytton Strachey's and Dora Carrington's photograph albums are held in the Modern Archives at King's College, Cambridge.

TEXT PERMISSIONS

INDEX

INDEX

INDEX